Patrick Pinnell

HENRY AUSTIN

Garnet Books

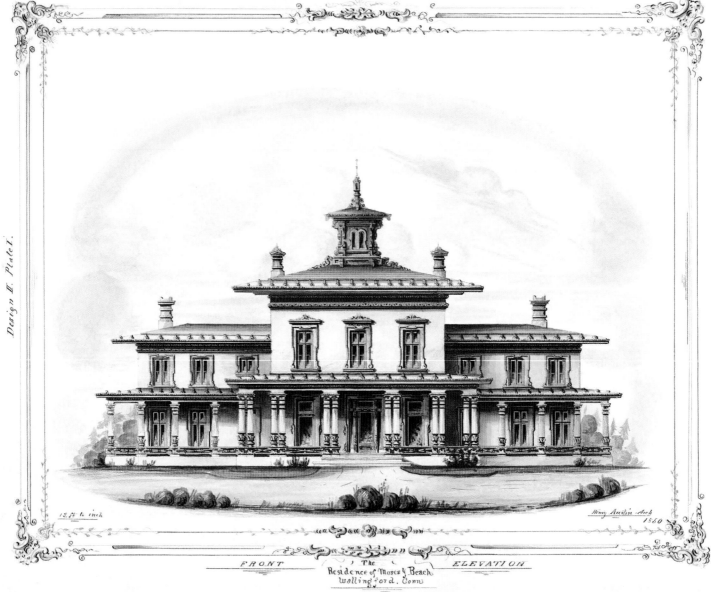

12 ft to inch

Henry Austin Arch
1860

FRONT The ELEVATION
 Residence of Moses Y. Beach
 Wallingford. Conn

JAMES F. O'GORMAN

Henry Austin

IN EVERY VARIETY OF

ARCHITECTURAL STYLE

Special Photography by Cervin Robinson

Research Assistance by Stephen Parnes

WESLEYAN UNIVERSITY PRESS

MIDDLETOWN, CONNECTICUT

FRONTISPIECE:

Henry Austin, Moses Yale Beach house, Wallingford, Connecticut (1850). Front Elevation (Austin Papers, Manuscripts and Archives, Sterling Library, Yale University).

Published by

Wesleyan University Press, Middletown, CT 06459

www.wesleyan.edu/wespress

© 2008 by James F. O'Gorman

All rights reserved.

Printed in Singapore 5 4 3 2 1

Library of Congress Cataloging-in-Publication Data

O'Gorman, James F.

Henry Austin : in every variety of architectural style / James F. O'Gorman ; special photography by Cervin Robinson ; research assistance by Stephen Parnes.

 p. cm. — (Garnet books)

Includes bibliographical references and index.

ISBN 978–0–8195–6896–0 (cloth : alk. paper)

1. Austin, Henry, 1804–1891—Criticism and interpretation. 2. Architecture—New England—History—19th century. I. Robinson, Cervin. II. Title.

NA737.A88O38 2009

720.92—dc22 [B] 2008039328

The publisher gratefully acknowledges the support of the Grace Slack McNeil Program for Studies of American Art and Architecture at Wellesley College.

An exhaustive effort has been made to locate the rights holder for the photograph of Trinity Episcopal Church (illustration number 80) and to clear reprint permission. If the required acknowledgments have been omitted, or any rights overlooked, it is unintentional and understanding is requested.

To

ROBERT L. MCNEIL, JR.

Champion of the Arts of
the United States

and

ELIZABETH MILLS BROWN

Champion of the Architecture
of Connecticut

CONTENTS

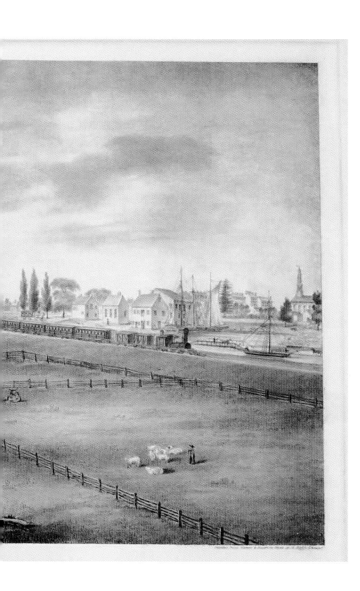

ILLUSTRATIONS

Henry Austin haunts the books on nineteenth-century American architecture, but he has not received the concentrated attention his position deserves as one of New England's most productive designers. Isolated and outstanding projects such as the demolished New Haven Railroad Station, the Grove Street Cemetery gate in the same city, the Morse-Libby house (Victoria Mansion) in Portland, Maine, the late, lamented Moses Yale Beach house in Wallingford, Connecticut, and the compromised New Haven City Hall (all antebellum works) stand in the literature for the achievements of a long career. No architect's work is composed solely of masterpieces, yet no one has yet published a study of these outstanding buildings within the context of the architecture of Austin's time or the complete body of his work.

This book is intended only partially to fill that gap. It is not a *catalogue raisonné*: it is an introductory overview of his career set within its historical framework. Too much remains unknown about Austin's life and work to fill a definitive study. This is a preliminary gathering of information, a group of brief chapters largely focused on the first two decades of his career, accompanied by selected illustrations of the works discussed. I justify this self-imposed emphasis, covering in some detail only three-fifths of Austin's professional span, by the pioneering character of the effort in terms of available published work, time at my disposal, the relative abundance of documents for the early years and the scarcity of information from later on, and the gradual leveling off of individuality in the works coming from Austin's office after the Civil War.

This is an attempt to separate fact from fiction, to discern what we can document about the architect's life and work as opposed to what has been written about it by later commentators. Because of the almost complete lack of available personal or professional documents originating from the man or his orbit, and the paucity of information about much of his work, this book needs to be impersonal and descriptive rather than biographical or critical. I intend it as a stimulus and guide to further research, not as an end in itself. The text and ample endnotes contain all the relevant information I have gathered about Austin, his office, and his work, and I have attempted briefly to evaluate that information and place it in the context of Austin's time. I have largely restricted myself to works

I could firmly document or reasonably assume to have been designed by Austin, and I have gathered as complete a visual record as I could find, part of which is illustrated here. (The complete information I have gathered over two years of research is contained in file boxes on deposit at Historic New England in Boston.) From this base, another scholar, should he or she be fortunate enough to uncover significant information now unknown, can detail Austin's life and evaluate his career as a whole. Meanwhile, we will look upon Austin's place in the history of American architecture not as the creator of a few landmarks but as a practitioner who helped shape the built environment of nineteenth-century southern Connecticut.

As an historian of nineteenth-century American architecture, I had paid vague attention to Austin's few noted works until I became a member of the board of trustees of the Victoria Mansion (his Italian villa for Ruggles Sylvester Morse) in Portland, Maine. Katharine J. Watson convinced me that I should get involved in the organization. Robert Wolterstorff, the director, and Arlene Palmer Schwind, the curator, have opened my eyes to the marvels of this outstanding example of American antebellum domestic architecture. Once hooked, I went looking for more about the architect, only to realize—as I have so many times before in my professional life—that if I wanted information, I would have to dig it out for myself. This book represents what I have learned.

I am not the first to write about the architect. Like Frank Furness in Philadelphia during the first half of the twentieth century, Henry Austin is thought of as a local hero in New Haven. In each instance architects, historians, preservationists, students, and others in the vicinity have sought out buildings and accounts, talked about them, and generally kept Austin's memory bright. Furness received a pioneering monograph on his career only in the early 1970s; Austin now belatedly receives his.

Austin has been the subject of a few brief notices in print. I have relied heavily on those works as well as on other sources of information. I began this overview of his career from the high ground prepared by the New Haven antiquarian George Dudley Seymour; Arnold G. Dana, whose scrapbooks at the New Haven Museum and Historical Society are a mine of information about the local built environment; Yale architectural historian Carroll L. V. Meeks, one of the few to discuss Austin's work in scholarly publications; Connecticut architectural historian Elizabeth Mills Brown; John B. Kirby, Jr., long-time student of the architect's work;

and H. Ward Jandl, who wrote an M.A. thesis on Austin for Columbia University in the early 1970s. Without the stimulus of these forerunners, my work would have been much more difficult.

I want also to thank several people who have supported my efforts in so many ways, especially Jeanne Hablanian of the Art Library at Wellesley College; Ian Graham of the Wellesley College Archives; MaryPat Navins and Lori Friedman of the Dean's Office, Wellesley College; my former Wellesley colleague Alice T. Friedman; Kathleen Rawlins of the Cambridge Historical Commission; Kendra Slaughter of the Museum of Fine Arts, Boston; John Herzan at the New Haven Preservation Trust; Christopher Wigren at the Connecticut Trust for Historic Preservation; Bob Craig and Terry Karschner of the New Jersey Historic Preservation Office; Rebecca McGaffin, librarian of the Young Men's Institute Library of New Haven; Nellie (Mrs. Harry C.) Jester of New Jersey and the Rev. Kenneth Walsh of Kingston, New York, direct descendants of the architect; Susan Klein at the Beinecke Library at Yale University; Nancy Finlay of the Connecticut Historical Society Museum; Harold Roth, F.A.I.A., who introduced me to the hospitality of the Quinnipiack Club in New Haven; Ricki Sablove, who did legwork in Trenton; Earle G. Shettleworth, Jr., of the Maine Historic Preservation Commission; Roger Reed; Timothy L. Decker of the New Jersey Historical Society; Michael J. Lewis of Williams College; Alan Jutzi of the Huntington Library; Karen Millison for technical service; Annemarie van Roessel of the Avery Architectural Library; and James W. Campbell and Amy Trout of the New Haven Museum and Historical Society. Chris Wigren and Sarah Allaback saved me much embarrassment by reading and commenting on an early draft. Stephen Parnes's research assistance has been of such importance as to merit a byline on the title page. Cervin Robinson's photographs have, as always, added clarity and quality to the exposition. Many others have helped in specific instances; they are acknowledged in the endnotes. As usual, I take full responsibility for the mistakes.

Finally, my chief debts are to the Andrew W. Mellon Foundation, which awarded me the Emeritus Fellowship through Wellesley College that allowed me over two years to visit Austin's standing works in southern Connecticut and elsewhere and to research archives in Hartford, New Haven, New York, and Maine; to the Grace Slack McNeil Program in the History of American Art at Wellesley College, which subsidized the publication of color photography; and to Susan Danly, who encouraged me to pursue this research and put up with the frequent absences it required.

Henry Austin (1804–1891) was born in the first decade of the nineteenth century and died in the last. He first saw light in the presidency of Thomas Jefferson and passed away, twenty administrations later, during that of Benjamin Harrison. At his birth Benjamin Henry Latrobe was beginning to concern himself with the design of the Greco-Roman Baltimore Cathedral; at his death the steel, brick, and terra cotta Wainwright Building for St. Louis marked the appearance of Louis Sullivan's most important work at the beginning of the rise of the skyscraper. Such longevity was not unknown among his contemporary practitioners. Alexander Jackson Davis (1803–92), Thomas Ustick Walter (1804–1887), James Renwick, Jr. (1818–1892), Gridley J. F. Bryant (1816–1899), his New Haven, Connecticut, rival Sidney Mason Stone (1803–1888), and many other nineteenth-century architects lived and worked to a ripe old age. Austin's independent professional practice lasted half a century. It began in the 1830s and survived into the 1880s. Like Davis's and Walter's, however, his career flagged after the early decades of productive achievement. The march of time, the rapid changes in society and culture in the industrialized century, the aftereffects of the financial panic of 1873, and the rise of competition in his own backyard—including that from some men he had trained himself—all contributed to the gradual leveling off of his career after the Civil War. It is the first part of that career that chiefly concerns us here. Unfortunately, in order even to study his early life and work, we must pick our way through incomplete and often fuzzy or contradictory information.

In the absence of known diaries by or letters by, to, or with reference to him (with three exceptions), Austin's biography cannot now be given in detail, and may never be. From what I know, he seems to have long lived a quiet life in modest frame houses on George Street in New Haven. He had two wives and many children.[1] Isolated inconsequential information reaches us: In the summer of 1841 the rented horse and wagon he was driving to the Mountain House on East Rock was upset, the wagon broken to pieces, and the horse killed.[2] He sat on the New Haven City Council in 1854. An article in the New Haven *Paladium* for 20 July 1858 reported on his expertise as a marksman. At the time of his death he had been for half a century a member of the Masonic Hiram Lodge. His obituary says that he was noted for "many kind and benevolent acts." He was a man of

"excellent habits," "very genial," "a firm and true friend, a thoroughly good citizen and a kind husband and father." This is, of course, the standard tenor of any eulogy; one doesn't speak ill of the dead. The antiquarian George Dudley Seymour, who must have seen the architect in passing in his old age, seems to rely on the obituary when he tells of Austin's "fine personal qualities, he was genial, generous, large-minded, helpful," and adds that he was below middle height and stocky, customarily wore a black broadcloth frock coat, and sported a brown wig, "contrasting oddly with a very wrinkled face."[3] A hint of vanity perhaps? Indeed, the one available photograph of the architect, a head-and-shoulders portrait taken in 1888 when he was 84, shows the hairpiece resting above a handsome face etched by the long years.[4] (See Fig. 1.) All of which leaves us with an incomplete and thoroughly unsatisfactory profile of the man.

Despite a steady flow of architectural commissions, especially before the Civil War, Austin seems to have been only moderately prosperous. After the war his practice slowed and its products lost some of the special quality they often had during the 1840s and 1850s. Credit reports during the 1860s and 1870s paint a picture of gradual decline, with fluctuating accounts of his reliability and worth. According to this measure he held his own in the office until the early 1870s, after which it was reported that he was getting too old and developing bad habits. By then he was in his late sixties and had every reason to begin turning over office chores to his son. He did not retire, however. His advertisements in *Benham's New Haven Directory* for a number of years after 1869 depict him as Architect and Superintendent.[5] He served on the Board of Commissioners of Public Buildings, and according to his obituary he was its chairman at the time of his death at the age of eighty-seven. According to the New Haven *Register*, the members of this commission "form[ed] the official protection against weak and unsafe buildings in this city." In one instance, they directed a builder to remove insufficient structural members he had installed in favor of those that had been specified by the architect, Henry Austin.[6] By this time, he had been joined in partnership by Fred D. Austin; after 1881 the office became Henry Austin & Son. Then seventy-seven years of age, and perhaps preoccupied with his task as inspector of public buildings, he gradually drifted away from the practice and the office slowly dissolved.

More important than these few biographical facts is the origin of Austin's professional career, but here we find ourselves in a muddle. Published notice of his life and work, other than quotidian newspaper items, seems to begin in 1887, when Austin still lived, first with an account in a mercantile publication that gives

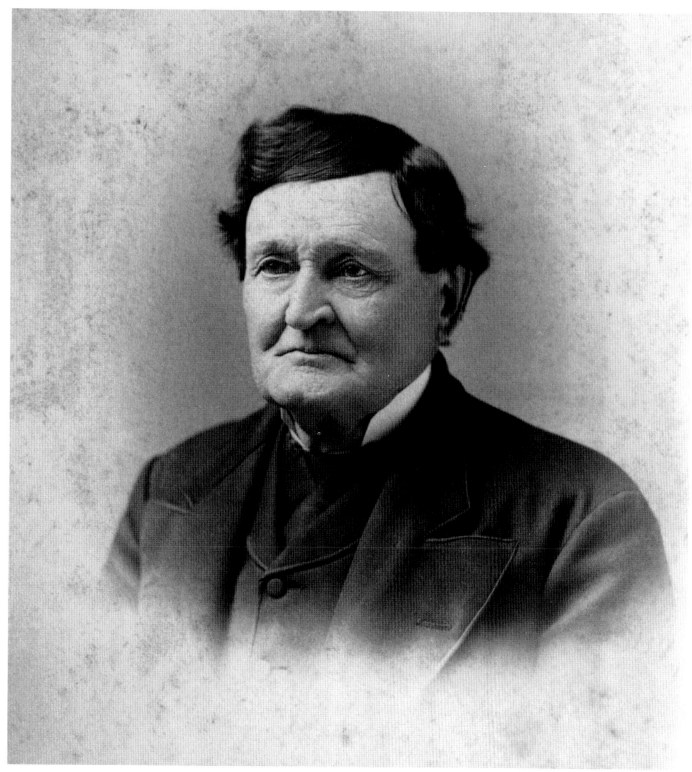

1. Henry Austin at eighty-four. (The New Haven Museum & Historical Society)

the year of his birth and reports that he opened his architectural office in 1836.[7] Atwater's coeval history of New Haven changes the opening of the office to the correct 1837,[8] and indeed, Austin first advertised his services in the New Haven *Columbian Register* on 7 January of that year. It was a period of national economic collapse that lasted until 1843—not an auspicious time to launch a career, although Austin by unknown means managed to secure several important commissions during those early years. His 1891 obituary places his birth in Hamden, Connecticut, and says that he began his working life as a carpenter at age fifteen (i.e., about 1819).[9] After five or six years (or about 1825), it reports, he "went into the architect business" and had been so engaged "constantly for the past 55 years." It takes no mathematician to see that there is something wrong with the obituary's chronology, for 1887 minus 1855 would place the beginning of his professional career at about 1832 rather than roughly 1825, and we know that neither of these dates is correct.

I've seen no documents verifying Austin's beginnings as a carpenter or builder, or explaining his reasons for moving from builder to designer, but a career path from mechanic to architect was common in this period of emerging professionalism before the establishment of schools of architecture.[10] And Austin's practice of writing detailed specifications for carpentry and masonry (which had become common by the 1840s), as well as his frequent engagement as superintendent of construction and the later description of him as an inspector of public buildings in New Haven, all suggest that he was thoroughly experienced in the mechanics of building.

George Dudley Seymour, who arrived in New Haven in the early 1880s, pulled together what he could about Austin's life and work, first published his findings in a newspaper article in 1910, and republished them in 1928.[11] He knew Austin at least by sight, and he interviewed architects and drafters who had worked for, known, or competed against Austin since midcentury. What he tells us has been frequently repeated. It should be respected, but it should be tested. Seymour mentions nothing of Austin's early training in that earlier article but in a later notice says that he was a carpenter at fifteen, obviously following the obituary, and, adding something new, says that he "was for some years in the office of Ithiel Town," and that, making the most of this opportunity and with access to Town's extraordinary collection of books, Austin opened his own office in 1836 (in another context he gives the correct 1837). If this is true, it would mean that Austin entered the profession at the right place and the right time, for Town was one of the most important American architects of his period.

Given the information (or hearsay) just surveyed, then, Austin could have worked for Town from (or some time in between) the mid-1820s to the mid-1830s. That would mean that he would have worked in Town's New York office, but it has never been said that his name ever occurs in office documents or accounts from this period (or later). Roger Hale Newton wrote that he had reason to believe that Town took Austin "under his wing as a protégé before 1833, giving the budding carpenter, contractor, or whatever he was, a taste for architecture, and opening his New Haven collection to him."[12] But he did not give his reason, and Town's famous book collection did not get a home in New Haven until the date Austin began his practice. Town moved back to New Haven in 1835 and built his house and library in 1836–1837, so Austin could have had little opportunity to work for Town there or use his local library as preparation for—as opposed to furthering—his own career. (His later ownership of some of Town's books does not prove anything about his studying with or working for Town, whose library was dispersed in several public auctions.) One problem with all the speculation about the relationship between Town and Austin is that not one of the first three notices I've mentioned, written during Austin's lifetime or at his death, says anything about such an apprenticeship. James Gallier, who worked in Town's office from 1832 to 1834, does not mention him.[13] On the other hand, the anonymous author of an 1843 article on the Yale library building says specifically that Austin was "a self-taught man, as all our architects are." Since this statement appeared in *The New Englander*, a quarterly published in New Haven and closely allied to Yale, and thus was written by someone local who presumably knew the architect, the statement cannot be dismissed out of hand.[14]

There is one document that links Town to Austin, but it presents as many problems as it solves about Austin's professional origins. From 1829 to 1835 Town practiced in partnership with Alexander Jackson Davis, and in 1839 wrote a letter of introduction for Austin to Davis.[15] Would Davis not have known Austin before that date if Austin had studied with, drafted for, or even—as is often supposed— supervised the construction of Town's buildings? It might be possible that he did not if Austin had left Town before Davis arrived (that is, before 1829) and went back to construction or tried something else until he opened his office some eight years later (a somewhat unlikely scenario for which we have no proof). Still, it seems reasonable to think that Austin's name might have surfaced in Davis's view at some point along the way. This was a relatively close community.

Despite the contradictory circumstantial evidence, despite the lack of convincing documentation, whatever the facts of Austin's relationship to Town, however,

his professional origins do have to be sought within Town's orbit. Town was certainly the major architectural presence in New York and New Haven during Austin's youth. They certainly knew each other. In 1884 Austin shared reminiscences of Town with Henry Howe, the much-published antiquarian, although he said nothing about having worked for him.[16] In 1887, when he owned the original drawings for Town's 1827 Connecticut State Capitol, he told the New Haven *Register* that Town told him that he lost money on the building because it was put up so cheaply.[17] The letter of introduction to Davis makes it clear that Town knew Austin well enough by 1839 to have a "very high opinion" of his "tastes and talents in the profession." (He is, of course, referring to Austin after 1837, not to an apprentice.) Where else would Austin have developed such tastes and talents other than in the shadow of Ithiel Town? Until a document surfaces placing him in Town's drafting room, however, that is all we can say with certainty about Austin's training in architecture. It is enough, though, to account for the characteristics of Austin's early work. His first houses, as we shall see, are clearly derived from Town's own precedent.[18]

1

We in the Western world have long been in a period of architectural history in which the Modernists have preached an antihistorical rhetoric. Knowledge of past styles was meant to give way to originality created by functionalist analysis or made to supply the tongue-in-cheek references of a Charles Moore, Philip Johnson, or Michael Graves. To understand the period in which Henry Austin began his career, we need to think outside that box, to understand that the study of historical styles, of published precedent, was then the meat of architectural practice, that buildings emerged from drafting rooms informed by study of the past. This was a time, first, of historicism (the exact imitation of past forms), then of eclecticism (the creative mingling of such forms). Since American architects of the early nineteenth century rarely traveled abroad (although some had immigrated from overseas), and almost never to exotic areas, what they knew of the historic styles they derived from books.

In a lecture delivered at the Franklin Institute in Philadelphia in December 1841, Thomas Ustick Walter explained acceleration in the broad distribution of knowledge as characteristic of a progressive age.[1] "The changes and revolutions to which the principles of taste in Architecture have been subjected [in recent years], by the ever varying progress of civilization," he said, "have multiplied styles and modes of building, almost to infinity." The distribution of information about past styles he attributed to the invention of steam-powered printing, the improvement of engraving, and, in a later emendation, photography. The press, he wrote, "that most powerful engine of civilization[,] pours forth its volumes daily." The architect now had available "the most perfect representations of the buildings of all ages and all countries . . . he is enabled to study and compare, the works of every nation."[2] Walter was merely voicing what others knew: that a library he owned or had access to was a basic tool for an aspiring member of the new profession of architect in the first half of the nineteenth century. The professional here, as in other fields such as law or medicine, was to become, or at least assume the appearance of, a learned individual.

The frontispiece to Part Two of the Pugins' *Examples of Gothic Architecture* of 1836 shows a medieval monk in his cell drafting plans while all around him reference books tumble from armoires.[3] It is a fanciful, romantic view of the

medieval architect, to be sure, but it says much of importance about the needs of the emerging professional in the early nineteenth century. The availability—or better yet, the possession—of a reference library and the ability to draw were his two basic needs and his two signs of status. They set him off as a professional from the mechanic he had probably been, and from the mechanics who had previously accounted for much building design before and just after 1800 (and continued to do in frontier areas). The Pugin frontispiece is an English conception, but Thomas Cole's famous painting, *The Architect's Dream* of 1840, commissioned by Ithiel Town himself, brings the point home to America. It shows an architect in the foreground seated like an osprey on a column capital at water's edge, surrounded by a nest of impressive folios and large drawings as he gazes off into a distance filled with his prey, the architectural monuments of Greece, Rome, Egypt, and the Middle Ages. Although the finished painting was not to Town's liking, it certainly celebrated his own position as one of the country's foremost architects and the man whose architectural library was unrivaled in the United States. These two images, the Pugins' and Cole's, are perfect portals to our understanding of Austin's era, as inspiration flowed from the historic buildings published in books gathered by the architect, through his creative faculty, and onto sheets of design drawings.

This process guided Austin's career. What may have been his first newspaper ad is accompanied by a cut of a Corinthian capital surrounded by drafting instruments, a roll of drawings, and a stack of books.[4] (See Fig. 2.) Through this process, the early-nineteenth-century architect produced works in a large variety—if not necessarily Walter's infinity—of architectural styles. By the association of certain styles with certain types of buildings, he created a legible built environment in which the purpose of a building could be distinguished from those of its neighbors by its reference to the architecture associated with the perceived characteristics of past societies. A cemetery gate might be Egyptian, a church Romanesque or Gothic, a government building or financial institution Classical.[5] That a later period scoffed at the process in no way diminishes the achievements of men such as Austin.

As we have seen, Austin's independent architectural career began in early 1837. We think of him as a New Haven architect, as indeed he was for most of his career, but in April 1838 he provided the building committee of Christ Church Cathedral in Hartford, a Gothic structure designed by Ithiel Town in 1827, with plans for the completion of its tower.[6] His project was accepted nearly a year later, on 29 March 1839, and it has been said that he personally supervised the erection

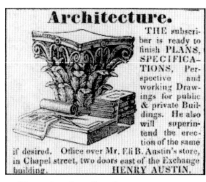

2. Henry Austin, advertisement.
(*New Haven* Columbian Register, 4 February 1837)

of the tower's all-stone terminal. In what may have been a knowing allusion to this task, the *New Haven Palladium* in July 1841 advised its readers that Austin "is in Hartford, straightening crooked things there."[7]

The *Palladium* went on to say that it had learned "that there ha[d] never been a professional architect in that city until Austin opened an office there." He had already decided to explore the architectural waters of the place. Between January 1839 and June 1841, for two and a half years, he placed ads in the *Hartford Daily Courant* announcing his presence. One version of the ad (30 July 1840, for example) gave his office address as "over No. 4 State Street, where he will be engaged for a few weeks, in designing and drawing plans and specifications for Public Buildings, Villas, Farm Houses, and Cottages, in every variety of Architectural style, and will superintend the same when desired. Persons who contemplate building, and consider beauty, convenience and economy of any consequence, will find it for their interest to call." It should be noticed that Austin's emphasis on style led him to leave out mention of structural consideration as of less concern to a prospective client than the tug on his purse, or perhaps as one who apparently began his career in the building trades, he assumed it to be too basic to warrant mention. The notice substituted budgetary consideration for structure in the time-honored Vitruvian architectural triad of *Utilitas, Firmitas, Venustas* (use, strength, beauty).[8] Just three weeks prior to the date of this announcement, he had placed an ad in the *Palladium* back in New Haven saying that he would be in that city "for a few weeks."[9] This suggests that for part of this time, at least, he bounced back and forth between the state's alternate capitals, perhaps riding the cars of the newly opened New Haven and Hartford Railroad.[10] As we shall see, he certainly designed one of his first New Haven houses and the Grove Street Cemetery gate while nominally located in Hartford.

The text of a second *Courant* ad (18 March 1841, for example) differs from the first and is in fact the more important. Austin's "Office and Library" were now in Kellogg's Building, No. 136 Main Street. He repeats the services previously offered but adds that "All who feel an interest in Architectural improvement are invited to call at his office, where he will be happy to offer them every opportunity of examining, gratuitously, his collections of books and drawings. Persons who contemplate building, and consider beauty, convenience, and economy, of any consequence, may find it for their benefit to call and examine before they commence." "Architectural improvement" paralleled the idea of the progress of civilization that Walter and other contemporaries saw as characteristic of their age in general and of their country in particular.

The combination of graphics and publications was the signifier of the emerging professional architect in the early years of the nineteenth century. Austin had entered architecture in the ambience of Ithiel Town and his rich library. It was an orbit that included, among others, A. J. Davis, Town's erstwhile partner and Austin's nearly exact contemporary. As we have seen, Town had written a letter introducing Austin to Davis in July 1839, near the beginning of Austin's Hartford sojourn.[11] As part of establishing the profession, some architects became advocates for popular education in the field, or what Mary Woods has called "entrepreneurship." Town's library was open to anyone with an interest in the arts,[12] and members of his circle followed his example. Davis, like Walter, lectured on architecture in popular forums. In an 1841 talk to the Apollo Association in New York, for example, Davis urged the education of the public in the value of emerging professional services.[13] He practiced what he preached. In about 1836 he announced in newspaper ads an exhibition of his "models in plaster; drawings, engravings, and books, representing the most remarkable buildings of ancient and modern times; with plans of public edifices, and rural residences in course of erection in various parts of the U.S." at his office and library, and invited the public to "conversations" in which he proposed discussing his and others' works with "those interested in Architectural Improvements."[14] Judging by his own similarly worded ads, and presumably in practice (although there is no known record of his lecturing in public), Austin followed Davis's example. There can be no doubt that the beginning architect kept an eye on the more experienced one. Although they were contemporaries, Davis's career was then much in advance of Austin's.

A man who apparently took advantage of Austin's offer to visit his office and library was one L. Roy, who wrote from Hartford to a friend in Champlain, New York, on 18 August 1841 that he awaited the return of "Mr. Austin, the architect whom I wish to employ drawing plans and specifications." "I am anxious," Roy continued, "to have a house perfectly proportioned and am therefore unwilling to move without professional advice." This sounds as if Austin had wooed him among his books and drawings. It also sounds as if a client like Roy thought of Austin primarily as a form giver rather than a constructor. Roy included his own rough sketch of what he wanted but acknowledged that "perhaps Mr. Austin will show me an entirely different plan, which I shall like better."[15]

I do not know whether Mr. Roy got his Austin house, but a check of local directories suggests that it was never erected on the site at Garden and Myrtle streets on which he had intended to build. The architect's office during the Hartford

years did attract a number of other clients, however. Among them were the Kellogg brothers, whose name appeared on the Main Street building in which Austin had his office and library in 1841. E. B. and E. C. Kellogg were lithographers who, among other things, produced the plates for the edition (copyright 1845) of Chester Hills's *The Builder's Guide*, in which, as we shall see, Austin published a series of designs for cottages and villas. The *Daily Courant* for 21 September 1842 contains an article copied from a Boston paper in which the anonymous writer says that "my latent spark of fondness for everything gothic was kindled into a flame [on a trip to Hartford] by an admirable representation of a gothic villa, designed with great taste, by Mr. Austin, the architect, for Messrs. Kellogg, of Hartford. I hastened to see the building itself, which is delightfully situated near Washington College." It should be noted that our visitor first viewed drawings of the house, that is, visited Austin's office, then looked at the building itself. This was presumably the house on Washington Street where the brothers lived until about 1850. (See Figs. 3, 4.) It appears in vintage photographs as what the architect Robert Venturi would call "a decorated shed," a box with applied "Gothick" ornament: towers with various profiles, a loggia of pointed arches on spindly clustered columns, an oriel, a row of quatrefoil windows along the attic, and a chimney impressed with pointed arches. It was much simpler than, but bore kinship to, A. J. Davis's Glen Ellen, the Robert Gilmore 1832 villa at Towson, Maryland. That villa appears in Davis's *Rural Residences* of 1838, a copy of which Austin owned (although when he acquired it is not known). He may have seen the original drawings in Davis's New York office if he did indeed present Town's letter of introduction. The Kellogg house, which, as we shall see, acquired as its neighbor Austin's Platt house of 1847, vanished long ago.[16]

Austin went on to design many buildings for Hartford: houses, an almshouse, St. John's Episcopal Church, the Wadsworth Atheneum (in association with Town and Davis), and others that we will consider in later chapters. In a notice in the New Haven *Columbian Register* for 20 November 1841, he announced that he had reopened his office in Mitchell's Building in that city. The Hartford sojourn was over, his career well underway, and that career was now to become intimately associated with the developing urban environment of New Haven.

At the time of Austin's birth, New Haven was beginning its period of great economic, population, and territorial growth as it expanded outward from the "Nine Squares" of its colonial plan. The port of New Haven became the generating force affecting all of southern Connecticut. With inventive giants like Eli Whitney, Oliver Winchester, and others not so well remembered, the city became an industrial

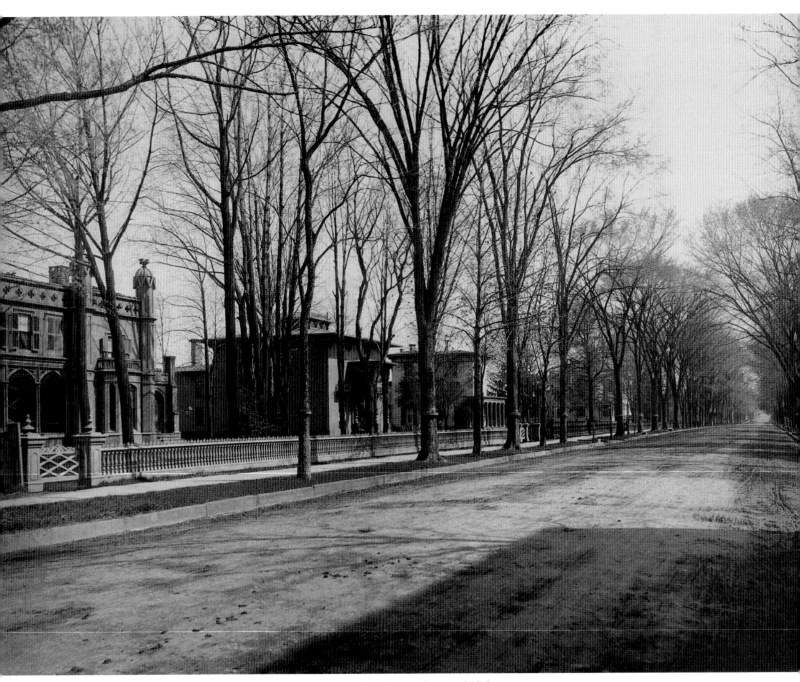

3. *Washington Street, Hartford, Connecticut. Henry Austin's Kellogg house (1841) on the left; his Platt house (1847), next right. (The Connecticut Historical Society, Hartford, Connecticut)*

4. Henry Austin, Kellogg house, Hartford, 1841. (The Connecticut Historical Society, Hartford, Connecticut)

center producing, through the years when Austin became one of the shapers of the city, firearms, carriages, hardware, pianos, watches, corsets, bicycles, and cigars made of leaf grown in the nearby Connecticut River Valley. A city whose population was four thousand at the architect's birth and thirteen thousand when he opened his office grew tenfold to forty thousand by the time of the Civil War and had more than doubled that figure by the time of his death. As we shall see, his City Hall of 1860 was a visible statement of that dynamic early-nineteenth-century history. Many of the leading industrialists, as well as educators from Yale College and other professional men, became Austin's clients. Without their achievements Austin would have had no clientele; without him (and to be sure his peer, Sidney Mason Stone), these civic leaders would have had no one to give expression to their stature in the community or shape to their civic organizations.

And from New Haven this development and Austin's practice radiated out into the nearby counties and towns, and beyond.

The biographical notice of Austin's career written in 1887, while he was still alive, tells us that he designed buildings "in every State of the Union."[17] There were, of course, fewer states (thirty-eight) then than now, but such a claim seems preposterous. It is true, however, that by midcentury he had worked beyond the borders of Connecticut. At least two houses in Maine are his; in the collection of drawings from his office at Yale there are inscriptions naming presumed clients in Pennsylvania and Michigan; his office was responsible for at least two projects in New Jersey; three projects can be located in Massachusetts (and another copied from a published design), and there are surely others.[18] One of those New Jersey projects gained wide attention at the outset of Austin's practice.

In the beginning, Austin must have profited from his association with the New Haven builder-speculator Nelson Hotchkiss. Information is sketchy, but we do know that in 1839 Hotchkiss, who signed the contract as architect, in partnership with Charles Thompson, was selected to build the Greek Revival First Presbyterian Church in Trenton, New Jersey.[19] Horatio Nelson Hotchkiss (1815–?), builder, manufacturer, and real estate developer, often worked with Austin, whose office in 1850 designed for him a house on Chapel Street in New Haven. (See Fig. 35.) Charles Thompson was a joiner who, with his brothers, worked also for Town and Davis.[20] At almost the same moment he was erecting Trenton's Presbyterian church, Hotchkiss was constructing a series of six villas called "Park Row" in the same place, also in association with Thompson, and was crediting himself as architect in association with Henry Austin. Austin's collaboration with Thompson may have dated back to his reported days as a builder himself. How any of these men got to New Jersey remains an unanswered question. Whether Austin had a hand in the design of the Presbyterian church also remains a question, but he surly participated in the design of the villas on Park Row. This early association with Hotchkiss might explain why Austin found success during the years of economic stagnation. The slippery distinction between builder and architect we see here in the person of Hotchkiss was one that was to be more precisely defined as the architectural profession became clearly established by Austin and his contemporaries.

In early July 1841 the weekly *Palladium* published a column on "New Haven Taste in Architecture" in which it quoted from the *Sentinel* of Wilmington, Delaware, about the activities of New Haven builders Hotchkiss and Thompson. The editor had received a lithographic view of Park Row, recently erected in Tren-

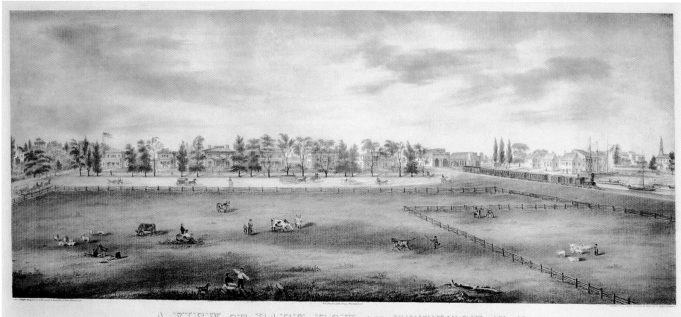

A VIEW OF PARK-ROW AT TRENTON, N. J.

5. Henry Austin, Park Row, Trenton, New Jersey, 1839–1840. Lithograph by P. S. Duvel. (From the Collections of the New Jersey Historical Society, Newark, New Jersey)

ton, New Jersey, "a beautiful and classic range of private residences" in the Italian style, all recommended by "their cheapness of construction, neatness and internal comfort." The view showed six villas, "all different yet all possessing a classic order of architecture, porticoes, porches, pillars etc. etc.," and each with parlors, drawing rooms, bedrooms, a well room, kitchen, pantry, and so on. They were priced at two to three thousand dollars. The editor concluded his report by recommending that "all lovers of taste, ornamental architecture, carpenters and masons, . . . examine these drawings [sic] for themselves." The editor, then, joined the architects in trying to improve the public's taste in architecture.

The lithograph to which the editor referred must have been A VIEW OF PARK-ROW AT TRENTON, N.J. by Alfred M. Hoffy printed by P. S. Duvel in Philadelphia and copyright by Nelson Hotchkiss in 1840. (See Fig. 5.) The caption tells us that the houses were built by Hotchkiss and Thompson from the design of Hotchkiss and Austin. It shows part of the city across the Delaware and Raritan Canal and the bucolic setting of the Row across from cows grazing on the commons. From this caption—and other sources—it is possible to date the design and building of the project to 1839–1840.[21] The information on the lithograph seems to suggest that Nelson Hotchkiss was the main force behind this development, since it lists him as a designer and builder and as the proprietor of the

lithograph. That Austin went unmentioned by the *Palladium* in its notice of the Row (although he is mentioned elsewhere in the same article) was not unusual. Architects rarely were named in the newspapers of this period, while builders frequently were.

Park Row came at the beginning of Austin's career, and the individual villas predicted much that was to follow in his domestic work. Whatever Austin's relation to Town, he surely knew of Town's circle of architects and draftsmen, a circle that included, in addition to Davis, James Gallier, James Dakin, Martin Thompson, and others.[22] The presence in Connecticut of the rather shadowy builder David Hoadley (1774–1838) ought also to be remembered.[23] This was a group largely devoted in the 1820s and 1830s to Neo-Classical, mainly Grecian, architecture. We are also told that by early 1837 Austin went out on his own to practice, beginning a career that lasted almost until the day he died. During that long stretch he first worked in the Roman and Grecian modes, but his office quickly began to project buildings in nearly all the historical styles, from classic to picturesque, from Gothic to Egyptian to Indian to Italianate to Romanesque, and so on, followed after 1860 by newly fashionable modes such as Victorian Gothic, French Second Empire, Queen Anne, and the Stick Style. With his local rival, Sidney Mason Stone, Austin dominated the New Haven architectural scene until the Civil War.[24] This parade of styles was based upon Neo-Classical beginnings.

The Park Row development, which was demolished long ago, was also called "The Cottages," "Cottage Row," or "Yankee Row."[25] The publicity generated by this development, its stylistic relationship to the Town circle, and its reflections in other early works from his office make it a key event at the beginning of Austin's career. The sources of inspiration for the circle of men in Town's orbit were largely English, and the idea of a suburban row of villas was certainly inspired by John Nash's Regent's Park development in London earlier in the century.[26] The evolution of Hillhouse Avenue in New Haven seems to have been influenced by this source. The immediate impetus for Trenton's Park Row, however, may have been A. J. Davis's unrealized Ravenswood Development of 1836. (See Fig. 6.) Did Austin see drawings of it when he presented his letter of introduction to Davis (if he did present it)? The chronology is shaky. One source dates the signing of the contract for Park Row to April 1839, and Town's letter of introduction is dated July of that year; nevertheless, it does ask Davis to show Austin "your drawings."[27] Designed for Charles H. Roach and intended for a Long Island, New York, site, the Ravenswood project envisioned a line of ten villas of Classical or Gothic design and a Gothic church.[28] The Trenton development seems to be a

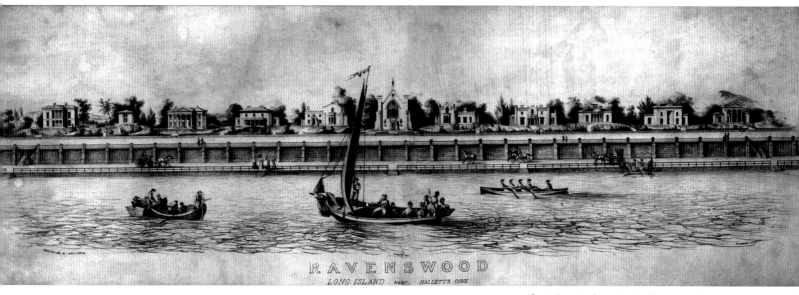

RAVENSWOOD

LONG ISLAND *near* HALLETT'S COVE

6. Andrew Jackson Davis, Ravenswood Development (project), Long Island, New York, 1836. Lithograph by N. Currier. (Collection of the New-York Historical Society)

reduced version of Ravenswood. Although the relationship between these exactly contemporary architects remains to be clarified in detail, as I have already noted, at this period Davis was certainly the leader and Austin the follower.

Like the Ravenswood Development, the Trenton Row was an example of what the Swedish travel writer Fredrika Bremer called the image of true American life, "the abundance of its small communities, of its beautiful private dwellings, with their encircling fields and groves."[29] The Trenton villas nestled in a leafy setting across from a bucolic commons, although industrialization soon made its presence felt in the area. One side was defined originally by the Delaware and Raritan Canal, dug between 1830 and 1834, and the New York and Philadelphia Railroad, and after 1851 by the Belvedere Delaware Railroad that paralleled the canal. The dwellings were alike in all but details. The parti was that of a three-bay, two-story box with or without wings articulated with Grecian or Roman details. The dwellings were fronted by a variety of porticoes, a practice we shall see Austin carried into his later domestic work. Roofs varied from flat to hip. Those houses with flat roofs and wings were clearly the progeny of Town's work, such as his own villa on Hillhouse Avenue designed in 1835.[30] (See Fig. 7.) Those squarish in footprint with a rear ell were of a type that A. J. Downing illustrated as a "New Haven Suburban Villa" in his *Theory and Practice of Landscape Gardening* of 1841 (after a drawing probably made as early as 1838).[31] (See Fig. 8.) The Park Row houses appear as the work of a newly minted architect following the style of what he saw as the latest designs around him.

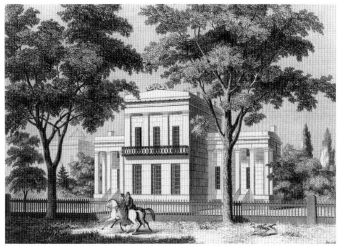

I have seen no architectural plans of the villas on the Row, but we can extrapolate one of them from a related source. Austin's now demolished New Haven house for George Gabriel, an umbrella manufacturer, stems from 1839 and is thus among his earliest domestic works. It was certainly inspired by Town's own villa, and it was almost identical to one of the Trenton houses. In her *History of Architecture* of 1848 Louisa Tuthill—well versed in New Haven architectural circles—described it as "a Grecian cottage . . . [with] five rooms and a hall or entry on the first floor conveniently arranged. The whole expense of the building was not more than two thousand five hundred dollars. H. Austin, architect."[32] In the larger book in the collection of drawings from Austin's office preserved in the Sterling Library at Yale University there is a sheet depicting the house in plans, front elevation, and perspective view.[33] (See Fig. 9.) It is shown as a rectangular three-bay, two-story central block with flanking one-story wings, a Grecian Ionic portico, and classical ornament in the parapet above the broadly projecting flat roof of the main block. The windows have heavy lids supported on bold brackets. In plan the entry occupies the front salient and the kitchen the rear ell; the other rooms of Tuthill's description are arranged symmetrically around the receding central axis. Three bed chambers occupy the upper story of the main block.

The Yale sheet is one of mostly watercolor drawings gathered into two manuscript collections presumably prepared for an intended publication that never materialized.[34] The perspective of the Gabriel house is a rare—although not unique—occurrence among them. It shows the urban house in an impossible park-like setting with mountains in the distance. The more typical drawing is the elevation, shown floating on the page without so much as a ground line,

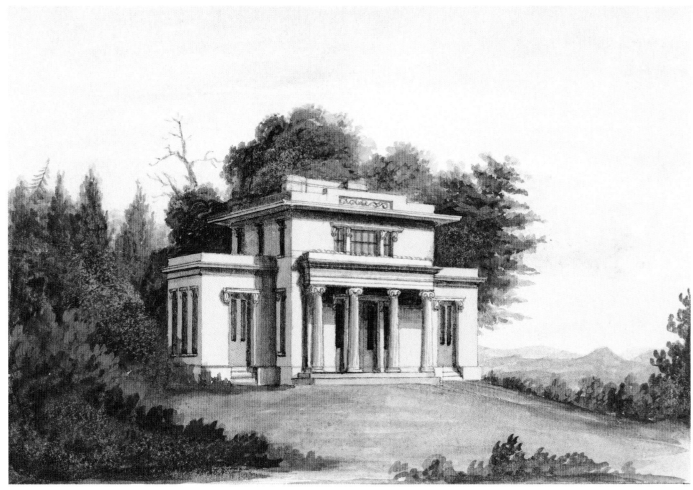

9. Henry Austin, George Gabriel house, New Haven, Connecticut, 1839–1840. (Austin Papers, Manuscripts and Archives, Sterling Library, Yale University)

that Tuthill's engraver embellished for the woodcut in her *History*. (See Fig. 10.) Although the date of the drawings given on the title page of one of the volumes is 1851, many of the projects predate that by a decade or more. Most of the graphics appear drafted especially for later publication, but, as we shall see, the original of the Gabriel perspective must have been drawn by 1839–1840, or about the date of the construction of Park Row.

The perspective of the Gabriel house had an active afterlife in the 1840s. Austin used it for his newspaper ad of 7 July 1840 to illustrate his ability "in designing and drawing plans and specifications for Public Buildings, Villas, Farm Houses, and Cottages in every variety of Architectural style."[35] His 1845 contributions to the new edition of Chester Hills's *The Builder's Guide* include two lithographed variations on the Gabriel house theme, one very close to its model and shown in a perspective reversed from the earlier versions and unique in this gathering

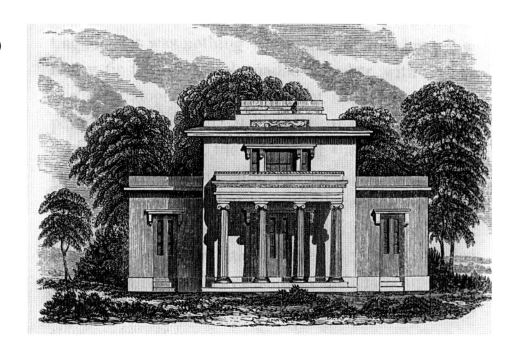

10. *Austin, Gabriel house. (From Louisa Tuthill,* A History of Architecture, *1848)*

of designs.[36] (See Fig. 11.) Here he has added porches in front of the wings covered with striped roofs resting on the thinnest of supports. This may or may not reflect the final appearance of the Gabriel house. The text describes both published designs as having been erected in New Haven with planed and matched board exteriors and tin roofs. Of the one closer to Gabriel's, it is said that "There is no building in the city which has been so much admired for chasteness and beauty as this." Assuming this is not just empty hype, Austin early made his mark on his city.

Austin clearly liked what he had achieved for George Gabriel because, as I've noted, it is repeated as one of the houses of Park Row (of course, the latter might have preceded the former, or the two may have been exactly contemporary, but the point remains the same). The house occupied by Charles Chauncey Haven in 1849, the second from the left as one faced the Row, is a repeat of the Gabriel design. (See Fig. 12.) The Sidney map of Trenton published in that year contains perspective vignettes of some of the houses, those to the left of center.[37] The Haven house perspective, although reversed, reflects the Gabriel house drawing now at Yale. The block occupied by Xenophon J. Maynard, on the left end of the Row, was a more elaborate version of the C. C. Haven villa. The J. F. Randolph house, third from the left, was the progeny of the New Haven villa published by Downing and a forerunner in Austin's work of the many cubical houses

PERSPECTIVE VIEW.

PANTRY	SINK ROOM

KITCHEN

BED ROOM DINING ROOM

LIBRARY HALL

PARLOR

GROUND PLAN.

10 9 8 7 6 5 4 3 2 1 0 10 20

10 9 8 7 6 5 4 3 2 1 0 10

X. J. Maynard.

C. C. Haven

12. *Henry Austin, X. J. Maynard, and C. C. Haven houses, Park Row, Trenton, New Jersey. (From J. C. Sidney map of the City of Trenton, 1849)*

with ornaments of various stylistic derivations he turned out during the 1840s and 1850s for New Haven and other Connecticut towns. Views of the remaining houses on the Row are too schematic to permit close description.

The villas of Park Row were erected as rental properties.[38] The Sidney map of 1849 named the current occupants. Xenophon J. Maynard was a businessman and investor: an organizer of the Union Manufacturing Company in 1836, an incorporator and board member of the Trenton Savings Fund Society in 1844, and an incorporator of the Trenton and South Trenton Aqueduct Company in 1848. Charles Chauncey Haven was an historian who settled in Trenton in 1846, wrote about its role in the Revolutionary War, and was active in the movement to have a monument built to commemorate the Battle of Trenton. Joseph C. Potts was part owner of the State Street Hotel and much other real estate in Trenton. He was in 1843 an incorporator of Mercer Cemetery, located on land adjacent to the rear of the Row.[39] In short, as we might expect, the occupants of Park Row were of the same class of comfortable, upper-middle-class business and professional men as those for whom Austin was later to erect any number of single-family houses in New Haven and elsewhere in Connecticut.

The Wilmington *Sentinel* and New Haven *Palladium* were not the only publications to broadcast words of praise for the Trenton development. Barber and Howe's *Historical Collections of the State of New Jersey* (1844) described the site as a "neat and beautiful row of private dwellings designated 'the cottages.' They were built a few years since under the superintendence of Messrs. Hotchkiss and Thompson, and while they reflect credit upon the skill of the architects, form a pleasing exhibition of an improved taste in the construction of private residences."[40] While the lithograph of 1840 assigned the design of the Row to both Hotchkiss and Austin, it is possible that the word "architects" here need not refer to that pair. At this time Henry Austin had in his office his younger brother, Merwin, and early in 1842, in a notice in the *Palladium*, that office was called the "rooms of Messrs. H. & M. Austin."[41] Despite the caption of the lithograph, one wonders about Hotchkiss's part in the design.

As late as 1855, what has been described as the first magazine article written about Trenton appeared in *Ballou's Pictorial Drawing-Room Companion*.[42] An illustrated review published in Boston, *Ballou's* had a national readership. According to the author, whose article was accompanied by views of city buildings including the Row, a visitor would find there "very neat, tasty cottages which . . . were built a few years since to lease, and exhibit a very commendable taste and judgment on the part of the architects and builders. Trenton has but few buildings

of much architectural beauty, and these cottages, as marking a new era in its municipal improvement, deserve a more extended notice than our limits will allow." And finally, Austin was given the highest accolade possible when his work became the source for other architects' designs, although, of course, that source was not acknowledged. Edward Shaw published a near-copy of Austin's Gabriel house in his *Rural Architecture* of 1843, and John W. Ritch did likewise in his *The American Architect* of 1849.[43] Austin knew of the latter, for he owned a copy of Ritch's book.[44]

In New Haven in 1841, "lovers of taste, ornamental architecture, carpenters and masons" could admire the Row in the lithograph at the *Palladium* offices (as well as admire the Gabriel house on the ground). With such a publicity blitz (which was followed by Austin's presence in Hills's *Builder's Guide*, where one could find four Austin domestic designs; Tuthill's *History*, where five of his buildings are illustrated and described; and the Congregationalists' *Book of Plans*, where one finds four ecclesiastical projects), Austin quickly took his first steps toward becoming a respected figure in Connecticut. The initial surge of national publicity did not continue, but by the early 1840s he had settled into the position of a leading New England architect.

2

DOMESTIC ARCHITECTURE OF THE 1840S AND 1850S

With the exception of a few larger structures, Henry Austin's best-known building type is perhaps the town house or country villa located mainly in New Haven or southern Connecticut. It is here that the varieties of historic styles are most evident in his career. As we have seen, his antebellum residential work began with buildings such as the Neo-Classical George Gabriel house in New Haven and Park Row in Trenton, New Jersey, both begun in 1839. This phase of his production culminated at the Tuscan villa he designed in 1857 for Ruggles Sylvester Morse in Portland, Maine (the Morse-Libby house), and his Italianate remodeling of Ithiel Town's Neo-Classical villa on Hillhouse Avenue in New Haven for Joseph Sheffield in 1859. (We will consider his adaptation of the Italian villa to the French mansard after the Civil War in a later chapter.) Between the Gabriel and Morse houses his office did indeed turn out designs recalling elements of many—if not all—varieties of architectural style from Gothic to Indian to Rococo, and some combinations as well.

Austin began his career in a period in which world architecture in all its historical and geographical manifestations was just beginning to be known and used in creatively revivalist or eclectic new work. Before the nineteenth century, from the Renaissance to Neo-Classicism, Western architecture descended from ancient Greece and Rome. Even the decorative vagaries of the Baroque and Rococo were based on the ancient Mediterranean details. The authorities were the Italian masters, Palladio, Vignola, and the like, who studied the forms of the classical past and laid down the rules of *disegno*. With the Enlightenment came a dawning curiosity about other architectural modes: first the Greek, then the Gothic, soon what were called the "nonhistorical styles" of India, China, and Arabia.[1] Publications showing the appropriation of architectural forms and decorative patterns from these newly recognized areas began to pour from the presses of Europe and England. In Austin's time, the newly studied details of all these styles filled the design kits of American architects. Beginning in this country with the work of Benjamin Henry Latrobe, an English immigrant who arrived in 1796, designers offered a wide variety of alternate revivalist modes, sometime for the same project. There were some who lobbied against the practice, such as the Rhode Islander Thomas Tefft,[2] but Austin was certainly not among them.

Austin's authority for the eclectic variety of his work came from the books in his own library as well as that of Ithiel Town.[3] We know some of the works he owned, but he must have had access to many others, some of which we can assume he knew from their relation to certain of his designs. It was probably near the beginning of his career that he bought J. C. Loudon's *Encyclopaedia*, Francis Goodwin's *Rural Architecture*, and James Thomson's *Retreats*. By 1843 he owned Peter Robinson's *Designs for Ornamental Villas* in the third edition of 1836, a work that contained examples of residences in the Swiss, Grecian, Palladian, Old English, Castellated, Ancient Manor House, Modern Italian, Anglo-Norman, Henry VII, Elizabethan, Ancient Timber (i.e., an English version of the log cabin), and Tuscan styles. The author avoided the Egyptian mode without explanation and the "Asiatic" as unsuited to the necessary arrangements for a country residence. For the latter Austin could turn for inspiration to Edmund Aikens's *Designs for Villas* of 1835, which he had acquired by the next year, wherein he could find inspiration for designs in the "Mohammadan Style." Both these and other books in Austin's library were English publications and (although this was refuted by A. J. Davis[4]) were not really suited to wholesale adaptation for an American domestic clientele, but their broad menu of stylistic offerings was instructive. As we shall see, he must also have had access to John Foulston's *Public Buildings Erected in the West of England* of 1838, for he found there much to emulate that sprang from Indian examples. One of Foulston's plates shows an eclectic ensemble of his buildings in an urban setting: "The Chapel . . . exterior, exhibiting a variety of Oriental Architecture, is seen in juxta-position [*sic*] with others of Greek and Egyptian character; the Author's intention being to experimentalize on the effect which might be produced by such an assemblage. If the critic be opposed to such strangeness, he may still . . . acknowledge, that the general effect . . . is picturesque."[5] In this period, that eighteenth-century aesthetic mode, the Picturesque, was nudging aside or replacing the old classical system.

American books on the plenitude of available styles did not begin to appear until Austin's own time. Among the few he might have known, I've not been able to place William Ranlett's *The Architect* of 1847–1849 in his possession, but it was for sale on Chapel Street in New Haven in the mid-1840s.[6] Its two folio volumes contain a series of essays and domestic designs for houses in the Italian, Tudor, Elizabethan, English Cottage, Grecian, Swiss, Indian, Romanesque, (premansard) French, Rustic, Plain English, Persian, Anglo-Norman, American, Greco-Italian, Anglo-Swiss, and other often strange examples of the eclecticism of the period. Despite the parade of nominally exotic styles, most of Ranlett's

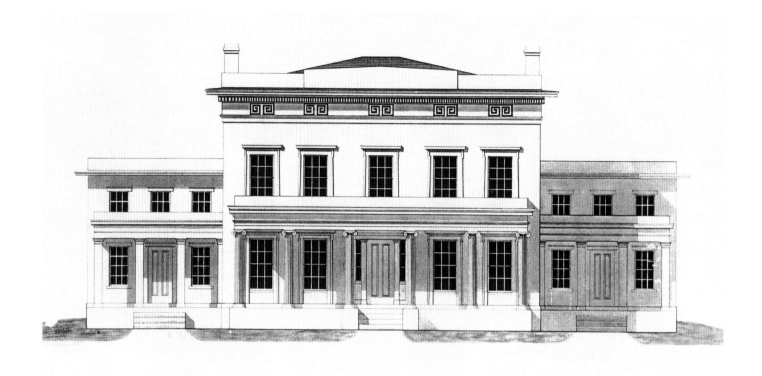

HENRY AUSTIN ARCH.ᵀ

13. Henry Austin, Neo-Classical villa.
Undated project. (The New Haven
Museum & Historical Society)

projects are cubical domestic blocks with deep overhangs supported by large brackets, works parallel to Austin's of the same period. Had his collection of drawings now at Yale been published, Austin's would have been one of those native books. And, finally, he owned A. J. Davis's *Rural Residences* of 1838, and there can be little doubt that he perused Andrew Jackson Downing's several publications of the 1840s.

Austin's first domestic works reflect the Neo-Classicism of Ithiel Town's orbit. I have discussed the Gabriel house and Trenton's Park Row in the previous chapter, but there are other such designs in the same mode. A larger version of the Town-Gabriel tripartite parti is preserved in a set of signed black-and-white drawings at the New Haven Museum and Historical Society for an unidentified villa that must date from the mid-1830s and might just have been an exercise rather than a project. (See Fig. 13.) It is Grecian Ionic in style with a two-story, five-bay central block flanked by story-and-a-half three-bay wings. All three blocks are fronted by one-story porticoes. In contrast to the plainer wings, the main block is decorated with Grecian frets beneath the cornice and fluted Ionic columns.[7] The

square plan of that block shows a central front-to-back hall containing a straight flight of stairs. It opens onto a portico at the rear. Front and back rooms on either side fill out the square, and the kitchen is located in the side block to the left.[8] Although, as we shall see, Austin moved on to a full menu of other styles, the basic rectangular core found here and touches of classicism—even in its Rococo manifestation—remained in his work throughout the first two decades.[9]

This imposing pile of the 1830s was certainly intended as a country villa. There is also preserved at the New Haven Museum a set of signed elevations and two plans dated 25 March 1840 for a different domestic type, a typical urban row house. It is unidentified but must have been for a commission because it is a legal document with the sheets also signed by the joiners Elihu Atwater and Amos Bradley as well as the mason James Winship.[10] Whether it was intended for New Haven or Hartford is not specified, but these were New Haven mechanics. The elevation shows an austere two-story, three-bay (stuccoed brick?) façade opened by stark trabeated windows. A (stone?) balustrade caps the wall but scarcely hides the high roof behind. An Ionic portico fronts the left side of the façade. The off-center rear service ell peeks out to the right of the front. Both of these early projects are too generic, too typical of their types, to display anything like a personal touch. That was to come with time.[11]

In later years, Austin adopted several types of urban domestic design that he (and others) used often in the towns of southern Connecticut. One, which was derived from the work of Town and Davis, took the form of a chaste, often stucco-coated, basic Italianate cube or near cube that was augmented on top by a cupola, on the rear and/or side by ells, and on the front by a portico.[12] A cupola[13] invariably crowned a flat or low hip roof with wide projecting eaves, a service ell formed a tail or wing or both, and a front (and, perhaps, rear) portico occupying one bay or extending across the façade carried the bulk of the ornamental signature. By dipping into his kit of various decorative details for this tack-on, customized frontispiece, Austin could personalize what was otherwise an off-the-shelf form. Within, a hall—often central, at times off-center—with a stair or leading to a stair, led back from the entrance between the parlors, while the kitchen usually occupied the ell. Such limited planning was far from imaginative. It harkened back to Palladio and found contemporary use in the domestic work of Sidney Mason Stone and Austin's other contemporaries,[14] Austin's residential designs had none of the richness of layout and variform spaces one finds in the work of A. J. Davis.

The house Austin designed for James E. English on Chapel Street in the Wooster Square neighborhood of New Haven in 1845 is a good example of the

type. English (1812–1890) early rose from carpenter to master builder, one whose "architectural taste" showed in several houses he erected in New Haven, then became a prosperous lumber dealer and man of affairs with interests in clock manufacturing, real estate, banking, and so on. By middle age he was one of Connecticut's richest men. Soon after moving into his new house, he entered politics, rising to the U.S. Congress during the Civil War and the governor's office afterward.[15]

The house has been raised a full story, but its original appearance is known from drawings in the larger book at Yale.[16] The square plan is fronted by a three-bay porch and extended toward the rear with an ell that originally contained the kitchen.[17] Entry is through a paneled door in the right-hand bay into a hall with a stair whose curved rail descends to an ornamental newel that, with variations, was to be one of Austin's signatures. A low hip roof with projecting eaves caps the cubical block, three bays across, originally two stories high, covered with stucco scored to look like stone. The trabeated windows are punched into the walls without frames. A low, flat cupola in the center of the skyline crowns the whole. Such a lantern allowed light to enter the center of the plan, often descending along the slant of the main stairway.

The plain, basic geometry of the composition is given an exotic kick, as often in Austin's immediately subsequent work, by the foliate "candelabra" columns of the front porch.[18] Here we encounter another of Austin's signatures, for such extraordinary supports are to be found on any number of his residential porches, especially those designed between 1845 and 1850. But let us look at some more examples before we pause to consider this phenomenon.[19]

In the year he produced English's house, Austin also designed the better-known house next door for Willis Bristol, a mainstay of the community, president of Bristol Boots and Shoes and the New Haven National Bank. The house is a paradigm of the type, and although the interior is somewhat compromised, it is reasonably well preserved, as we can tell by comparing it with the drawings in the larger book at Yale.[20] (See Figs. 14 and 15.) It was divided into apartments about 1933[21] and recorded in the Historic American Buildings Survey in 1964. Square in plan, with no ell, the house has a central hall reaching from the central one-bay portico in front through an archway to a stair hall and then to a five-bay porch at the rear (now partially enclosed) that originally overlooked the harbor. The drawing of the plan at Yale shows the central hallway divided by an archway and the parlor divided into two areas by what was probably a framed, trabeated opening that is usually called an "arch." The front elevation is two-story on a high

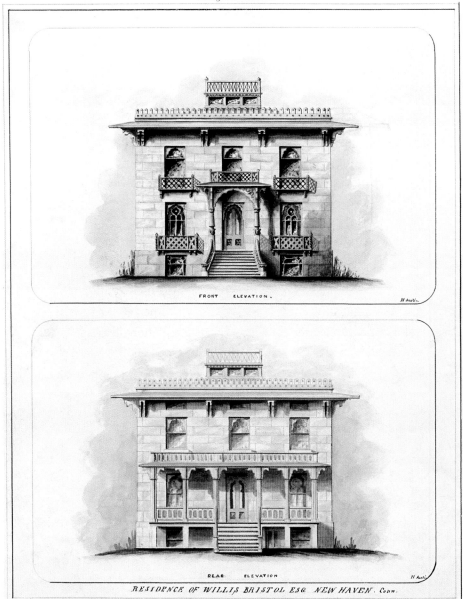

FRONT ELEVATION.

H Austin

REAR ELEVATION

H Austin

RESIDENCE OF WILLIS BRISTOL ESQ. NEW HAVEN. Conn.

14. Henry Austin, Willis Bristol house, New Haven, Connecticut, 1845. Front and rear elevations. (Austin Papers, Manuscripts and Archives, Sterling Library, Yale University)

basement, three bays across, crowned by deep eaves on widely spaced bold brackets supporting, in the drawings, a high fence-like cresting. (Another fence-like cresting shown on the cupola in the drawings no longer exists.) Iron balconies of medieval quatrefoil pattern front the windows, and the same fencing design marks the cresting above the portico. The main roof is too flat to be seen from the street. The low cupola lights the stair hall below, where, as usual, a curving

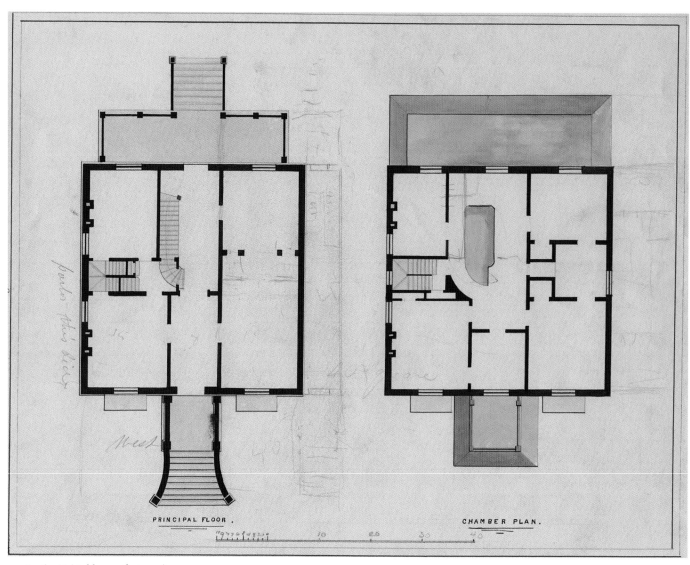

PRINCIPAL FLOOR .

CHAMBER PLAN .

15. Austin, Bristol house, first- and second-floor plans. (Austin Papers, Manuscripts and Archives, Sterling Library, Yale University)

rail swoops to an ornamental newel. A lambrequin ornamental motif crowns the wall that surrounds the stairwell; at ground level it nearly abuts the leafy classical cornice that tops the rear entrance area. We will see again this eclectic juxtaposition of such motifs.

The striking thing about the Bristol house is Austin's augmentation of its crisp Neo-Classical volume by an exterior and interior display of Indian Revival ornamental motifs. The scalloped or multifoil arch is everywhere: jigsawed into boards set into the trabeated windows, the main and rear doors (whose frames also echo it), and on three sides of the portico. The mullions echo the lines of the arch; they could have been inspired by those Foulston shows on the façade of his Mount

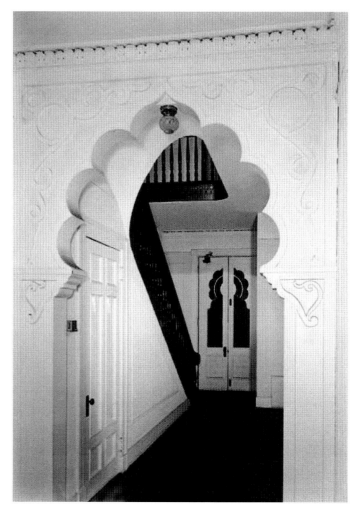

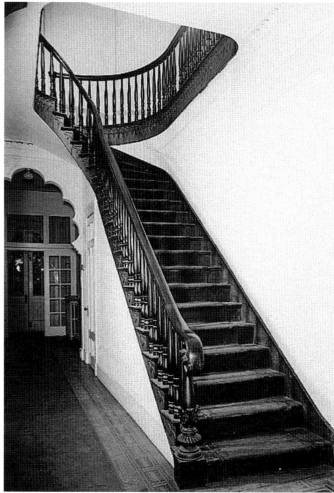

Zion Chapel in Devonport.[22] (As a general rule, Austin's historical sources—like those of his contemporaries—were filtered through English works.) The scalloped arch also forms the archway between the front hall and the stair hall so that, from the entrance, one had a glimpse of the scalloped curve repeated thrice.[23] (See Figs. 16 and 17.) Curvilinear strapwork of Moorish inspiration fills the spandrels of these arches and other areas outside and in. But it is the front portico, with its splayed stairway sweeping up to the level of the main floor, that engages the visitor. (See Fig. 18.) This is reminiscent of an Indian *chattris*, the corners of the roof supported by four candelabra columns. The rear columns here, as on the porch of the English house and in the drawing at Yale for the Peck house, do not engage the front wall of the block. They are freestanding, detached from the cubical core, clearly additions to it, not elements of it. (See Fig. 19.)

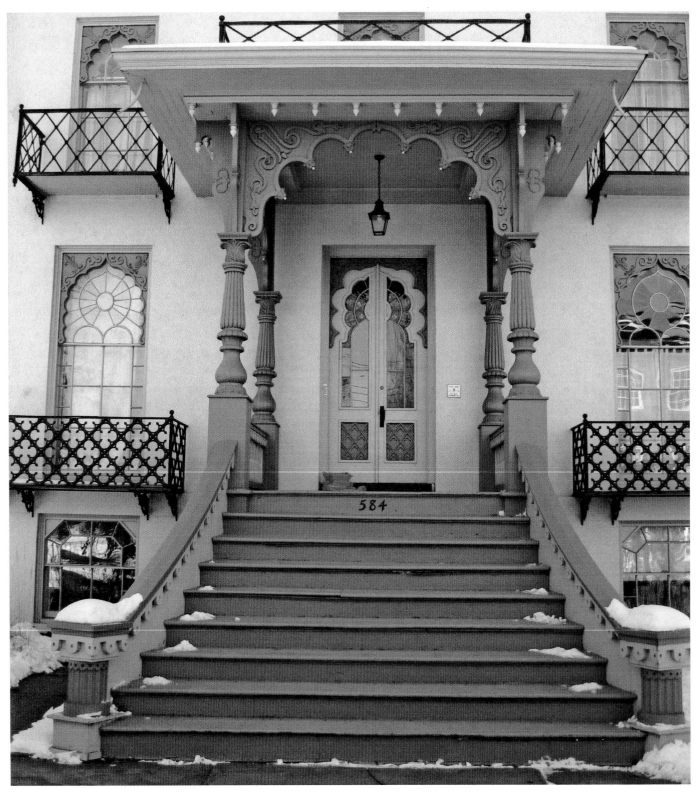

18. *Austin, Bristol house. Portico. (Author, 2006)*

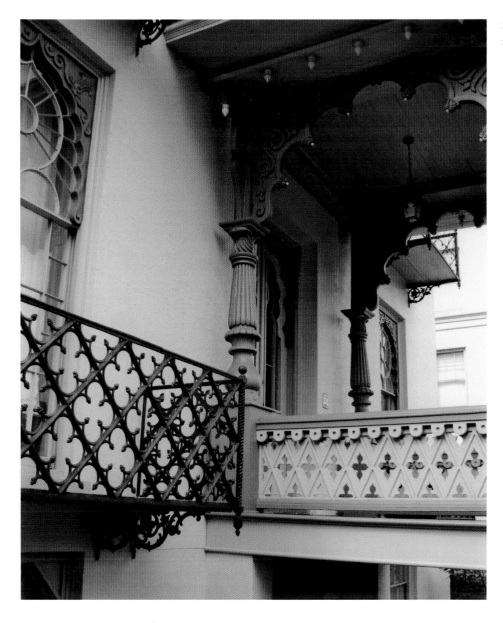

The James Dwight Dana house of 1849 on Hillhouse Avenue in New Haven is (or was originally, before additions) a slight variation on the type we have just seen. (See Fig. 20.) Dana (1813–1895) was a geologist, mineralogist, and zoologist, son-in-law of the famed professor Benjamin Silliman, and for nearly fifty years the much-published and much-honored professor of natural history and geology at Yale.[24] Plans and elevations for his residence on Hillhouse Avenue are also in the larger drawing book at Yale.[25] It too was recorded by the Historic American Buildings Survey in 1964. A broad rectangle in plan is fronted by a three-bay

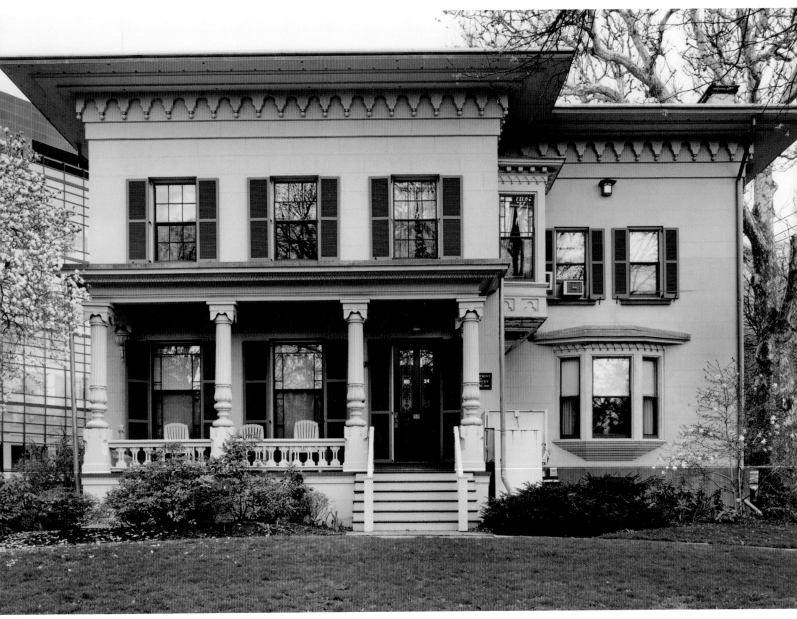

20. Austin, Dana house. As altered.
(© Cervin Robinson, 2007)

porch and extended by a rear ell with a side porch. The right-hand door leads
into the entry hall with a straight flight of stairs introduced by the usual sculpted
newel, here in the form of an S. (See Fig. 21.) This newel and the turned balusters
are very similar to those at the slightly later Jonathan King (O. B. North) house on
Chapel Street. The elevation is, as usual, a two-story, three-bay block surmounted
by a low hip with wide overhangs topped by a low cupola. The rectangular win-
dows are cut unframed through the stuccoed brick walls. A decorative border

beneath the eaves merges a corbel table with a lambrequin pattern. Austin used the same ornamental device on many other houses of the period and on the contemporary Presbyterian church in Trenton. (See Fig. 64.)

The balusters (if one may use the term here), socles, and columns of the porch are the chief ornamental details of the exterior. (See Figs. 22 and 23.) In Western architecture of the classical tradition, columns—and every other detail—are designed so as to express clearly—if subtly—the spread of the superimposed

21. Austin, Dana house. Newel. (Author, 2006)

22. Austin, Dana house. Portico. (Author, 2006)

23. Austin, Dana house. Detail of the candelabra column of the portico. (© Cervin Robinson, 2007)

weight of the building carried to the ground. In the orientalizing posts of Austin's work of this period, on the other hand, this sense of stability is undercut not only by the use of floral motifs that seem to deny them the strength necessary to perform their function, but also by the fact that the diameter of the turned column is seriously diminished near the base, making it thinner there than it is above, often dramatically so. At the Dana house and elsewhere, where the urn-

shaped bases have thin stems, this lack of visual architectonic strength is particularly noticeable. Austin used a wide variety of these supports on his midcentury houses, including some, as here, with a decidedly unclassical incorporation of fluted shafts. The source for these supports is often given as John Nash's Royal Pavilion at Brighton, where indeed bulbous foliate bases are to be found on the exterior,[26] but their pedigree is not so simple.

In these details, Austin's architecture touches on the nineteenth-century love for the exotic, for Orientalism, that distortion of Eastern cultures that also found its way into the painting and literature of the period. In architecture this was caused in part by a growing sense of fatigue in the West generated by the sameness of the classical system based on the five orders that had prevailed since the Renaissance and reached its rigid conclusion in Neo-Classicism. The American Chester Hills recognized this when he wrote that "Architects incur the censure of dullness because many other [orders] have not been invented,"[27] but it was the Englishman Humphrey Repton who used this sense of boredom to argue for the introduction of Indian forms into modern architecture. In his *Designs for the Pavilion at Brighton* of 1808, he illustrated the rich variety of Indian supports by comparing several of them to an uninspiring row of the five classical orders.[28] The "accurate Designs of Mr. Thomas Daniell . . . [in his *Oriental Scenery* of the 1790s] have opened new sources of grace and beauty," he wrote.

England's venture into India led inevitably to the discovery of what Repton called the "awful wonders of [its] antiquity." By the late eighteenth century, Joshua Reynolds, George Dance, and others were pointing the way to these exotic sources as models to enliven the increasingly rote repetition of the classical tradition. Drawings of Indian sites such as the ancient rock-cut temples at Ellora began to flood into England, among them the works of Thomas and William Daniell published as a series of large folios titled *Oriental Scenery* between 1795 and 1808.[29] These, in turn, influenced British and eventually American architecture, as witnessed by the published work of John Foulston in England and William Ranlett's *The Architect*, which appeared in New York in two volumes of fascicules in 1847–1849. The latter contains a design for a small villa in the Indian style. English precedents such as John Nash's Royal Pavilion at Brighton inspired such exotic American flowers as Iranistan, Leopold Eidlitz's villa for P. T. Barnum erected 1846–1848 at Bridgeport, Connecticut. Austin also fell briefly under the spell of India. Raymond Head wrote that "in his obsessive use of Indian details he was at his most highly original,"[30] but "obsessive" is too strong a word, for this is true only in some decorative details added to buildings in New Haven and vicinity,

mainly during the late 1840s. Indian influence never had the great impact on Austin's work that it did on Eidlitz's at Iranistan. The emphasis on these exotic touches that marks discussions of Austin's careeer is an exaggeration (as I shall note again in looking at the New Haven railroad station) and the result of not looking at that career as a whole.

If Brighton is one source for Austin's exotic supports, the columns of Saint Andrew's Chapel in Plymouth, as illustrated in John Foulston's publication of his English works, stands behind some examples.[31] (See Fig. 24.) The name Foulston gives to these supports, "candelabra," suggests not so much architecture as the decorative arts, and these features more closely resemble candleholders or bedposts than they do traditional columns.[32] This leads us back to the observation I made about the supports on the porches of the Bristol, English, and Peck houses. These porches are detachable; they are not integral parts of their houses. They are, to use the distinction best expressed in the Italian words for furniture and building, *mobile* and *immobile*, words akin to the English "movable" and "immobile," or "detachable" and "fixed." In a sense, the blocks of these houses constitute architecture, while their porches are so much furniture. In fact, it is possible to find similar supports in the furniture of England and the United States at this period.[33]

At the Dana and some other Austin houses the rear supports for the front porch roofs are brackets, so they rely on the wall to sustain them and are thus more easily seen as extensions to the basic block of the house. The outer posts have curious capitals with dropped corners that to Western eyes seem to be the blanks from which one might carve Ionic volutes. They were, rather, inspired by some capitals found at the rock-cut caves at Ellora in India, views of which were published by the Daniells and used by Repton as part of his frontispiece vignette and his array of Indian supports contrasted with the classical orders.[34] (See Fig. 25.) Austin reused elsewhere these Ellora capitals, which in good American fashion he transferred from stone to wood. Such is eclecticism; such was the value of books in Austin's practice. The wonder is not to be found in Austin's rich use of his myriad sources, however; it is to be found in how he got his clients, these sober New England industrialists, businessmen, and educators, to accept such exotic furniture added to their otherwise four-square houses. Banister Fletcher's "non-historic styles" at this period were usually associated with frivolous or holiday uses, such as park kiosks or garden ornaments. It could only have happened by Austin flashing books of historical precedent and urging his clients to catch the latest British fashion.

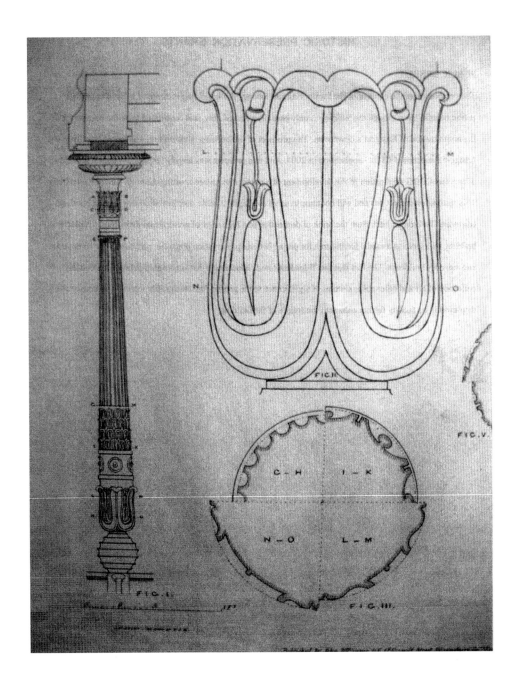

The houses so far examined were Italianate with touches of Anglo-Indian or Indian ornament. There is in the larger book at Yale a domestic design more completely dependent on Indian precedent. It is telling that it was probably never built, perhaps because it finally seemed too exotic for Austin's New Haven clients.[35] Labeled generically as a "Dwelling House," this is a project for what appears to be his standard cube fronted by a complete Indian composition. (See

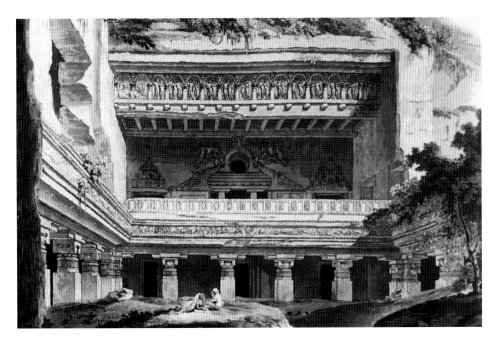

25. Cave 10, Ellora, India. (From Thomas Daniell, Oriental Scenery, *1803)*

Fig. 26.) It was a "logical step"—if one can use that expression for so illogical a design—beyond the Bristol house, some details of which reappear here. The parti is of a two-story, central, flat, ogival arch beneath a raised wall punctuated with corner minaret forms and flanked by stacked windows, the upper ones fronted by balconies and covered by a roof with a broad overhang supported by elaborate brackets. This design seems to merge the Great Gateway to the Garden Court of the Taj Mahal at Agra with the gateway leading to the mosque at Chunar Gur as published by William Hodges in 1786 and elsewhere.[36]

The house for Nathan Peck, Jr., that once stood on George Street between Church and Orange Streets in New Haven was a variation on the cubical houses just examined.[37] Plans and elevations naming Peck are found in the smaller book at Yale; the plan also bears the graphite note "Erastus Brainerd Jun/Portland Con."[38] I've seen dates of 1847 and 1854 assigned to the Peck house, either of which might be when it was built, although the former is the more likely, but there is reason to believe that the design—rather than the building it prescribed—might predate the English and Bristol houses. Austin added a story and reused the design for the existing Brainerd house in 1849 (see Fig. 27), the same year that his brother produced a close variant for Henry R. Brewster in Rochester.[39] Since Merwin Austin left Henry's office in 1844, he either returned for a visit or visits later, which is possible, or carried a copy of the design with him when he moved west.

Design XXVI Plate I.

Scale 1/10

Front Elevation.

26. Henry Austin, "Dwelling House,"
before 1851. (Austin Papers,
Manuscripts and Archives,
Sterling Library, Yale University)

It is, as usual, the portico that distinguishes the Peck house from other varia-
tions of the cube with cupola, portico, and tail. The Bristol *chattris* has here been
translated into a medieval, ogival, multifoil pavilion without losing its charac-
ter as a detachable piece of furniture. Although this is a visual change, the ogee
was common to both the Indian and Gothic styles, and, as has been pointed out,
the period made little distinction between the two, in part because it was then
believed that the origins of the Gothic were to be found in the East.[40] The expres-
sion "Hindoo Gothic" was used by at least one contemporary critic.[41] The col-
umns of the Peck design are engulfed by foliage; those of the Brainerd portico

27. Henry Austin, Erastus Brainerd house, Portland, Connecticut, ca. 1850. Portico. (Author, 2006)

have fluted shafts beneath the drop-corner capitals of Ellora and above a floral footed urn with an extremely narrow stem. It is a perversion of a classical column. Merwin's columns at the Brewster house are different again, with bulbous bases and tapering shafts beneath a torus (a shape usually found at the base of a classical support).

There are drawings in the larger book at Yale for other variations on this type of domestic work. The design for what is labeled the J. H. North house is another spin on the Bristol house scheme with columns based upon those of the Dana house.[42] The variations include a hip roof on the cupola with bracketed eaves, an encrustation of scroll-saw supports for the vertical finial, oversized brackets supporting the broad overhang of the main roof, a rather classical frieze over the central window on the second floor, and a window flanked by others with inset multifoil arches. The paired columns of the portico have regulation fluted shafts resting on floral bases and topped by the drop corner capitals. The design is probably closer to 1845 than to the 1850 that is usually given. The house was erected on South Main Street in New Britain, although it is gone now. Vintage photographs, which name the occupant as Frederick N. Stanley rather than J. H. North, show that it followed the drawings rather closely.[43]

The Nelson Hotchkiss house of about 1850 at 621 Chapel Street in New Haven has never been firmly documented as designed by Austin's office, although there is in the collection at Yale a drawing close in shape to what is here.[44] Hotchkiss collaborated with Austin on the Park Row development in Trenton, as we have seen, and at this date worked as a lumber dealer specializing in window blinds and sash. He lived in a number of houses in the area, and it has been suggested that he was a speculative builder.[45] His cubic box with a flat roof and cupola was built of brick covered with stucco. The window openings are trabeated with simplified versions of what—although they were common in the period—were Austin's signature frames, here notched at the top, pinched in halfway down, and ending with a scroll at the boldly projecting sill, itself resting on characteristic blocky supports. The columns of the one-bay portico are about as classical as Austin could get after his initial works. They are baseless in the Greek Doric manner, with fluted shafts and reductive foliate capitals.

There were in this period two southern Connecticut residences related to the series we have just discussed but that deserve to be called villas rather than houses. The smaller of the two was commissioned by Philo Brown and the larger by Moses Yale Beach. Brown (1803–1880) was president and manager of Brown & Brothers, "manufacturers of brass, copper, German silver and other metals in

sheets, wire, tubing, etc."[46] He built his Austin-designed house on Waterbury Green in 1850; plans and elevations are in the larger book in the collection at Yale.[47] The plan—which is scribbled over with graphite notes and dimensions—is, as elsewhere in Austin's domestic work of this period, almost Palladian in its internal division of the square. A broad central hall with a double-back main stair led to a servants' stair and on into the kitchen in the rear ell. The handwritten notes tell us that a sitting room, bedroom, dining room, and one unspecified space (perhaps the parlor) filled out the corners, each side divided by a fireplace. Another note reads "Built of Wood/Shingle Roof."

A piazza surrounded the main block. Here again Austin's eclectic imagination is on display. The supports were candelabras, the "railings" rococo cartouches, the roof edged in a lambrequin decorative pattern. Where the windows of the houses we have already discussed, with the exception of Hotchkiss's, were usually punched through the wall without frames, here there are elaborate surrounds of a type that, with many variations, became another of Austin's signatures. As at the Hotchkiss house, they begin at the top simple enough but pinch in midway down and then turn into Baroque scrolls. With or without encrusted carving, they reappear frequently inside and out in Austin's work of the period. Finally, the cupola is lower and broader than we have seen, its roof with exaggerated overhangs and a tall finial with scrollwork braces.

The demolition of the Moses Beach house in Wallingford in the early 1960s removed from our cultural patrimony one of the special examples of American domestic architecture. (See the Frontispiece and Fig. 28.) Beach (1800–1868) was a journalist and owner of the *New York Sun*. Design drawings exist in the larger book at Yale;[48] the building was well documented at the time of its destruction by the Historic American Buildings Survey in measured drawings and photographs. It was designed about 1850. In plan the central square was flanked by symmetrical wings; in the original elevation the three-bay, two-story center towered over the lower three-bay, two-story wings. The building was in fact an updating of that Neo-Classical villa with which we began to look at Austin's domestic work. (See Fig. 13.) It was the piazza that surrounded the core block and the decorative details, inside and out, that set it apart from its forebear.

As executed, the central block was raised by an attic story beneath the broad overhang of the roof, but in the main it followed Austin's design. He reused a modified version of the Dana columns on the piazza[49] (see Fig. 29), and the exterior window and door frames resemble those of the Brown villa. The tall, narrow tower-like cupola was remarkably different from the low, broad roof ornaments

28. Henry Austin, Moses Yale Beach house, Wallingford, Connecticut, 1850. (Cervin Robinson for the Historic American Buildings Survey)

that we have seen. (See Fig. 30.) Although observers have remarked on the generally oriental effect of the villa, Austin's decorative details here are actually derived from the classical tradition, albeit in its ultra-Baroque, Rococo, or Churrigueresque embodiment. It is true that, in the way he handles his encrustation of carved brackets, the effect of the silhouette from a distance approaches that of northern Hindu architecture.[50] The casework of the interior was encrusted with Rococo carving of a kind we find elsewhere in his work of this period, a "hankering to load up lintels with piles of foliage [and figures]," in the words of Elizabeth Mills Brown.[51] (See Figs. 31 and 32.) According to George Seymour, the fireplaces had Italian marble surrounds, and Italian "frescoes" originally graced the interior.[52]

Austin and others continued to turn out for many years such Italianate cubical houses enriched with candelabra columns and their variants for New Haven

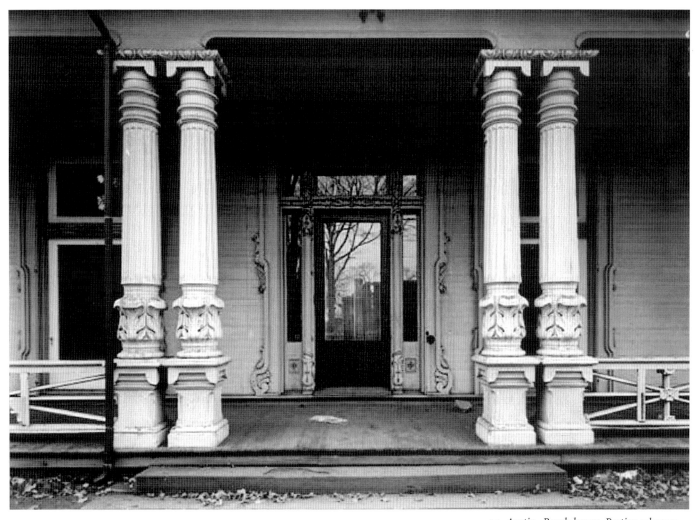

29. Austin, Beach house. Portico columns.
(Cervin Robinson for the Historic American
Buildings Survey)

and other southern Connecticut towns. The Henry Z. Platt house on Washington
Street in Hartford, built in 1847, with its extravagant, vaguely orientalized por-
tico fronting the usual cube, has been assigned to him.[53] (See Figs. 33 and 34.)
That porch might be a heavy-handed reworking of the Bristol house portico. Both
are more furniture than architecture. (A variation on this porch appears on the
Thaddeus Clapp house of 1849 formerly in Pittsfield, Massachusetts.[54]) The Platt
house stood next to Austin's Gothic Kellogg house on Washington Street, the two
demonstrating the architect's stylistic versatility in the 1840s. (See Fig. 3.) His
contemporary, Sidney Mason Stone, designed a splendid example of the type, the
Ezekiel Trowbridge house in New Haven, in 1852. Elizabeth Mills Brown dates
the cube with candelabra columns at 478 Orange Street in the same place to
1866.[55] The influence of this form seems to have traveled up the Connecticut

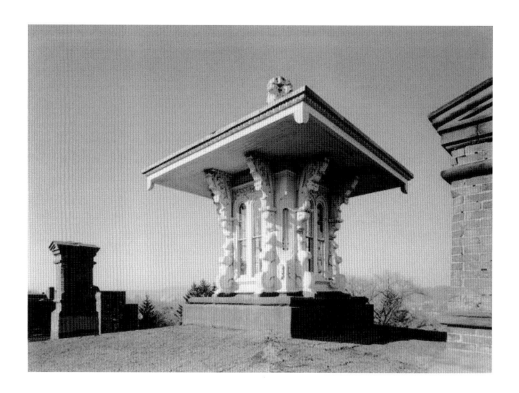

River to Amherst, Massachusetts, where the portico columns of William Fenno Pratt's 1863 Italianate box-with-cupola for Leonard Hills seem mild versions of Austin's signature supports. But Austin developed other house forms as well, ranging from some examples with exaggerated hip roofs to town houses fronted with double bows. An example of the former is the house shown in the smaller book at Yale that is assigned in pencil to Oscar M. Carrier of Olivet, Michigan.[56] The plan is a rectangle with a central porch and entry and rear ell. The three-bay, two-story elevation is topped by an oversized hip with bold pendants at the corners. This is echoed in a smaller size on the front porch.

An example of the double bow-front form is the second Nelson Hotchkiss house at 607 Chapel Street in New Haven. (See Fig. 35.) Again the attribution is undocumented, but circumstantial and stylistic evidence "strongly suggests Austin." Elizabeth Mills Brown dates it to 1854.[57] The bows of the second Hotchkiss house embrace the richly ornamental entry. They are relatively plain, with simply framed trabeated windows and a lambrequin decorative motif beneath the projecting cornice. The doorway has two leaves capped with round arches, while the semicircular overdoor encloses a pair of pointed arches. Stumpy candelabra columns flanking the entry rise to the top of the doors to support elaborate brackets that themselves uphold a projecting glazed bay at the second story.

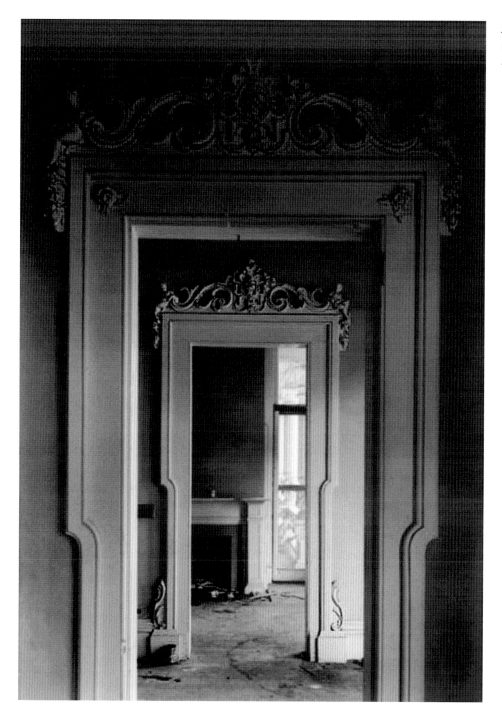

*31. Austin, Beach house. Interior.
(Cervin Robinson for the Historic
American Buildings Survey)*

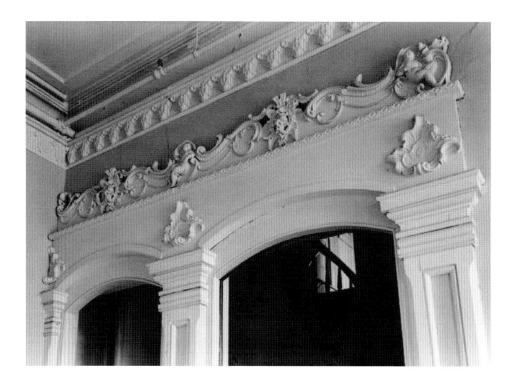

This is defined at the corners by slimmer candelabra and covered by a flat roof whose deep eaves are edged by another lambrequin border. Examples of this house type in New Haven, none firmly linked to Austin but reasonably attributed to his office, include the extant Nehemiah Sperry house (1857), the Edward Rowland house (1865), and the totally transformed Gaius Warner house (1860, now the Union League Café).

Austin experimented with at least one other house type. He jumped on the Orson Squire Fowler bandwagon about 1850. Fowler, the noted phrenologist and sexologist, published his influential views on the best form and construction of a house in *A Home for All; or, the Gravel Wall and Octagon Mode of Building*.[58] There is in the larger drawing book at Yale a project for a residence octagonal in plan that is unnamed on the drawing but became the William S. Charnley house in New Haven.[59] Charnley was of the socioeconomic class characteristic of the bulk of Austin's clients: president of the New Haven Water Company and of the Quinnipiac Bank. On the principal floor of the house Austin adapted to the octagon the usual dining room, kitchen, sitting room, and parlor around cruciform passages centered on a hall with a stair. Added pencil lines show how the form might be extended in five directions. The drawing indicates stone or stucco scored to look like stone, but the house was built of plastered brick rather

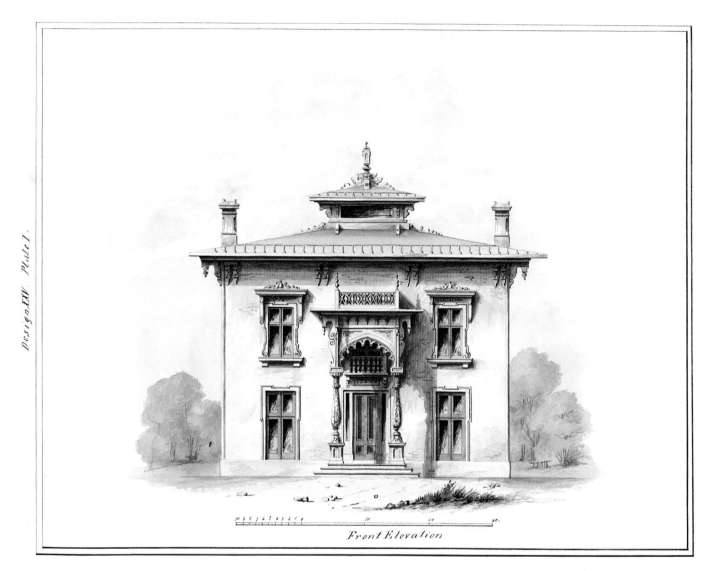

Front Elevation

33. Henry Austin, dwelling. Façade.
(Austin Papers, Manuscripts and Archives,
Sterling Library, Yale University)

than the more economical walling system Fowler advocated. The exterior had
two stories capped with a broad roof and cupola. Projecting lids on bold brack-
ets crowned the trabeated windows of the ground floor; the upper windows were
round-arched. Neither in the drawing nor in the house was the entrance por-
tico given the exotic treatment of Austin's cubes. Yale pulled down the dwelling
about 1913.

Austin had other geometric and stylistic fish to fry besides the cube and the
octagon. Like nearly all of his peers in about 1840, he could turn out a Neo-
Classical box with one hand and a Gothic cottage with the other (and find them
depicted on facing pages of Louisa Tuthill's *History of Architecture* of 1848). As

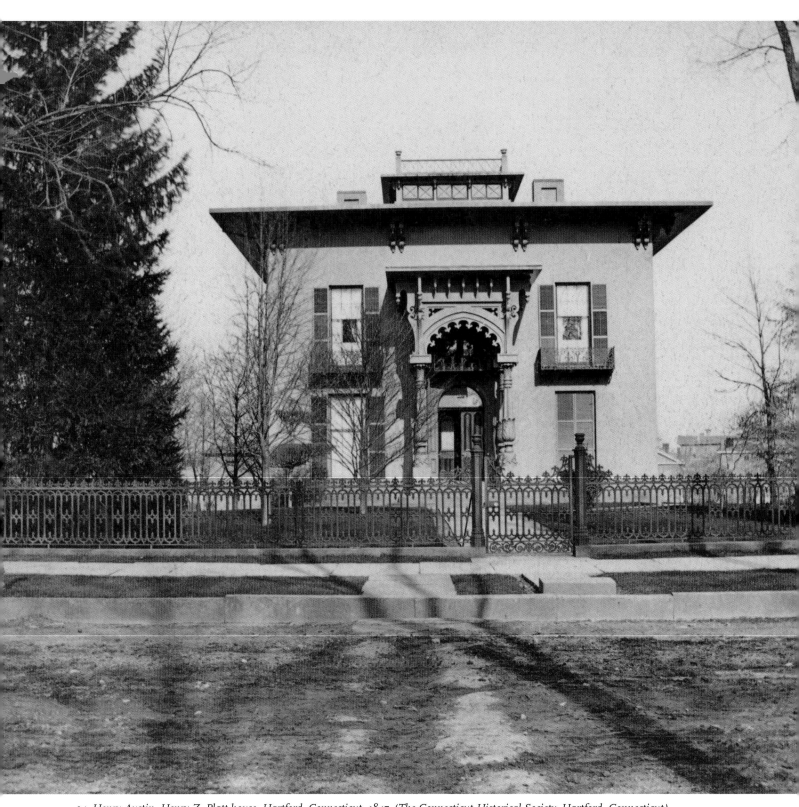

34. Henry Austin, Henry Z. Platt house, Hartford, Connecticut, 1847. (The Connecticut Historical Society, Hartford, Connecticut)

35. Henry Austin, Nelson Hotchkiss house, New Haven, Connecticut, ca. 1850. (Author, 2006)

we have seen, the Kellogg house in Hartford of 1841 must be among the earliest of his medieval-inspired domestic works. A box with "Gothick" trim, it suggests his cognizance of A. J. Davis's work at the time. There is a group of designs in the Yale drawing books, and therefore probably from the mid-1840s, that suggest that he was paying attention to A. J. Downing's collaboration with A. J. Davis as well. (See Fig. 36.) Since Gervase Wheeler was in the Austin office just after the middle of the decade, when his own Gothic Boody house in Brunswick, Maine, was designed, it might be supposed that he had a hand in these studies.[60] He arrived in the office in 1847, however, and one of these designs appears somewhat altered in the edition of Chester Hill's *Builder's Guide* (with copyright

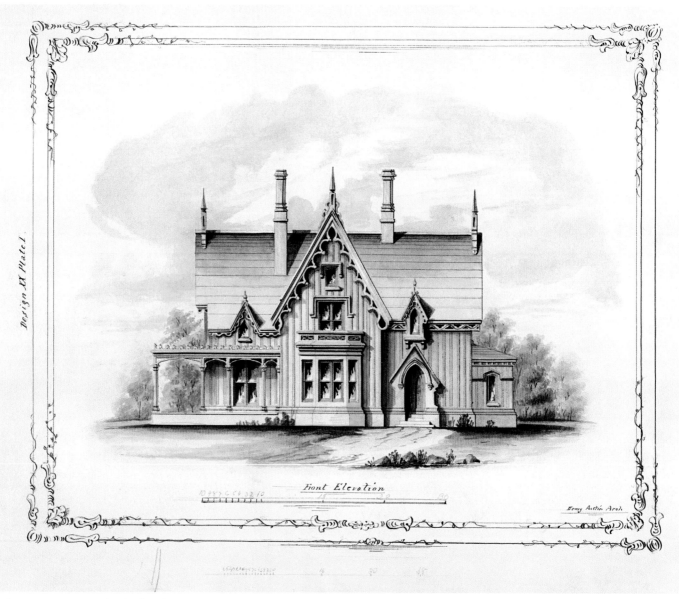

Front Elevation

Henry Austin Arch.

36. Henry Austin, "Gothic dwelling house," before 1851. (Austin Papers, Manuscripts and Archives, Sterling Library, Yale University)

of 1845) (see Fig. 37), and another was the source for Merwin Austin's Elm-Wood cottage in Mount Hope (Rochester), New York, which was published in January 1846.

There are designs for five Gothic cottages in the larger drawing book. They exhibit the standard vocabulary of the genre: high-pointed roofs, ornamental barge boards, pinnacle-and-pendants piercing the gable peaks, labels above windows. Some are board and batten; others appear intended for flush boards or stucco. Ornamental barge boards were common in this period, and Austin might

*37. Henry Austin, "Villa in the
Cottage Style." (Chester Hills,
The Builder's Guide, 1846)*

FRONT ELEVATION.

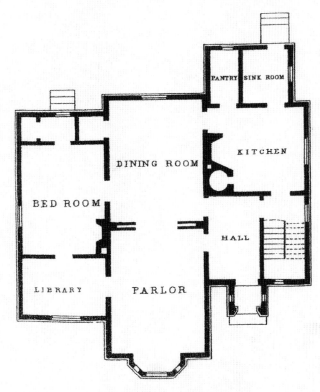

GROUND PLAN.

38. Henry Austin, "A cottage in the
modernized Gothic style." (Louisa Tuthill,
History of Architecture, 1848)

have been inspired by those in the copy of A.W. N. Pugin's *True Principles of Christian Architecture* (1841), which was in his possession in 1845.[61] In two of these cottages the massing is symmetrical; in the others, subtly asymmetrical. One cottage is shown in perspective set against a rugged terrain.[62] Another has a pencil note in the margin that reads "Edward Mays (?) Washington Pa," but I have been unable to identify it further. As we shall see, another seems to be a preliminary design in the large drawing book for the Scovill house, "Rose Hill," in Waterbury, erected in 1852.[63]

The caption for the elevations and plans of the Tudor "Villa in the Cottage Style" reproduced in the *Builder's Guide* says that it was built in New Haven at a cost of $2,400. The exterior was of pine boards, the roof shingled. It was warmed by a furnace in the basement. A perspective of the same cottage appears in Tuthill's *History of Architecture* facing a cut of Austin's Gabriel house.[64] (See Fig. 38.) It should be remembered that Tuthill well knew the New Haven architectural scene, and since no perspective of this design appears in Hills's *Builder's Guide*, she must have had access to a drawing from Austin's office. She calls it "modernized Gothic" and says that it is "suitable for a rural city, a village, or for the country." She quotes Joshua Reynolds's opinion that houses should be the same color as their materials so that they will "always be in harmony with the

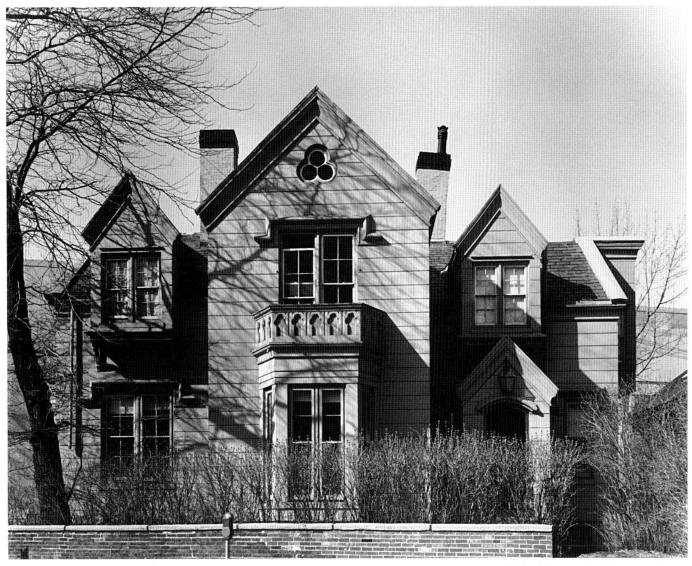

landscape" (white was not a common house color before the arrival of the English Colonial Revival later in the century). The house from this design said to have been erected in New Haven has not been identified, but a builder named Michael Norton seems to have had *The Builder's Guide* before him when he erected his own house at 85 Brattle Street in Cambridge, Massachusetts, in 1846.[65] (See Fig. 39.) With minor changes of detail, he reproduced with flush siding the exterior published in the *Guide*, but the interior diverges from Austin's design, with details that are Grecian rather than medieval. This is the single instance now known of a builder copying a design published by Austin.

William Henry Scovill (1796–1854) was in 1850 the head of the Scovill Manufacturing Company, maker of brass buttons; a warden of St. John's Episcopal Church, for which Austin designed a new building in 1846; and a public benefactor of the town of Waterbury.[66] The design in the drawing associated with Scovill's house shows a variation on the "Cottage in the English, or Rural Gothic Style" in A. J. Downing's *Cottage Residences* of 1842, and, as we shall see, must have existed by 1844. Austin has changed the hip roof to a transverse gable, flanked the central gable with two smaller ones, and substituted board and batten for Downing's exterior walls of stone. Paired chimneys, oriels, and a three-bay front piazza all remain from the published example.

The client is not identified in the drawing book, and the existing Scovill house did not follow exactly this design (and was altered later). As executed, the house was picturesque in outline but scarcely Gothic in style. A vintage photograph shows that the building had but one front gable (without decorative barge boards) and no paired chimneys, and the front piazza became a single-bay portico flanked by oriels.[67] The interiors retain a simpler version of the florid Rococo ornament that once graced the Moses Beach house. The existing front porch was added sometime before 1894, and the gabled dormers flanking the larger central gable, which hark back to the original drawing, appeared sometime thereafter. A more faithful following of the drawing at Yale was to be found at Merwin Austin's Elm-Wood cottage, at Mount Hope (Rochester), New York, of 1845.[68] The owner, Thomas H. Hyatt, read and reread Downing, we are told; what he got at Mount Hope was a design by Downing out of Henry Austin as drafted by Merwin. Since Merwin left his brother's office in 1844, the design probably existed by then, although the possibility exists that he could have traveled between Rochester and New Haven any number of times.

Henry Austin thus tried his hand at picturesque and exotic architectural forms, as well as variations on the Neo-Classical cube. He also turned out several versions of another common upscale domestic style of the 1840s and 1850s, one in which the picturesque made peace with classicism. It also allowed for less restricted planning than did the small Italianate box. This is, of course, the Italian or Tuscan villa, to which Austin added some major examples. English in origin as Austin knew it, and often discussed in British publications available to him such as Loudon's *Encyclopaedia*[69] and other works, the modern Italian villa was introduced to a broad public in the United States in Andrew Jackson Downing's *Theory and Practice of Landscape Gardening* of 1841 and his *Cottage Residences* of 1842.[70] Downing's subsequent books, and those of many other architects, includ-

ing Samuel Sloan, Gervase Wheeler, and Calvin Vaux, and houses designed by those authors as well as by John Notman, Richard Upjohn, A. J. Davis, Thomas Tefft, and others, spread the style across the land.[71] A notable example ninety miles up the Connecticut River is the Austin Dickinson house in Amherst, Massachusetts. Designed by Northampton's locally famous William Fenno Pratt for the poet's brother in 1855, it has, as we shall see, the same exterior composition as Henry Austin's later King and Morse-Libby houses. All three owe an ultimate debt to A. J. Downing (and hence to A. J. Davis).

For Downing, the Italian villa was "remarkable for expressing the elegant culture and variety of accomplishment of the retired citizen or man of the world . . . [and also] very significant of the multiform tastes, habits, and wants of modern civilization. . . . The Italian villa . . . expresses not wholly the spirit of country life or of town life, but something between both, and which is a mingling of both."[72] Austin designed villas for cities, but for sites that enjoyed expansive views. He thus perhaps avoided Louisa Tuthill's scorn for "the Italian villa, designed for the border of a lake, . . . [that is] placed near a dusty high-road." But her scorn extended to eclectic design in general, so perhaps he overlooked her chapter on American domestic architecture, although that is unlikely, since she illustrated two of his New Haven houses as well exemplifying what she advocated.[73]

Descended from the towered vernacular farmhouses and rustic villas of the Tuscan countryside and filtered through English country estates (such as Queen Victoria's Osborne house, 1845–1849, on the Isle of Wight), the Italian villa found varied expression in this country. There are features common to most examples, however. A tall tower, the sine qua non, is often square in plan, off-center, and has an observatory or belvedere at the top. Site and vistas were important adjuncts to these houses, so porches or verandahs are also frequently present. The asymmetrical plan typically rises in rectangular blocks of smooth planes to low pitched roofs with deep overhangs supported by emphasized brackets. The best exteriors are constructs of highlighted planes and deep shadows. All details are as a rule classical; openings are usually round-arched and often covered with triangular or segmental pediments; balconies enrich the ensemble.

There are two drawings for Italian villas in the larger of the books at Yale. One, so labeled, must be among Austin's earliest attempts at the genre, for it looks like a model for a toy train set.[74] It has the expected features, but they are stumpy and ill proportioned, and apparently it was intended to be clapboarded. There are designs by others for wooden villas, but this one is decidedly too homey.[75] The other project, which is found in the smaller book, is more accomplished.[76] It

could be a preliminary study for Austin's Norton villa of 1849. The juxtaposition of tower, arcaded porch, and salient topped by a low pediment is there, although the tower is actually around the corner from the front façade, and the building is more richly ornamented. A band of Neo-Grec roundels encircles the tower beneath the observatory, the upper windows are surrounded with a version of Austin's signature frames, and the bay window of the salient as well as the side and rear verandahs are enriched with paired chamfered piers. The salient itself is three stories. If the designer was attempting to improve on the Italian villa published in Downing's *Cottage Residences*, he must have realized he had failed, but in the Norton villa itself, he produced a version much closer to that model.

There is a set of beautiful drawings in the larger book at Yale for the John P. Norton villa on Hillhouse Avenue in New Haven.[77] (See Figs. 40 and 43.) Austin must have realized that the location and the client added up to a major opportunity: Hillhouse was the showcase for the work of Town (who had lived there), Davis, Austin, and Sidney Mason Stone. He presented the house in complete plans and elevations rendered in accomplished watercolors. John Pitkin Norton (1822–1852) was the first professor of agricultural chemistry and of vegetable and animal physiology at Yale. He had little time to enjoy Austin's creation, alas, since he died the year it was finished. The house he ordered survives with major alterations, but enough remains to demonstrate the quality of Austin's achievement. (See Fig. 41.)

Although the picturesque outline of the Italian villa made it a choice for suburban or rural sites, Austin's four major works in the style (one the result of a remodeling) are all to be found within city limits. In the case of Norton's villa, this did not stop him or his draftsman from representing the front elevation set against a rugged terrain. Hillhouse Avenue was certainly more countrified then than it is now, with giant university buildings looming over it, but Austin's presentation shows it on the banks of a lake at the foot of rolling hills, on the one hand, and next to a dense wood, on the other. The elevation itself is a knock-off of Downing's "Villa in the Italian Style" in his *Country Residences*, although reversed from the woodcut illustration and given narrower and more vertical proportions. (See Fig. 42.) Gervase Wheeler, who in 1849 had just left Austin's circle, adopted the same format for the "Large Villa in Roman Style" he published in his *Houses for the People* of 1855.[78] One can imagine the two men in New Haven leafing through Downing's publications looking at designs that were as much A. J. Davis's as the author's. Well into Austin's career Davis led the way.

The Norton first-floor plan shows a library and a parlor aligned behind the façade of the salient, a hall and stair hall beyond the triple arcade, and a "Bou-

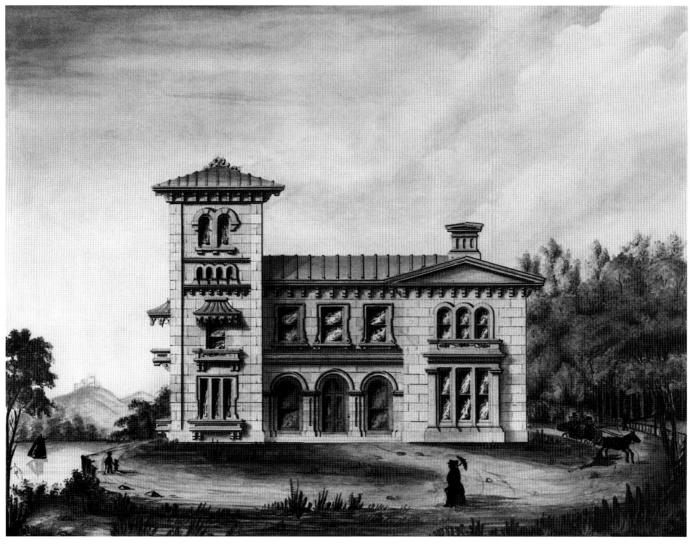

40. Henry Austin, John P. Norton house, New Haven, Connecticut, 1849. Principal elevation. (Austin Papers, Manuscripts and Archives, Sterling Library, Yale University)

doir" at the foot of the tower with the dining room across the hall toward the rear. (See Fig. 43.) For the most part, the exterior details of the building, built of brick covered with stucco scored to resemble stone, are simple, crisp, blocky, and bold (see Fig. 44); on the interior, this changes dramatically. The eclectic propensity of Austin as designer is fully in evidence at the Norton villa. The Italianate round arch of the entrance door is transformed on the interior into a multifoil ogee in the plasterwork (see Fig. 45), and the walls and ceiling of the hall are impressed with Mooresque overall decorative patterns, while surviving cornices, which vary from room to room, include classical dentils, egg and dart, and reel and bead motifs. As at the Bristol house, oriental and classical motifs collide. But the piéce

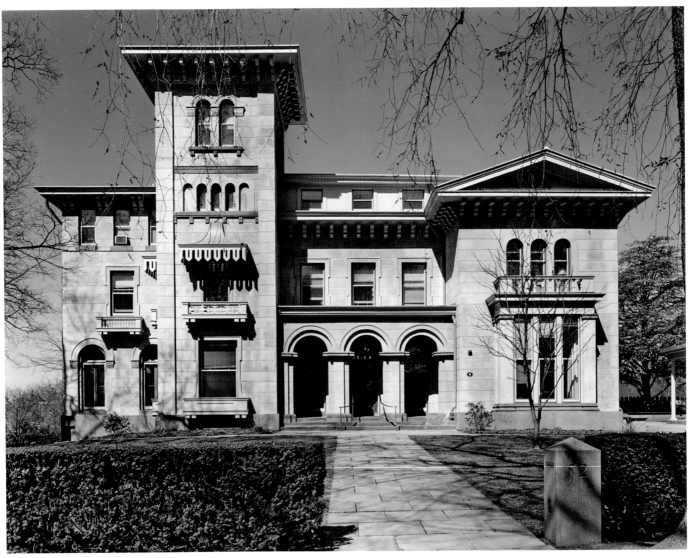

41. Austin, Norton house. As altered.

(© Cervin Robinson, 2007)

de rèsistance on the ground floor is the most impressive if difficult-to-describe newel that catches the handrail of the main staircase as it flows down from the upper level.[79] (See Fig. 46.) This is a curvaceous, free-form object sitting on a floral base and covered with expertly carved leaves. (See Fig. 47.) It is the most impressive of Austin's signature newels. There were in New Haven at this period two ornamental carvers named R. E. Northrop and George H. Brown.[80] Whether this is the work of either man or of someone else, it is the work of a gifted artisan.

Austin followed the Norton villa with another for Jonathan King (O. W. North) in 1852–1853 for a more constricted and less posh site on Chapel Street in the Wooster Square area.[81] Here the tower occupies the center of a composition of

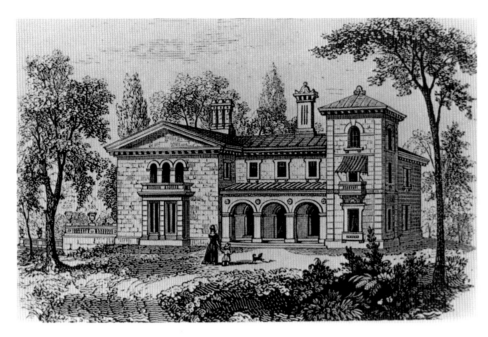

crisp rectangular forms, with a salient to the east and a porch to the west. (See Fig. 48.) This arrangement is to be found in Downing's bracketed villa in the *Cottage Residences*, although there it is simpler and clad in vertical board and batten siding. A round-arched door at the ground level of the King tower is surmounted by a trabeated window at the second story topped by a pronounced triangular pediment on the usual large brackets. Triple round-arched windows light the observatory. The deep eaves of the roofs are upheld by thick, close-spaced brackets. The salient is fronted at ground level by a projecting window bay surmounted by the balustrade of a balcony covered by a swooping hood with a lambrequin fringe of wood, the whole echoing a figure in A. J. Downing's *The Architecture of Country Houses* of 1850 and akin to a design in the first volume (1852) of Samuel Sloan's *Model Architect*.[82] The roof of the porch to the west of the tower is sustained by paired chamfered piers of the kind we've seen in the more accomplished villa designs in Austin's drawing book. Beyond the entrance is a central hall that rises to an open well lighted from the lantern above. The handrail of the curvilinear interior stair ends in an S-shaped newel that is the cousin of that at the slightly earlier Dana house.

The Tuscan villa was prescribed for picturesque sites because of the lofty belvedere at its summit from which views could be admired in all directions. At the King house, one could enjoy a view to the north of Wooster Square and to the south of the harbor from the height of the tower, but the design is otherwise a

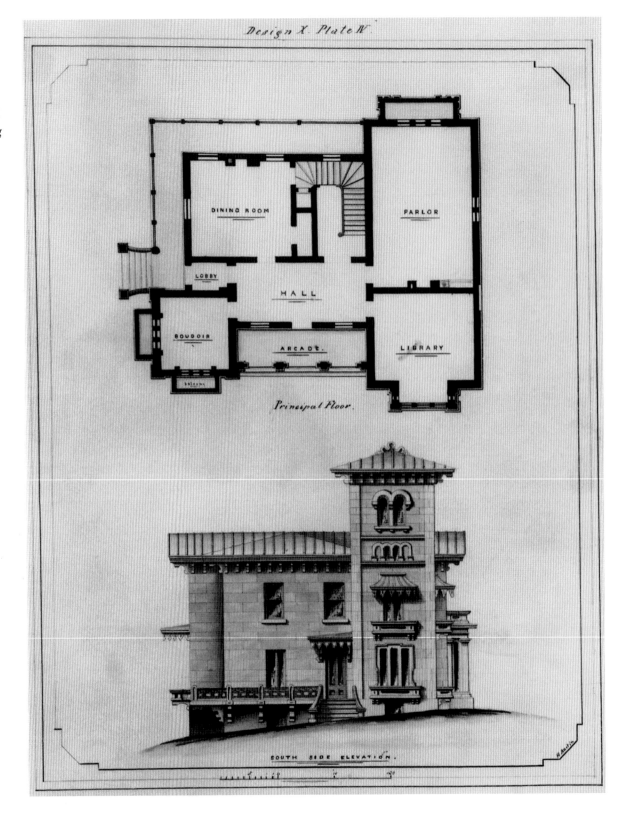

43. Austin,
Norton house.
Side elevation
and plan.
(Austin Papers,
Manuscripts and
Archives, Sterling
Library, Yale
University)

rather awkward fit into the row of closely spaced, boxy houses—many of them also designed by Austin—that form the immediate neighborhood. When Austin—or his client—decided to reuse the compositional format he employed here for one of his most spectacular Italian villa commissions, he did so in another urban setting, but one with a sweeping view from the observatory of Casco Bay and the Atlantic Ocean. That commission resulted in one of the culminating domestic designs of his antebellum years, and of the Italianate villa in general, the Morse-Libby house or Victoria Mansion in Portland, Maine.

Sylvester Ruggles Morse (1816–1893) was born in Portland but made his fortune as a hotelier in New Orleans.[83] In 1857[84] he and his wife, Olive Ring Merrill Morse (1820–1903), commissioned a summer house from Austin to be built

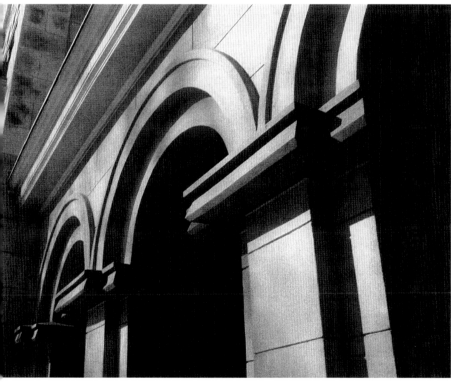

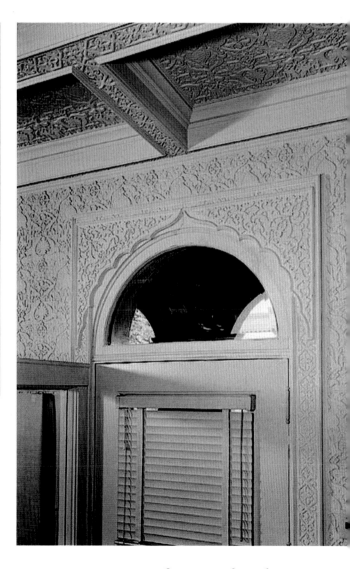

(above)
44. Austin, Norton house. Detail of front arcade.
(Author, 2006)

(right)
45. Austin, Norton house. Interior detail.
(Ned Goode for the Historic American Buildings Survey)

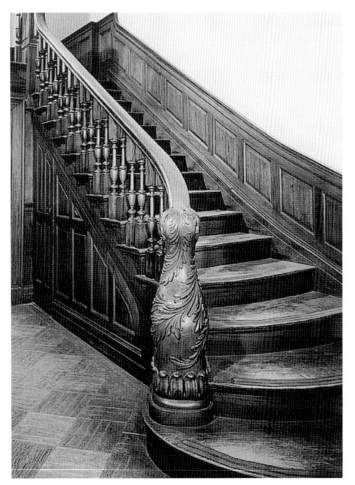

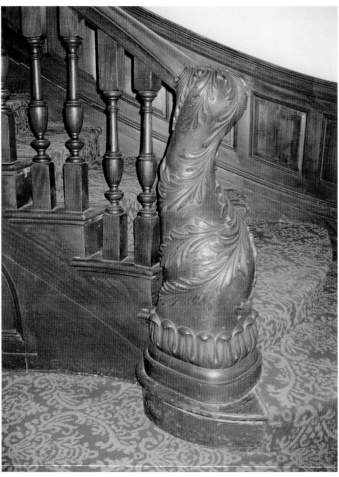

(left)
46. Austin, Norton house. Stair.
(Ned Goode for the Historic American Buildings Survey)

(right)
47. Austin, Norton house. Newel.
(Author, 2006)

in Portland on land he had acquired in 1856. How the architect and the client connected remains a mystery; we can only guess that it occurred in New York. No drawings have been located. Other than the signed specifications for the house, no documents linking the two have come to light. Given the result, it is obvious that Morse wanted his Portland neighbors to envy his deep pockets and admire the modish evidence of his successful career. The villa is an elaborate version of the King composition on a plan not unlike another that Gervase Wheeler published in his *Homes for the People,*[85] but its site, its incorporation of Portland (Connecticut) brownstone for the principal elevations and richly carved exterior ornament, and its extraordinary and extraordinarily well-preserved interiors make it one of the showcases of American domestic architecture. For the latter it would seem that Austin can take little credit except for the raw spaces, since Gustave Herter, a German immigrant, designed the interiors, including the

48. Henry Austin, Jonathan King (Oliver B. North) house, New Haven, Connecticut, ca. 1852.
Current state. (© Cervin Robinson, 2007)

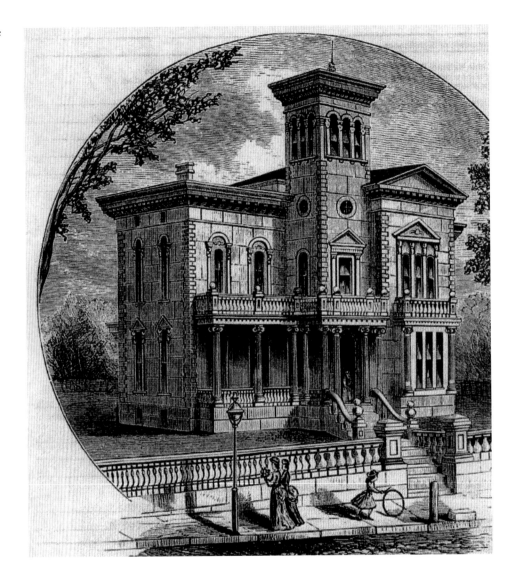

49. Henry Austin, Ruggles Sylvester Morse house (Morse-Libby house; Victoria Mansion), Portland, Maine, 1857–1860. (From William Willis, Guide Book to Portland, *1859).*

furniture of the main rooms, and Giuseppe Guidicini, an Italian immigrant, executed the trompe l'oeil wall paintings.[86] Nonetheless, this house, with its Tuscan forms, Grecian Ionic porch capitals, Second Empire parlor, Gothic library, Turkish smoking room, Pompeian bathroom, and Bedouin tent painted on the ceiling of the belvedere, comes close to summing up at one site the architect's promise to create works "in every variety of architectural style."

The originally gently sloping site on an urban street above Portland harbor was leveled to provide a platform for the house.[87] (See Figs. 49–52.) As in Wheeler's plan, and probably many another Italian villa, there is a slightly off-center stair hall leading from the vestibule to a porch alongside the one-story kitchen

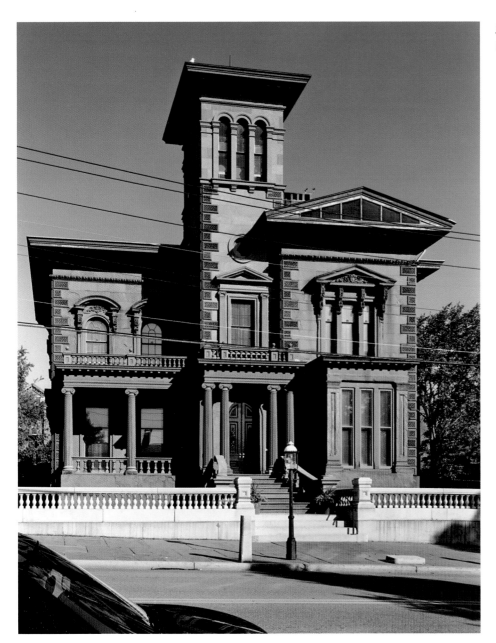

50. Austin, Morse-Libby house.
(© Cervin Robinson, 2007)

ell. To the left is a parlor with front and rear porches; to the right are a reception room, dining room, and library before the ell. The space of the hall itself rises surrounded on three floors by two balconies to a figural lay light. (See Fig. 53.) The free-standing flying stair sweeps up between newels to a decorative window at a landing, then doubles back to the second floor. There is the air of a midcentury hotel about the space. Bedrooms and a bathroom are on this floor, and the

(overleaf)
51. Austin, Morse-Libby house.
Detail of tower. (Author, 2006)

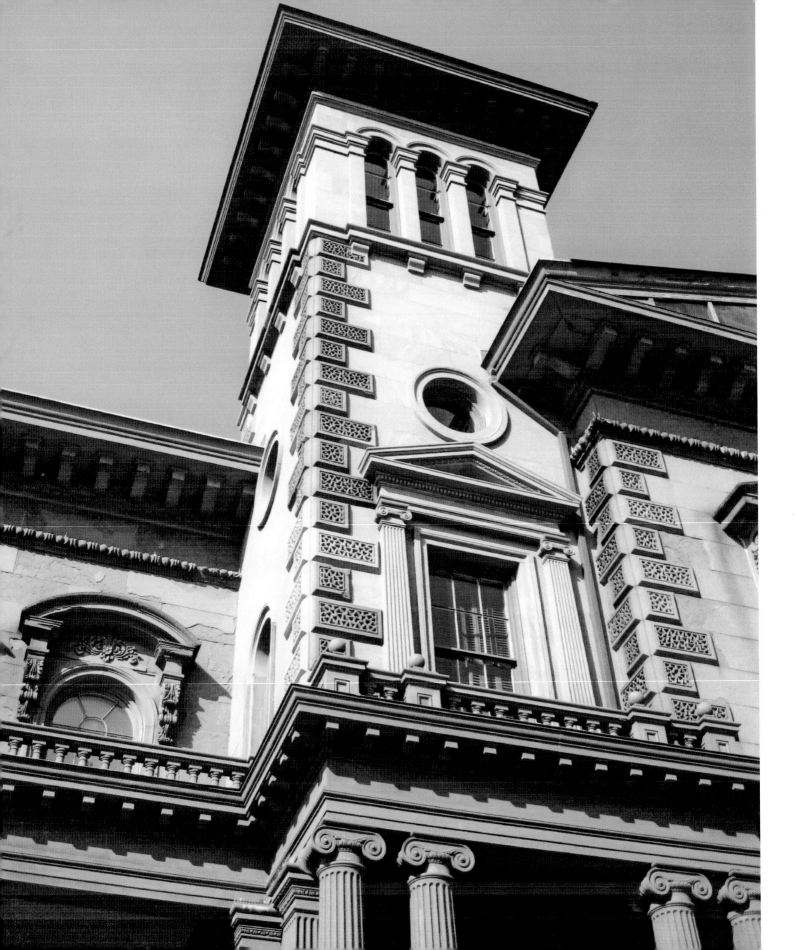

52. Austin, Morse-Libby house. First-floor plan. (Courtesy Victoria Mansion, Portland, Maine)

PANTRY

KITCHEN

BACK HALL

LIBRARY

PANTRY

PARLOR

DINING ROOM

HALL

CHAMBER

VESTIBULE

RECEPTION ROOM

Turkish smoking room occupies the space within the tower. The third floor contained a billiard room and other rooms; a winding stair at this level leads to the observatory at the top of the tower. The house sported the latest in domestic technology, including running hot and cold water, a flush toilet, and central heating.

It has been said that the composition was designed to look best from the intersection of Danforth and Park Streets, but the reuse of the similar form of the confined King house makes that seem accidental.[88] It may be that Austin never saw the site, that Morse merely bought the drawings with none in mind. The exterior composition reads from the front, right to left, as salient, tower, and porch, although the vertical thrust of the tower carries the eye away from the horizontal. The salient is capped by a triangular pediment with deep eaves sustained by many brackets. There is a triple window with a triangular pediment at the second level and a protruding window bay off the reception room. A woodcut perspective of 1859—surely made from a drawing rather than from the finished building—shows a balustrade, now missing, before the second-floor windows.[89] (See Fig. 49.) It carries across the width of the façade. The major blocks of the building are edged in vermiculated quoins of alternating length. The entrance porch is reached by steps between flared brownstone rails rising from carved foliate baskets resting on squat piers.[90] These steps parallel those Austin used at the contemporary Merchants National Bank in New Haven.[91] (See Fig. 104.) The porch entablature is supported by widely spaced pairs of fluted Grecian Ionic columns, an order like one to be found in the sixth edition of Asher Benjamin's *American Builder's Companion* (1827) and elsewhere. A Grecian detail on an Italian villa announces Austin's origins in Ithiel Town's circle and, once again, his inherent eclecticism. Above the entrance entablature on the front is a trabeated window framed by an aedicule, a bull's-eye window, and the triple round-arched arcade of the belvedere topped by the usual broad-bracketed eaves of the tower roof. The three arches were, in fact, cut out of one brownstone lintel. The Ionic order of the entrance carries over into the porch to the left as single columns;[92] above are a pair of round-arched windows capped by bold segmental hoods resting on corbels. The Morse-Libby house is in form not unlike many other Italian villas, but its commanding site in Portland, the rare use of brownstone in Italian villa design, and its amazing interiors all set it apart from similar domestic works.

Austin's first domestic commission in the state of Maine had called forth a much more modest design. All of the works discussed above represent high-style architecture, but there is at least one Austin house that flirts with vernacular tradition. Signed plans and specifications for the Moses Perkins house are in

(opposite)
53. *Austin, Morse-Libby house. Stair hall. (© Cervin Robinson, 2007)*

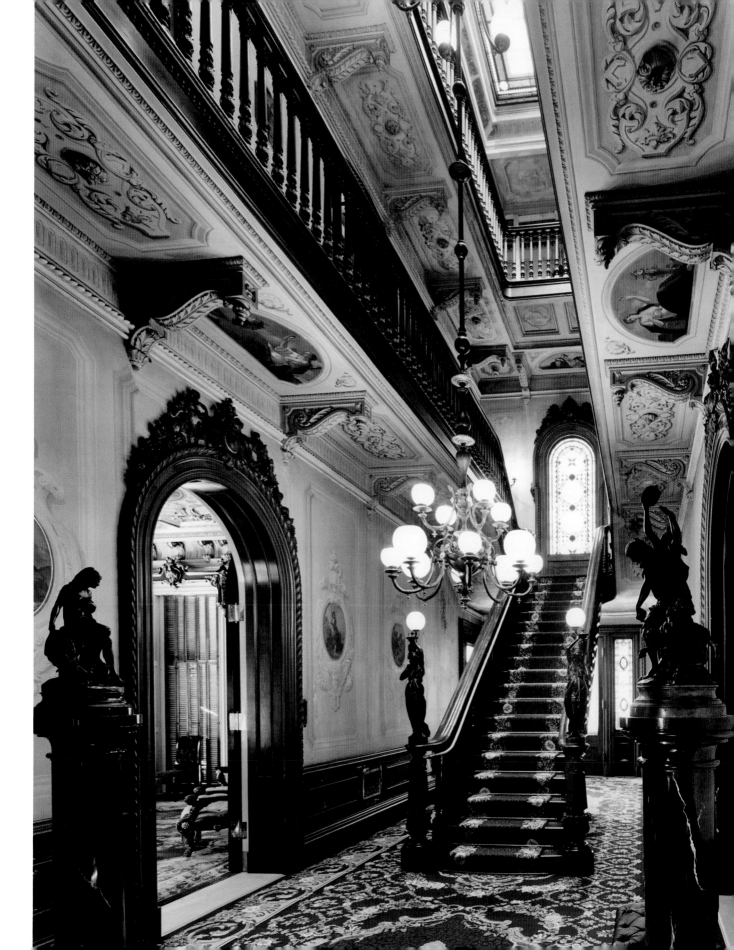

the collection of the Castine Historical Society, and the house itself sits on Court Street overlooking that town's harbor. (See Fig. 54.) It is an Italianate farmhouse with an attached carriage house, a truncated form of the continuous domestic architecture so characteristic of nineteenth-century rural Maine. It was probably erected between 1852 and 1855. It has nothing in common with any other Austin domestic work, except the chamfered posts of the entrance porch, or with Ruggles Morse's grand stone and brick pile in Portland.

At the Morse-Libby house Austin reached a pinnacle of his antebellum domestic work, but it was rivaled by another, slightly later commission. In 1859 Austin remodeled Ithiel Town's house on Hillhouse Avenue in New Haven (see Fig. 7) for Joseph E. Sheffield (1793–1882), a very successful businessman and a major benefactor of Yale University. Austin's work turned the Neo-Classical composition of the 1830s into a makeshift but nonetheless impressive Italianate villa. He added a triangular pediment to the original block, an Ionic porch, a service wing to the rear, and flankers with protruding polygonal bays to create a symmetrical Palladian five-part plan, and embraced it with towers of uneven height to produce

54. Henry Austin, Moses Perkins house, Castine, Maine, ca. 1852–1855. (Collection of the Maine Historic Preservation Commission)

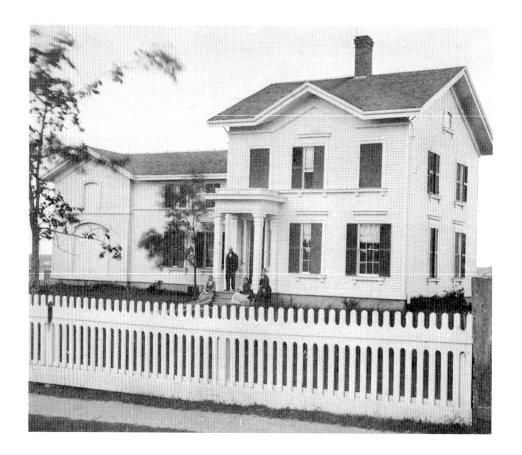

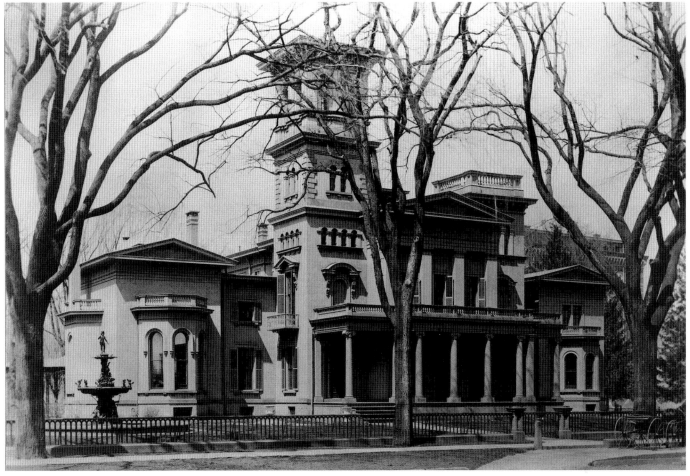

a picturesque silhouette.[93] (See Figs. 55 and 56.) The taller tower rose through five stories of pedimented and round-arched windows. At its crest was an observatory opened on each side by pairs of tall round-arched sash windows inset between broad pilasters. It was Austin's most enriched campanile. He must have been proud of the result—and of his association with a man as influential as Sheffield—for he quickly used a perspective view of the house, engraved by John William Orr of New York, in an advertisement[94] and placed a copy of it in the cornerstone of his New Haven City Hall. Since he had long been an established architect, he had not published an ad since the early 1840s.

By the advent of the Civil War, Austin had indeed designed in many architectural styles, if not all as he promised in his early ads, and he had freely mingled them as well. It is refreshing to find his latitudinarian attitude toward the materials of the past in an era of orthodox discussions of the correct use of historical

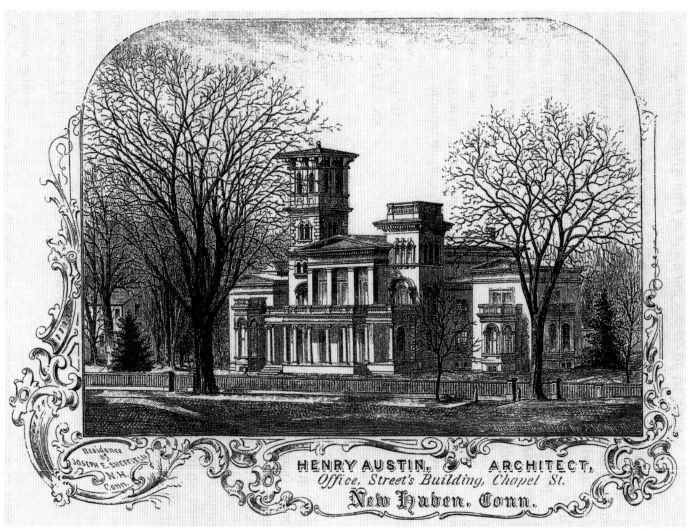

HENRY AUSTIN, ARCHITECT,
Office, Street's Building, Chapel St.
New Haven, Conn.

56. Henry Austin advertisement with view of the Sheffield house, 1860. (The New Haven Museum & Historical Society)

forms, as witnessed by the negative criticism of Robert Mills's 1845 project for the Washington Monument in the District of Columbia with its Egyptian obelisk rising out of a ring of Grecian columns.[95] But Austin seems to have willfully or of necessity stayed on the fringes of the arguments of the profession. Examples of his work can be found outside Connecticut, but the bulk of it was erected within that state, and it might be said that he designed with the freedom such a parochial environment afforded him. His ambience, his library, and his occasional contacts with more cosmopolitan architects such as Gervase Wheeler and, yes, perhaps, Henry Flockton, offered fodder for his creative agenda. After the Civil War he would continue to follow varieties of domestic style, but with some gradual falling off in personality.

3

ECCLESIASTICAL ARCHITECTURE OF THE 1840S AND 1850S

Henry Austin designed the bulk of his ecclesiastical work in the wake of the Second Great Awakening, a Protestant revival of the late 1790s to about 1830,[1] a movement that had a major impact on American society and, among other things, led to an increase in church membership. He also worked in the aftermath of the disestablishment of the Congregational Church in Connecticut. It was a period of active church building, and he received his share of new work and commissions for the remodeling of existing fabrics. In southern Connecticut he vied for such work with Sidney Mason Stone, who is often primarily—although not necessarily correctly—remembered as a church architect. It was also a period of active discussion by the various denominations of the proper style for such a building.

The sources were all English or European.[2] Within the Church of England, the reform movement in church architecture was led by the Cambridge Camden Society and the Oxford Movement from the 1830s on. In 1841 Cambridge began to publish *The Ecclesiologist*, a journal that tried to influence ecclesiastical design outside England and prescribed a style based on English Gothic precedent. Although as a Roman Catholic A. W. N. Pugin stood outside the Anglican fold, he too, in several publications such as *The True Principles of Pointed or Christian Architecture* (1841), a copy of which Austin owned by late 1845,[3] and *An Apology for the Revival of Christian Architecture* (1843), which he may have owned, argued for Early English Gothic as the proper style for religious buildings. These reformists hated— the word is not too strong—the attempts at Gothic architecture in the churches of the late eighteenth and early nineteenth centuries, which were in fact Protestant auditoriums with pulpits and galleries adorned with pointed openings and sprinkles of wooden "Gothick" crockets and finials. They championed the study, publication, and imitation of churches of the Early Middle Pointed or Decorated period, with a high nave lighted from above by clerestory windows and lower side aisles clearly separated from the nave by arcades. The nave was also to be separated from the narrower chancel by steps, screens, or other such devices. There should be no galleries. There should be a southern porch, an altar, a baptismal font, and other furniture liturgically placed. The ideal church Pugin illustrated in his *True Principles* became the model for Anglican and, in America, Episcopal parishes. Trinity Episcopal Church in New York (1839–1846) led the way. It

was designed by Richard Upjohn, an English immigrant and the leading church architect of his time.

But if Gothic was prescribed for the Episcopalians, it would not do for Congregationalists and other dissenting groups. The early and middle nineteenth century did not use past forms willy-nilly, at least in nonresidential design. It sought appropriate associations between style and building type. In a period of Romanticism and Historicism in architecture, the Congregationalists could not avoid the pull of the Middle Ages, but they opted for the pre-Gothic style, the French Romanesque and its Germanic cousin, the *Rundbogenstil*. Succinctly put, and in effect the main difference between the one and the other in this period, the Gothic arch was pointed and that of the Romanesque was a half circle, hence the German name. Among Austin's books was a grammar of the latter, Karl Moellinger's *Elemente des Rundbogenstils* (1845–1847), a catalog of details ranging from moldings to window forms that Austin added to his library five years after its publication.[4] The Round-arched Style entered American Protestant architecture at Upjohn's Church of the Pilgrims in Brooklyn of 1844–1846 and his Bowdoin College Chapel in Brunswick, Maine, of the same period.

It took Austin a little while to understand the theory that dictated the appropriate uses of ecclesiastical styles. His earliest erected churches were Gothic but hardly models of Ecclesiology, and they included a Congregational house. During the 1840s he nudged closer to English precepts for Episcopal work. By the end of the decade he had switched to the round-arch mode for the Congregationalists, at first to the *Rundbogenstil*, and then to a movement that sought a return to (or a continuation of) Federalist forms. Only in the last of these could he be called something of an innovator, and even here he was not alone. There is no record that he ever designed a church for Roman Catholics, who were in short supply before midcentury and generally reviled by their Protestant critics.

What seems to be Austin's earliest surviving ecclesiastical design stems from his Neo-Classical beginnings. Although the drawings by which we know this project for a "Circular Church" must have been executed not long before 1851, the project itself must reach back to a decade earlier. There are four plates in the larger of the two drawing books at Yale, front and side elevations, a plan, and a transverse section. The building was intended to occupy the center of an urban square; the drawing of the orthogonal front elevation shows it set awkwardly against a perspective view of its surroundings animated by staffage.[5]

The circular nave extends in plan into a rectangular chancel and an organ loft beyond the axial pulpit and is fronted by a deep hexastyle portico. The blocks of

pews, in four sections divided by three aisles, echo the curve of the walls. Rising from that plan is Austin's reworking of the ancient Pantheon in Rome, a Corinthian temple-front portico joined to a domed cylinder. It must be said, however, that it lacks any of the qualities of the original. The design has lost the spherical proportions of the Roman monument. The relationship between portico and cylinder is changed for the worse: the portico is too small and the cylinder too squat. On the interior, the dome is coffered, as is its model (but unlike its model, it was probably intended to be built of lath and plaster); on the exterior, however, it dives behind a parapet rather than developing the stabilizing stepped rings one finds in Rome; the sides of the cylinder are opened with large round-arched windows encased in bulky, sculpted frames typical of Austin's later work; the ancient oculus at the summit of the dome has become a low lantern with a broad cap; and the architect has obviously looked at some engraving of his model (that by Piranesi is perhaps the best known) that showed Gianlorenzo Bernini's "ass's ears," the twin towers flanking the pediment that in this form defaced the building from the 1660s until about the time of Austin's death. Bernini's were low kiosks, but Austin elevated them to tall ecclesiastical towers.[6]

The use of such a model for ecclesiastical—and other—buildings was rather common from the Renaissance to the early nineteenth century, when circular churches were erected with some frequency in the United States.[7] Several were designed by Benjamin Henry Latrobe, Robert Mills, and William Strickland in Philadelphia and elsewhere in the East—for example, Mills's Baptist Church in Baltimore of 1816—but as an ecclesiastical type, it seems rare in the work of the Grecian Revivalists in Ithiel Town's circle.[8] We have no information about the genesis of this project, so we will probably never know why Austin conceived it or why he retained it for his collection of drawings when, in the 1840s, he turned to more acceptable styles—such as the pointed- and round-arched modes—for the churches with which it is grouped in the drawing book.

Gothic St. John's Episcopal Church in Hartford appears to have been the first ecclesiastical structure erected from Austin's design. (See Fig. 57.) It came during the tenure of popular Thomas Church Brownell (1779–1865), bishop of Connecticut and founder of Washington (later Trinity) College. The parish laid the cornerstone in mid-July 1841 and dedicated the building in April 1842. The unknown but seemingly well-informed author of an 1843 article in *The New Englander* of New Haven wrote that "the new Episcopalian church in Hartford, and the Wadsworth Atheneum . . . show that he [Austin] was made for 'head work.'"[9] No drawings or other documentation are at hand and the building does not survive, but church

57. Henry Austin, St. John's Episcopal
Church, Hartford, Connecticut, 1841.
The original spire is missing here.
(The Connecticut Historical Society,
Hartford, Connecticut)

histories assign the design to Austin, who did indeed have an office in Hartford
at this period, as we have seen.[10] With contemporary work at the Atheneum, the
library, and the Kellogg House in Hartford, the architect was certainly in a medi-
eval, or at least picturesque, frame of mind.

Except for the polygonal brick chancel, the church was constructed to the top
of the tower of Chatham freestone; above that, as was usual at the time, the belfry

and conical spire with pinnacles were the work of carpenters. Close examination of vintage photographs suggests that the masons laid the rough-faced stone in a random ashlar pattern somewhat akin to that Austin used at the nearly contemporary library building at Yale (where the upper reaches of the exterior are also of wood). The single full-length tower-belfry-spire was centered on the gable of the body of the church, as had been the spires of the meeting houses of the previous decades. From the street it rose sharply skyward, echoed by a profusion of pointed windows (and one quatrefoil within a circle), as well as by buttresses, pinnacles, and crenellations. The spiky ensemble had the look of brittleness that characterizes so many early examples of the pre-Anglican revival in this country, more "Gothick" than Ecclesiological. It was a step beyond Town's Christ Church Cathedral, which Austin had worked on when he first came to Hartford, but not a long step.

St. John's would seem to have been too early and in too remote a location to have been influence by the Cambridge or Oxford reform movements (*The Ecclesiologist* first appeared the November after the laying of the cornerstone at Hartford), although there were touches of what the reformists wanted to see in ecclesiastical design. The style was Early Pointed. An axial entryway beneath the tower led to a narthex under the choir loft and then to the central aisle of the broad nave with galleries supported by clustered columns, and on to the narrower chancel. (See Fig. 58.) The transverse section lacked a clerestory. Four large pointed windows on each side amply lighted the large, open room, which accommodated a congregation of 850. A broad-ribbed vault punctuated by ornamental bosses spanned from side to side above galleries and pews. It was presumably composed of lath and plaster hung from the roof trusses (as suggested by the horizontal striations in the vault webs, visible in a vintage photograph, that indicate the presence of lath behind the surfaces) and visually "supported" at the walls by ornamental corbels. Above the chancel it broke into three segments. The parapets of the galleries and the wainscoting of the chancel were articulated with panels of pointed arches. The wood throughout was grained to resemble oak.

At the time of the consecration the chancel contained all the implements of High Church Anglicanism: a pulpit, a reading desk, and a cross above the altar and beneath the large, pointed window at the end of the vista. This was divided into three lancets by mullions. Flanking the altar were massive Gothic-style chairs set against high paneled wainscoting, and on each side of the chancel was a vestry room. The marble font stood at the end of the aisle beneath the left gallery. Except for the furniture and despite its Gothic Revival touches, the interior must have

58. Austin, St. John's, Hartford. Interior. (The Connecticut Historical Society, Hartford, Connecticut)

retained much of the broad openness of an eighteenth-century meeting house.[11] The building vanished long ago.

Drawings for the Congregational house at Northford cover three plates in the larger drawing book in the Austin collection at Yale.[12] There are two plans, a transverse section, and front and side elevations, the former dated 1845. (See Figs. 59 and 61.) It is one of two or three dated drawings in the collection. Austin called

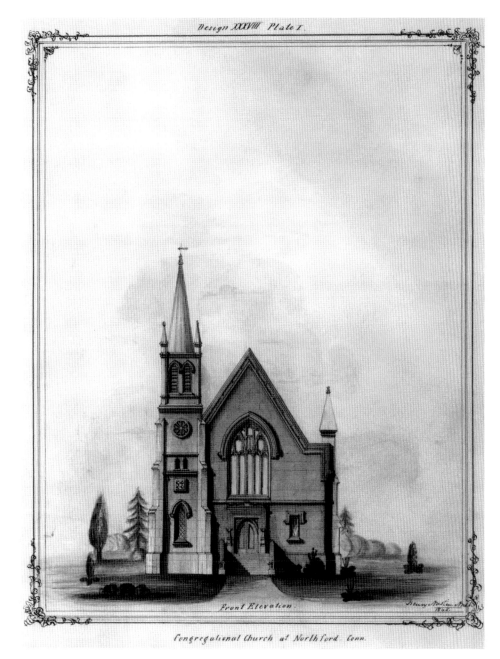

Design XXXVIII Plate I.

Henry Austin Ar.
1845.

Front Elevation.

Congregational Church at Northford. Conn.

59. Henry Austin, Congregational Church,
Northford, Connecticut, 1845. Main front.
(Austin Papers, Manuscripts and Archives,
Sterling Library, Yale University)

for builders' proposals in the New Haven *Columbian Register* on 26 July 1845. The
date 1846 on a shield within a quatrefoil appears above the ground-floor win-
dow of the existing tower (the cornerstone was laid in June of that year), but the
church was not finished for several more years.[13]

The watercolor rendering of the main front shows the church on a flat site
rather than on the hill on which it sits. Buildings in the Yale drawings are fre-

quently shown in unrealistic locations. Austin moved off center a tower-belfry-spire akin to that of St. John's, Hartford. Broad stairs lead to the pointed central entry set within a rectangular frame beneath a grand mullioned window. (See Fig. 60.) The high-peaked roof line is emphasized by a broad cornice. To the right are a trabeated window with pronounced drip molding and a buttress topped by a tall pyramid (two other buttresses are to be found at the rear corners); to the left is a three-story tower with diagonal, staged buttresses, a belfry, and a spire surrounded by pinnacles. The asymmetrical, major-minor tower

60. Austin, Congregational Church, Northford. Main front. (© Cervin Robinson, 2007)

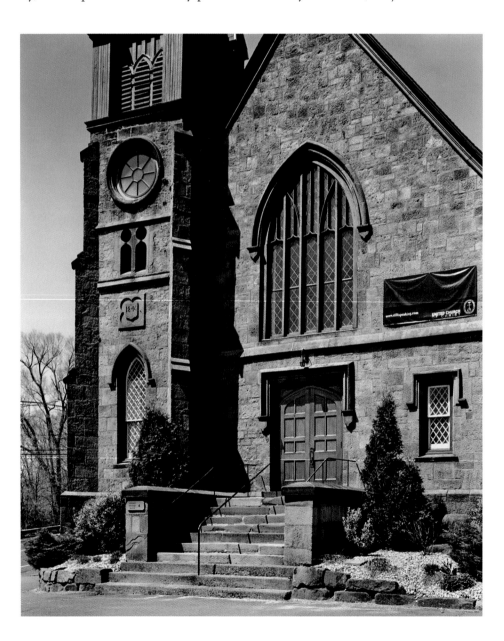

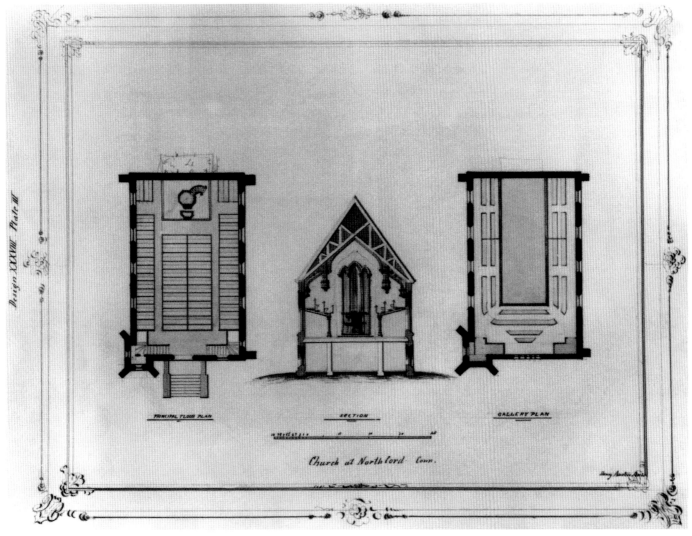

61. Austin, Congregational Church, Northford. Section and plans. (Austin Papers, Manuscripts and Archives, Sterling Library, Yale University)

silhouette will reappear in more pronounced form in some of Austin's subsequent churches.

Except for the wooden belfry and spire, the exterior of the building was executed in Portland brownstone laid in horizontal ashlar. What is left today, however, is a battered remnant of the original church. The spire is missing. The external walls were rebuilt at least twice (in 1863 and 1873), and the whole structure was reworked after a major fire in 1906 gutted the interior. The drawings at Yale show a rectangular plan with a corner tower, three-sided gallery, and axial pulpit. (See Fig. 61.) (There is a penciled addition of a shallow recess in the wall behind the pulpit, but no such feature exists.) Four windows on each side light the room. The transverse

section at Yale depicts the church raised on a basement, with a steep roof upheld by scissors trusses.[14] Polygonal piers support a gallery. The interior is toped by overhead trusses with arched braces that terminate in large pendants. A triple lancet, like that at St. John's, rises in the wall behind the pulpit, the central arch of which, slightly wider and taller than the side arches, is shown as a narrow window.

There has recently come to light a large one-point, ink-line perspective of the original interior (see Fig. 62).[15] A maker's mark in the paper dates the drawing to about 1900. Since Northford-born Clara Eliza Smith (1865–1943) taught mathematics and drawing at the State Normal School in Bloomsberg, Pennsylvania, from 1889 to 1897, it seems reasonable to attribute it to her.[16] Whether it pre- or postdates the fire has yet to be determined. Better than the small section, with which it generally agrees except for the design of the pulpit, the trusses, and some other details, it shows the interior as built from the point of view of the gallery over the entrance. Clearly depicted are the pews (in three sections divided by two aisles), the galleries, and globes flanking the pulpit and arrayed along the bottom of the gallery parapets. The globes are not present in the Yale section and were no doubt added later to accommodate gas lighting. The pulpit itself, embossed with pointed and quatrefoil panels, stands before the rear wall decorated with a trio of tall, pointed, windowless lancets framing a decorated field, probably indicating stenciling. As we shall see, such decorative patterning once marked the interiors of some of Austin's other ecclesiastical work. The central window shown behind the pulpit on the Yale section is not repeated here.

The perspective also details a hammer beam ceiling and arched braces, as well as the large pendants suspended from those arches. As we have seen, in October 1845—close to the origin of this commission—Austin bought a copy of A. W. Pugin's *The True Principles of Pointed or Christian Architecture* (1841). Plate VI of that publication shows a hammer beam roof related to, but of course more elaborate than, the design for Northford. There may have been other sources too. The pendants are variants of the fifteenth-century ones found, for example, in the (stone) Norman choir vaults of Oxford Cathedral or the Divinity School in the same place. (Jandl remarked that Northford came as close to the Norman Revival as Austin ever got.[17]) These precedents had been used already by members of the Town circle such as A. J. Davis and James Dakin, who certainly worked from engraved views in their (or Ithiel Town's) possession, but none had used the pendants so boldly as here.[18] Nor had Upjohn at the contemporary First Parish Church in Brunswick, Maine (1845–1846), although there the rich display of the carpenters' virtuosity is more impressive.

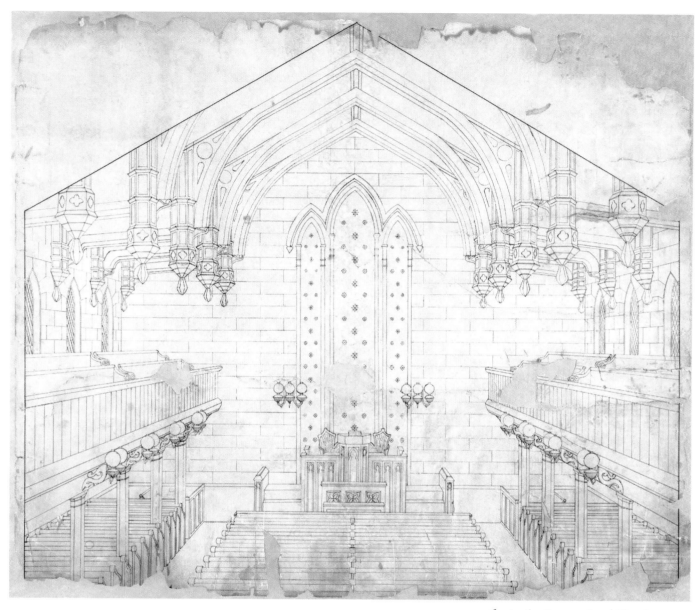

62. *Austin, Congregational Church, Northford. Perspective of the interior attributed to Clara Eliza Smith, ca. 1900. (The New Haven Museum & Historical Society)*

By the mid-1840s, then, Austin had turned out at least two Gothic Revival churches, one Episcopal and the other Congregational. News of the appropriate architectural expression of these different denominations had apparently not yet reached the New Haven office. But the *avviso* was on the way.

For the larger St. John's Episcopal Church in Waterbury, Austin produced a variation on his two previous ecclesiastical designs. (See Fig. 63.) This, like many other ecclesiastical structures of the period, proved a fragile thing. The

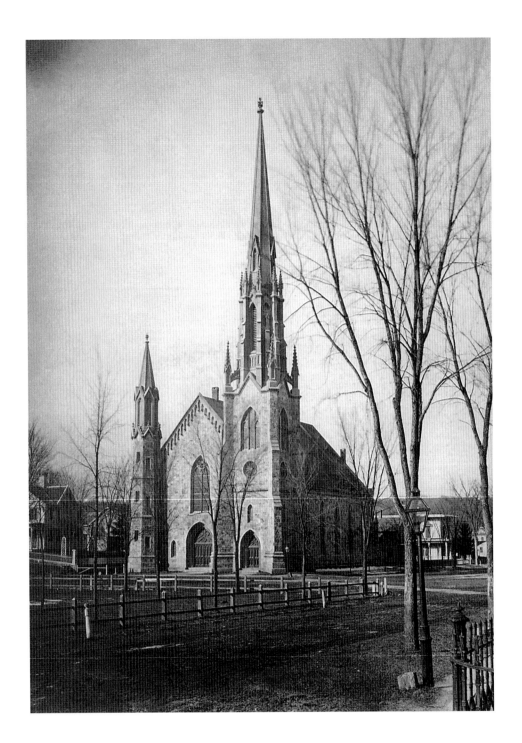

63. Henry Austin, St. John's Episcopal Church, Waterbury, Connecticut, 1846–1848. (Courtesy St. John's Church)

congregation laid the cornerstone in June 1846 and consecrated the building in January 1848; in 1857 high winds in a snowstorm toppled the steeple, which damaged the south tower in its fall. The church was gutted by fire in 1868 and replaced in 1873 with a building designed by Henry C. Dudley of New York. Austin's church is represented in the smaller of his books of drawings at Yale only in a watercolor front elevation. A contemporary woodcut perspective published in the local newspaper depicted the church and that was copied for national viewing, as usual without mentioning the architect, in *Godey's Lady's Book* in 1848.[19] The dedicatory description suggests that Austin had begun to catch up with the English Gothicists, for it says that "the style of architecture adopted is intended to be purely Gothic, and is copied from drawings obtained from the antique Sacred Temples of the Middle Ages."[20] It concludes by noting that the "design was drawn by Henry Austin, Esq., a justly distinguished Architect of New Haven, and under whose general superintendence, the edifice has been completed."[21]

As usual the copying pertains to details, not to the structure as a whole. On the front of St. John's, we find for the first time in Austin's known ecclesiological work pronounced major and minor towers flanking the entrance. The dedicatory description of the front, recalling the central placement of the towers of churches of previous years, calls the arrangement "still somewhat unusual" in contemporary work. The "massive" walls were of local granite "laid unhewn, presenting to the eye a stately pile as immutable and endurable as time itself." (Not quite. As we have seen, fire destroyed the building after just twenty years.) Staged diagonal buttresses braced the main, square bell tower, on the right, which rose in stages to the wooden octagonal belfry and spire topped out at 186 feet. Small flying buttresses sprang from pinnacles above the tower buttresses.[22] All openings were pointed except for a tondo in the main tower and the rectangular staggered openings of the octagonal stair tower on the left. These spiraled upward to reflect the turning ascent within. A corbel table of pointed arches beneath the eaves edged the broad gable.

In the interior, entered through a "massive oaken archway," "awe and solemnity" struck the auditor. "The associations of past ages rise up in review before him, and as the eye wanders over this heavy, substantial and venerated model of antiquity, subdued by the improved arts of modern refinement—an idea of its grandeur and peculiar adaptation of style for Temple architecture, strikes the spectator with sensations of awe and admiration." Nostalgia tempered by progressivism: this is a contemporary view of the Gothic Revival. There was a narthex, then a rectangular hall with an organ loft over the entrance and galleries.

A broad arch spanned fifty feet above the auditors in "slips" divided by central and side aisles. This vault was "relieved by bold spandrels springing from the centre, and terminated by pendants descending between the heads of the side windows." I am not certain what the author intended to describe, but this sounds as if the interior, overhead, might have resembled that at Northford. In the organ loft stood a case "of faultless construction, as a specimen of Gothic workmanship" thirty-six feet high and twenty broad. A heavy Gothic Revival railing (like all the interior woodwork, it was black walnut) enclosed the raised chancel "separated from the rear wall by a [rood?] screen extending across the whole width of the nave, reaching to the height of the galleries." Within the railing the communion table occupied the center, with the reading desk to the right and the pulpit to the left. The center of the large window above the table bore a painting on glass of St. John by "Hamilton of New York," a work the design and execution of which "have excited the admiration both of judges of the art, as well as those of less pretensions." A library and vestry rooms flanked the chancel, an arrangement we have seen in Austin's church in Hartford. Each was accessible from the church or an adjoining chapel. The breathless prose of the contemporary description I have quoted captures something of the excitement caused by the first appearance in Waterbury of the ecclesiastical Gothic Revival.

The reference in the dedicatory description to a style "purely Gothic" copied from drawings after "antique Sacred Temples of the Middle Ages," as well as the separation of the chancel from the nave and the array of furniture placed therein, strongly suggests, despite the fact that Austin had apparently followed no prescribed model and retained the hall form rather than the basilica with nave and side aisles, that somewhere along the line he—or his clients, the rector, Rev. J. L. Clark, or Bishop Brownell—had encountered Ecclesiological ideology. Or was it the presence in his office of Henry Flockton that influenced his thinking (the church was designed slightly before Gervase Wheeler reached New Haven)?[23] And perhaps by this time it had also dawned on Austin that Gothic was peculiarly adopted for Episcopal work, so he had better follow a different path when working for others.

The unbalanced towers of St. John's, Waterbury, echoed those of Richard Upjohn's Church of the Pilgrims in Brooklyn, but more importantly, Upjohn introduced the Round-arched Style there, and after the middle of the decade Austin adopted it as appropriate for non-Episcopal ecclesiastical work. For the Third Presbyterian Church in Trenton, New Jersey, a new congregation that commissioned a building in September 1849, he centered a straight, full-length tower on

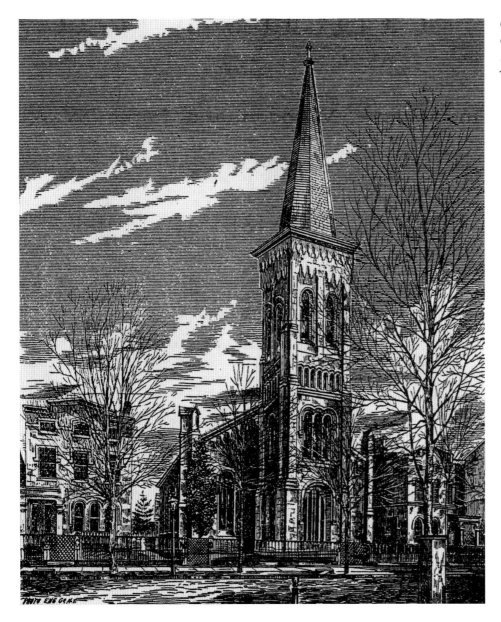

64. Henry Austin, Third Presbyterian Church, Trenton, New Jersey, 1849. (From Illustrated Manual of the Third Presbyterian Church, 1879)

the gabled rectangle of the nave and used half-circular window heads throughout.[24] (See Fig. 64.) Fire destroyed this stone church too, in 1879, but old views, and photographs taken after the flames subsided, show a building with an axial, three-stage tower capped by an octagonal spire without pinnacles and articulated with Romanesque details. Austin's favorite roof structure, scissors trusses, spanned the hall-like auditorium, leaving the underside of the trusses to form a shallow gable as the ceiling. Fronting the organ loft was a pair of columns

65. Austin, Third Presbyterian Church, Trenton. Interior after the fire. (Trentoniana Collection, Trenton Free Public Library)

supporting round, stilted arches, the central arch taller and wider than those to the side. (See Fig. 65.) A variation of this would reappear in the church at Portland, Connecticut. The Third Presbyterian Church was rebuilt somewhat altered after the fire and demolished in 1985.[25]

All the churches discussed above, except St. John's, Hartford, were built—or intended to be built—of stone or brick and experienced major fires. In the late 1840s, Austin began a series of wooden churches for small towns in southern Connecticut; ironically enough, several remain standing, although not without changes. The drawings for three of these churches at Yale show that he intended

them to be built faced with stone or with stucco scored to resemble dressed ashlar. They also show that he intended to use the Round-arched Style for the trio. As with the buildings already surveyed, the bodies of these churches all retain the form of the eighteenth-century meeting house.

The extent to which traditional New England ecclesiastical forms lingered in Austin's churches of the late 1840s and 1850s, even those with pointed openings, can be judged by a remark made by a man who was briefly associated with Austin and who said that he knew firsthand the Gothic Revival in England. As a recent immigrant, Gervase Wheeler declared to an American prospective client that he had worked with Pugin and the Ecclesiologist R. C. Carpenter, a man Henry-Russell Hitchcock said "came as close as anyone to being the Anglican Pugin."[26] Carpenter was indeed a friend of Pugin and an early member of the Cambridge Camden Society, and—again according to Hitchcock—his St. Stephen's, at Selly Park Road in Birmingham, was "perhaps the most 'correct' example of 14th-century English parish church model being built in 1841 by any architect other than Pugin." If we take Wheeler at his word—and there is some confusion about this[27]—he brought to the United States fresh knowledge of the English Gothic Revival.

Wheeler came to the United States in 1847, when he was apparently in his early twenties. By August of that year he had formed a loose association with Austin, who was then forty-three, one that seems to have lasted for a year or so.[28] In September 1848 Wheeler wrote a letter from New Haven, and presumably from Austin's office, to Rev. Leonard Woods, president of Bowdoin College in Maine. "We are very full of business in the office," he wrote, "but I am sorry to say no churches excepting one here nearly finished & of a character that I am glad to have escaped any connection with."[29] He does not specify the church, although St. John's, Waterbury, is closest in time, but any of Austin's latitudinarian Gothic Revival works would have earned the scorn of a man who said he had been taught by Carpenter, a designer Hitchcock further characterized as "one of those single-track perfectionists who took the doctrine of an architectural revolution quite literally."[30] Wheeler had been recently employed to decorate the round-arched Bowdoin College Chapel.[31] He might have passed on to Austin the news of Upjohn's stylistic innovation there, and may even have recommended it to him as an alternative to what Wheeler saw as the inadequate Gothic work than came out of Austin's office. Austin acquired Moellinger's *Elemente des Rundbogenstils* shortly after Wheeler left New Haven.[32]

The first of this new breed of churches, for the Congregationalists of Kent in

northwestern Connecticut, came out of the office a year after the date of Wheeler's letter. Austin received the commission in August 1849—a month before his commission for the Presbyterian church in Trenton, for which, as we have seen, he employed the Round-arched Style—and the dedication took place in 1850. The architect's office recorded the design in the larger of the drawing books in four sheets containing front and side elevations, plans of the main and gallery levels, and a transverse section.[33] The drawings show a church completely articulated in the Round-arched Style but, as Meeks pointed out long ago, since trabeated windows topped by heavy drip moldings now light the building, the uninformed congregation must have shied away from what probably appeared as an unwarranted a stylistic association as the Gothic would have been. Or perhaps a local builder convinced the flock that flat headers would be easier to build and thus less expensive. As erected, the church retained only its token semicircular window over the entrance. (See Figs. 66 and 67.) Round-arched architecture might go unquestioned in Trenton, but in this small Connecticut town Austin met some opposition, even among Congregationalists, as he tried to move in a new stylistic direction.

At Kent, Austin reverted to the unbalanced vertical accents he had used for the Episcopalians of Waterbury. The plan is a simple rectangle with the footprint of a square stair tower added to the right front corner and that of a second, smaller tower to the left. The section shows an open hall with Austin's usual scissors trusses supporting the roof. Five windows on each side light the room. In the drafted elevation those windows show as *bifore* beneath overarching half circles. In the building itself they are covered with lintels and chunky moldings. The front elevation presents a high-peaked gable with a round-arched corbel table between the towers. That to the right rises through a two-stage buttressed tower, belfry, and octagonal spire originally but no longer surrounded by pinnacles (and capped in the drawing with a weather vane rather than a cross[34]). That to the left shifts from a square in plan to an octagon as it rises through several stages to a swooping pointed roof.

The geometry of the church as it stands follows the drawings except for the trabeated windows, but there are many other alterations. Austin seems to have designed for stone or stucco scored to look like horizontal dressed ashlar, but the exterior surface is now flush horizontal boards that Austin used elsewhere and that appear to be original. The building has been painted white outside and in, a victim of later English Colonial Revival taste, but it was probably intended to be a hue imitating stone outside, and remaining patches of stenciling attest to a richly

66. Henry Austin,
First Congregational Church,
Kent, Connecticut, 1849.
Exterior as currently painted.
(© Cervin Robinson, 2007)

colored decoration within.[35] (See Fig. 68.) Old photographs also show that murals were at one time present on areas of the walls.[36] (In 1847 Austin had been hired to direct the decoration of the interior of Town's Trinity Episcopal Church in New Haven. The major item listed on the expense account is "frescoing."[37]) In the text accompanying Austin's Design III in *The Book of Plans*, discussed below, the editors state clearly that "We need hardly to suggest that the predominant color of a

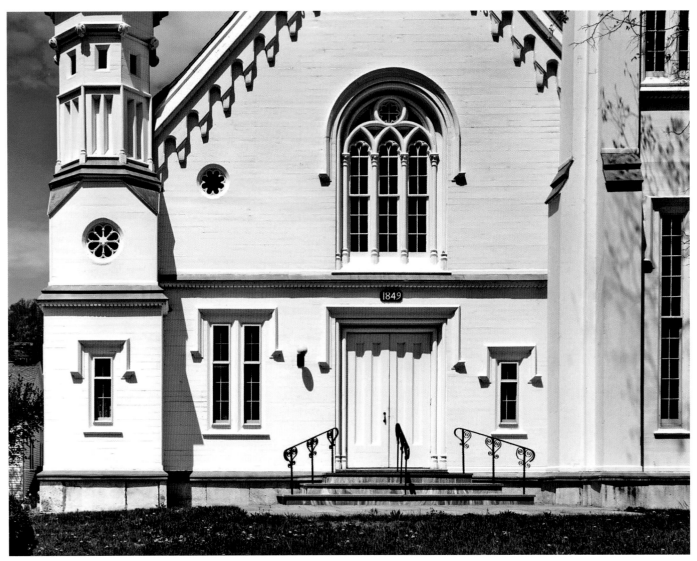

67. *Austin, Congregational Church, Kent. Detail of front as currently painted.* (© *Cervin Robinson, 2007)*

[church] building like this, should be some neutral tint, some of the many shades of drab or grey. To paint it white would be well nigh to ruin its proper effect." The sectional drawing calls for a pulpit that resembles what survives in the church. (See Fig. 69.) The details of this, with half-round stilted arches, seem to echo Austin's other use of the distinctive form, most notably in the interior of his contemporary church in Trenton and one of the towers of the New Haven Railroad Station. The pulpit, too, has been slathered with white paint. Other than its unfortunate color, the church is well maintained by its proud congregation.

The Congregational churches at Plainville and Portland, Connecticut, followed that at Kent. Designs for both are preserved in the larger of the drawing books

at Yale.[38] At Plainville, the congregation allocated money for the erection of the meeting house in October 1849 and dedicated the place a year later, although it was not heated until the following year. It is recorded in the drawing book in three sheets: the façade, the side elevation, and a transverse section.[39]

The existing church follows the drawings closely (except for later additions). Here again the architect—or his clients—pulled punches. Stylistically, Plainville is a hybrid in which Austin used half-round arches for the main entrance and flanking windows on the ground floor, but switched to pointed ones for the upper openings of the façade and tower and for the windows along the flanks. (See Fig. 70.) The combination reeks of stylistic indecision on the part of the congregation, the architect, or both. The high gable roof is supported by the usual scissors trusses; its eave line at the top of the façade sports brackets rather than a corbel table. There are token buttresses, one angled at the corner of the tower, two tacked on to the opposite corner of the façade. The single full-length tower, asymmetrically placed to the left of the entrance, supports a spire with dormers but no pinnacles. It still bears the clock face within a diamond-shaped frame shown on the drawing. No surfacing material is indicated; the church is now clapboarded. (See Fig. 71.)

At Portland, Austin finally achieved a fully round-arched midcentury Connecticut meeting house. The congregation voted money for construction in November 1849, and as with the previous two churches, the dedication took place a year later. The four sheets of drawings consist of the façade, side elevation, transverse

69. *Austin, Congregational Church, Kent.*
Pulpit as currently painted. (Author, 2006)

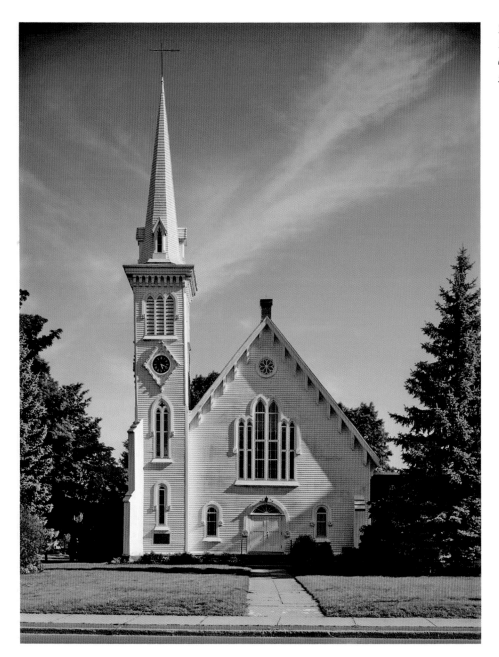

70. Henry Austin, Congregational Church, Plainville, Connecticut, 1850. Exterior as currently painted. (© Cervin Robinson, 2007)

*71. Austin, Congregational Church,
Plainville. Detail of the exterior.
(© Cervin Robinson, 2007)*

sections, and plans.[40] (See Figs. 72 and 73.) They show a variation on the design
of the church at Kent: unbalanced towers flanking a high-gabled hall, the win-
dows round-arched throughout. (The differing widths of the towers caused the
entrance and window above to fall off-center with the gable in the drawing. That
this was corrected in the building suggests either that the drawing was made
before construction or that the draftsman got it wrong.) The principal tower rises
in two stages to the belfry, on which stands the spire with a dormer and pinna-
cles. No material is indicated for the exterior; it is now clapboard. The side eleva-
tion shows six round-arched windows lighting the interior. Plans reveal an organ

Design XXXIV. Plate I.

FRONT ELEVATION.

Church at Portland Conn.

72. Henry Austin, Congregational Church,
Portland, Connecticut. Main front.
(Austin Papers, Manuscripts and Archives,
Sterling Library, Yale University)

CHURCH at PORTLAND.

Design XXVI · Plate IV.

GALLERY

PULPIT

SCALE 10 to one inch

HENRY AUSTIN Architect.

73. Austin, Congregational Church, Portland. Sections. (Austin Papers, Manuscripts and Archives, Sterling Library, Yale University)

loft over the entrance and a polygonal apse containing the pulpit. The section shows the usual scissors trusses over the hall.

Vintage photographs prove that the church was erected according to Austin's drawings, but the present building is sorely compromised. The minor tower was removed after 1945, when the spire and belfry disappeared from the taller one (now replaced by a lower extension), an addition was added to the rear in 1955, the interior was resurfaced, and English Colonial Revival white paint was spread around with abandon. The interior retains only the low gable-shaped ceiling generated by the underside of the scissors trusses and the tripartite round-arched frame for the apse. Here the oversized pendants of the kind we know in Austin's

work from the church at Northford, which appear in older photographs, are now missing.

Austin's next series of ecclesiastical projects, also intended for Congregational houses, was designed jointly with his young assistant, David Russell Brown,[41] and distributed through publication. They appeared as colored lithographs in 1853 in *A Book of Plans for Churches & Parsonages* sponsored by a general convention of Congregational churches.[42] The Austin and Brown designs joined copies of drawings by other architects including Richard Upjohn, James Renwick, Jr., Gervase Wheeler, Joseph C. Wells. Henry W. Cleaveland, and Sidney Mason Stone. Austin and Brown, who are credited with four designs, more than most of the others, were in heady company with Upjohn and Renwick.[43] These were New Yorkers with national reputations. The men represented in the book had, according to the text, "manifested a praiseworthy interest in our work, and several of them have taken pains, in the midst of pressing engagements, to possess themselves of our views and to prepare plans calculated to help our purpose."[44] The designs presented by these fellow travelers ranged from the humblest house of worship to the most elegant. It has never been noted that anyone ever erected one of the Austin and Brown churches.

The intention of the committee was to provide plans, specifications, and estimates promoting "convenience, economy, and good taste" to congregations contemplating the erection of frontier churches. It has been said that the book was the Congregationalists' answer to the Ecclesiologists' Gothic, that it endorsed the Round-arched Style (the Romanesque or *Rundbogenstil*). The longest section of the text does indeed concern "Style," but the discussion is latitudinarian, and while it seems to favor the round arch, it does so for reasons of topography rather than religion: "A true Gothic structure would be inappropriate on a wide level prairie, as a Grecian Doric would be in the wildest and most abrupt regions of New England. [The writer had obviously never visited the sites of many Gothic cathedrals in France or some ancient temples of the Mediterranean.] The modifications of these styles, however, known as the Rural English, and the Norman or Romanesque, are adapted to a great diversity of situations, and they are, almost any of them, a great improvement upon the miniature temples and cathedrals which have been so much in vogue in our country for years past." Other than a passing slap at Roman Catholicism as the "Mother of Harlots" (in reference to the use of the cross), there is no sign in this section of an attack on other denominations, stylistic or otherwise. A balance also prevails in the projects themselves. Several take the form of what is often called "carpenter Gothic," with vertical

board and batten exteriors. Both Upjohn and Renwick showed Gothic Revival projects, although Upjohn's Romanesque Design XVI was something that Austin must particularly have noticed, as we shall see. Sidney Mason Stone's entries are clearly labeled Romanesque.

The drawings from Austin's office published in *A Book of Plans*, although copied as lithographs, not surprisingly recall those in the unpublished drawing books at Yale. There is, however, no duplication between the two. In the later publication there are usually front and side elevations, a plan, and a cross section. The designs differ very little from those of most other contributors; the first two build upon Austin's works at Kent, Plainville, and Portland. Design II, given to Austin and Brown in the Contents but signed in the lithograph by Austin alone, is a spare gabled rectangle of clapboards with a slender tower, belfry, and spire without pinnacles placed in the center of the façade intended, as the text makes clear, for rural parishes. (See Fig. 74.) In plan the axis from the porch leads to a vestibule beneath the tower into the hall beneath the "singers' gallery," down the central aisle to the table and pulpit. The room is covered by a flat ceiling hung from the trusses. Four nine-over-nine light trabeated windows range down either side.

Design III, also signed by Austin alone despite the joint authorship given in the Contents, was, according to the text, conceived for a corner site, or at least one approached diagonally. (See Fig. 75.) The schema is again that of a gabled rectangle. The lean tower-belfry-spire with minor pinnacles is shifted to the corner of the façade, the tower ornamented by an oculus window set within a diamond frame (*alla* Plainville). Ornament is more profuse here than in the previous design. "Care should be taken to make all the mouldings sufficiently heavy and bold, otherwise there will be the danger of a cheap and bald look." (The text appears to have been written by the committee, but this conforms to Austin's detailing.) Although drawn for wood, brick or stone would be preferable. Openings are round-arched within frames topped with lintels or triangular pediments. Two lateral aisles make a central passage unnecessary. The plan shows a study added beyond the pulpit, but this does not appear in the side elevation. Inside exposed trusses with pendants (*alla* Northford) support the roof hung from a king post truss.

Design VII, signed by both Austin and Brown, seems to be their version of the small church published in *Upjohn's Rural Architecture* of 1852. (See Fig. 76.) "It is a plain, simple building adapted to almost any rural location, and . . . within the means of the least affluent parish." The rectangular plan provides a central aisle

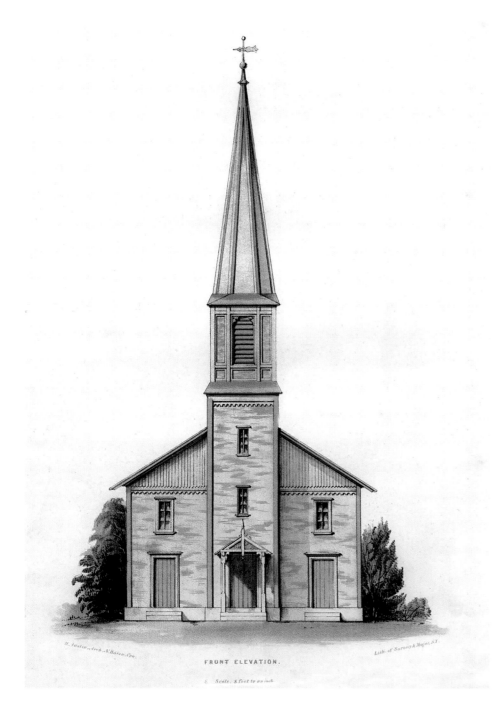

FRONT ELEVATION.

Scale. 8 feet to an inch

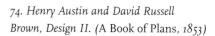

74. Henry Austin and David Russell Brown, Design II. (A Book of Plans, 1853)

75. Austin and Brown, Design III.
(A Book of Plans, *1853*)

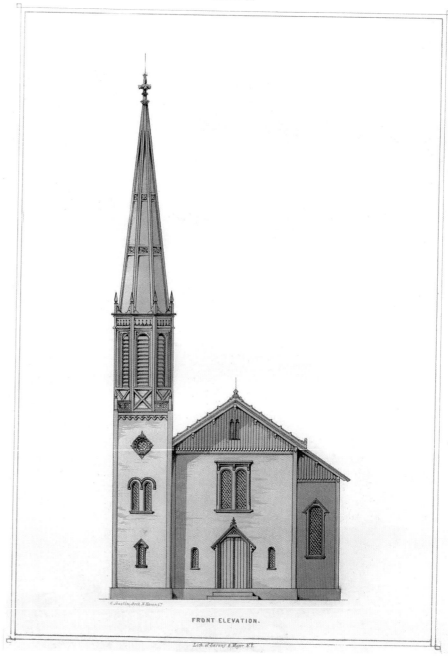

FRONT ELEVATION.

76. *Austin and Brown, Design VII.*
(A Book of Plans, 1853).

but no side aisles; the room is covered with a flat ceiling. The perspective drawing—the only one among the Austin and Brown plates—shows a gabled box of wood with trabeated openings, bracketed eaves, bell cote, and entrance porch. The exterior finish was intended to be clapboards set within exposed frames.

The final Austin and Brown design (XIII), so attributed on the lithograph, the one often reproduced by recent scholars, is the most elaborate and, despite its round-arched openings, rises to a Gothic silhouette, as if seeking a compromise between Episcopalian and Congregationalist desires.[45] (See Fig. 77.) Like Renwick's Design XVIII, it exemplified what the architectural historian Henry-Russell Hitchcock once called "round-arched Gothic." Although it might be built of wood, brick would be better and stone best, according to the text. Its five-stage, free-standing tower-belfry-spire stands asymmetrically detached to the right of a façade that is emphatically divided into a tall central bay edged by piers topped by tall pinnacles flanked by lower and narrower bays as if to suggest a nave and side aisles within.[46] The plan is unusual. (See Fig. 78.) Austin has placed between the façade and the "audience-room" spaces suitable for committee use, Bible study, or

77. Austin and Brown, Design XIII.
Main front. (A Book of Plans, 1853).

Austin & Brown Arch.t N. Haven.

FRONT ELEVATION.

Lith of Sarony & Major, N. York.

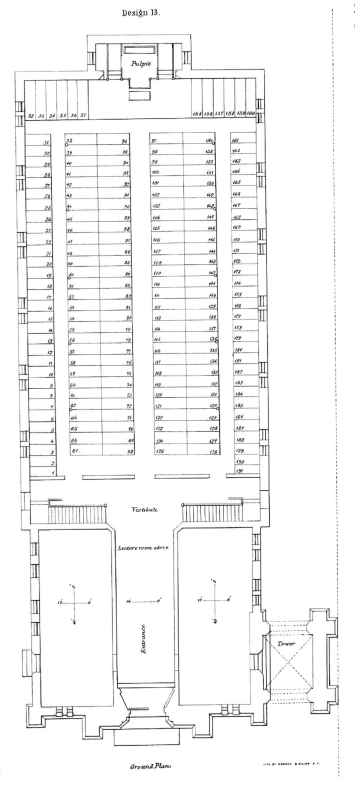

Design 13.

Pulpit

Vestibule

Lecture room above

Entrance

Tower

Ground Plan.

LITH. OF SARONY & MAJOR N.Y.

78. *Austin and Brown, Design XIII. Plan.*
(A Book of Plans, *1853*)

lectures on two levels.[47] The text makes a functionalist justification for this awkward arrangement: "it removes the audience so far from the street that no annoyance or interruption of the services will be likely to result from the passage of carriages or from other noises common to busy and populous thoroughfares."

Its contributions to the *Book of Plans* show Austin's office to have been part of the group of architects who turned out ecclesiastical work in the Northeast in the early 1850s. Although one would like to think that Brown's hand is much in evidence in these rather ordinary designs, the office was no better or worse than the competition. Another ecclesiastical work of this period was, however, more imposing.

Austin's office projected a new Methodist Episcopal church for Waterbury, Connecticut, as it was preparing the projects in the *Book of Plans*. (See Fig. 79.) In 1852 the membership acquired from William H. Scovill, who had just finished building the house Austin designed for him, "a part of his garden on East Main Street" at the corner of Phoenix Avenue, and erected thereon a brick church.[48] It stood until 1887. An article published in the *Waterbury American* at the dedication in March 1854 names Austin as architect. Benjamin Pillsbury was the resident minister.

The contrast between the Gothic St. John's Episcopal church in Waterbury, dedicated six years earlier, and the new Methodist house shows that Austin now fully understood the appropriate architectural expressions for the different denominations. He may have gotten the idea for the overall composition for St. John's from Richard Upjohn's Design XVI in the *Book of Plans*, a twin towered, round-arched church. The Methodist house was probably the most completely *Runsbogenstil* design of Austin's career, for although he was certainly interested in contemporary German work, he was not so deeply affected by it as was his Rhode Island peer, Thomas Tefft.[49] Round-arched throughout, with twin square, spireless towers flanking a high central gable, articulated with pilaster strips and corbel arcades, the brick *Westwerk* looked as though it had come from the drafting room of a provincial Heinrich Huebsch.[50] He or his assistants certainly had Moellinger's *Elemente des Rundbogenstils* at hand as they worked.[51] Within, a lecture hall occupied the ground floor, while one reached the "audience room" by stairs to the left and right of the entrance. A gallery and choir loft circled three sides of the room. In all, there was accommodation for some nine hundred worshipers. Interior woodwork was grained to resemble oak. "The tasteful style, . . . which the walls and ceiling *in fresco* impart, give a general effect pleasing to the eye, and a rich finish to the whole contour." The artist was, appropriately enough, Philip Nengel, a German-born fresco and encaustic painter who later moved to

79. Henry Austin, Methodist Episcopal Church, Waterbury, Connecticut, 1853–1854. (From The Town and City of Waterbury, 1896)

Baltimore. The *Waterbury American* thought the building "one of the handsomest, and most commodious [Methodist] houses of worship in the State."

The *Rundbogenstil* was not the only Round-arched Style Austin employed in his ecclesiastical work of the 1840s and 1850s. He also used the half-circle for its classical rather than its medieval associations. This was true as well of a group of mid-century architects that included not only Austin but also Arthur Gilman, Minard Lafever, and Sidney Mason Stone. Stone's Fourth Congregational Church in Hartford in 1850, his 1855 First Congregational Church in Naugatuck, Connecticut,

and Lafever's 1851–1852 Dutch Reformed Church in Kingston, New York, are good examples.[52] In these and a number of other works they returned to, or perhaps we might say continued (for this has the look of a survival rather than a revival), the Federal Style of the beginning of the century. In fact, in the First Methodist Church on Elm Street in New Haven, a work of 1849, Austin seems to have paid tribute to the Asher Benjamin and Ithiel Town design across the street.[53] As I have said, he was not alone in this midcentury turn to the classical past. In addition to Stone and Lafever, it led Arthur Gilman to design the Arlington Street Church in Back Bay, Boston, begun in 1859, in, as the architect himself wrote, "a return to those solid and classical principles which were characteristic of the churches of a former age."[54] We usually associate the Neo-Federal Style with the turn of the twentieth century. The breadth of this episode in the history of mid-nineteenth-century architecture seems to be little remarked outside of Connecticut.[55]

Austin could slide easily into the Federal mode because of his origins in the shadow of Town and because most of his previous churches, except for details, had never departed far from the gabled box with axial staged tower-belfry-spire that marks Protestant houses of the late eighteenth and early nineteenth centuries. What specifically steered him to design in a Neo-Federal direction when working away from the shadow of Town, however, may have been his many commissions during the 1840s and 1850s to rebuild or remodel earlier churches in Connecticut. At the First Church of Christ, Congregational, of New Haven, he lowered the pulpit and galleries and rebuilt the slips in 1842–1843. In 1847 he directed the redecoration of Trinity Episcopal Church in New Haven and renovated Grace Episcopal Church in Hamden.[56] In 1854 he proposed to do over the whole interior of the Congregational Church in North Guilford, but nothing came of that.[57] In 1855 the committee of the 1809 St. John's Episcopal Church at Warehouse Point (East Windsor) contacted Austin as a "suitable person of architectural skill to take a survey of the said Church and ascertain what can be done and the probable cost of so doing." The commission went nominally to the short-lived mid-fifties partnership of Austin and David Russell Brown. "The galleries and the old square pews were taken out [and] new long windows were put in place of the double row of short ones" at a total cost of about $6,000. The church reopened in April 1856.[58]

Another major commission of this sort was to rebuild Trinity Episcopal Church in Seymour in 1857. (See Figs. 80 and 81.) "Of the original [1797] structure," wrote the architectural historian J. Frederick Kelly, "practically nothing remained save the framework" when Austin was finished, but of course, that frame dictated

the overall profile of the rebuilding.[59] A gable-covered box with an axial, full-length tower, belfry, and spire (the area above the belfry has been rebuilt lower and simpler since Austin's day), the church's openings are round-arched except for those with segmental crowns along the lower story of the side elevations and the main doorway set within a tabernacle frame. The exterior is clapboard. At a glance the building seems to be, as the placard next to the main entrance says, a work of the late eighteenth century, but closer inspection suggests otherwise.

81. Austin, Trinity Episcopal Church, Seymour. Detail of the front as currently painted. (© Cervin Robinson, 2007)

The frames of the windows and door are telltale signs of Austin's presence, for they are bold and chunky compared to real Federal work. Kelly the antiquarian thought them "devoid of architectural interest;" for us they are the signs of Austin's hand.

On the interior the galleries are supported by an arcade on piers, their faces paneled spandrels with balustrades above. (See Fig. 82.) Kelly thought the poly-

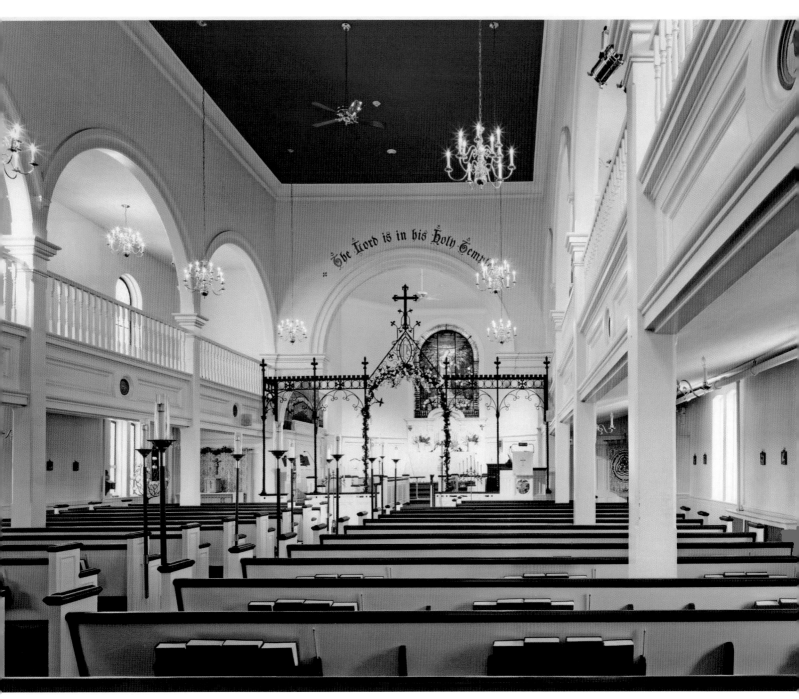

82. Austin, Trinity Episcopal Church, Seymour. Interior.

(© Cervin Robinson, 2007)

gonal chancel was an Austin addition to the original plan, but the O. H. Bailey aerial map of the town dated 1879 shows a rectangular chancel, and records indicate that it was enlarged in 1891. It is set off by an archway. Above the seating and the galleries the ceiling is flat. What Kelly saw was grained woodwork of the Victorian period and stenciled ornament on the walls. Inside and out, this meeting house too has succumbed to the English Colonial Revival taste for bleached surfaces. Here Austin drew effectively on his origins, for this may be one of his finest surviving achievements in ecclesiastical architecture.

The architect not only designed for rebuilding, he designed for building in a Federal vocabulary. His Congregational Church in Danbury, Connecticut, and Gilman's Arlington Street Church were near contemporaries: the latter followed the former by about a year. Both were in the line of descent from Christopher Wren and James Gibbs to Asher Benjamin and Ithiel Town. The Danbury church, built of wood rather than brownstone, was, however, something of a country cousin of the Boston building, which cost more, perhaps, than all of Austin's churches combined. In both cases the round-arch articulation had nothing to do with the Middle Ages; the details were Roman throughout, although, as usual, Austin's heavy touch was apparent in his work.

For the Danbury Congregationalists, who first gathered in the new church in May 1858,[60] Austin assembled a single, axial tower and spire, aedicule, blind arches, orders, and the other vocabulary of the pre-Ecclesiologist Anglo-Protestant tradition. The building disappeared long ago and is remembered, when it is at all, chiefly for the crash that occurred during the erection of its soaring spire. The first attempt ended in disaster. It was assembled on the ground, and while being raised into place it fell, destroying itself and part of the roof. On the second attempt the spire was built in place; it peaked at 220 feet.

Austin's achievement in ecclesiastical design over the two decades just surveyed shows him to have been representative of the profession. One would be hard-pressed to see him as much different in this work from his cross-town rival, Sidney Mason Stone, or from the many architects and builders who dotted the New England landscape with ecclesiastical spires in the mid-nineteenth century. He was busy during the 1840s and 1850s and he did good work, but his lasting reputation does not rest significantly on the houses of worship we have just surveyed.

Austin's career as architect of monumental and public buildings began with a bang with his proposal for an Egyptian Revival gateway at the New Haven Burial Ground (Grove Street Cemetery). (See Fig. 83.) He was thirty-five at the time, but he had apparently been in business for himself for little more than two and a half years of economic panic in the country and could have had little to show as monumental executed work. How he got the job remains a mystery, although at least two of the five members of the Proprietors' Committee, Aaron Skinner and Augustus R. Street, were later to be his clients.[1] What we do know is that in September 1839, when he was also beginning his sojourn in Hartford, the "talented architect and fellow-townsman, Mr. Henry Austin," proposed to the city a gateway "of the Egyptian order, with wings—one of which is to be occupied by the family of the sexton, and the other as a hearse-house."[2] The publication of this news contained no astonishment at the style of the project. This was part of an overall scheme to enclose the grounds originally opened in 1796, and by 1841 the sculptor Hezekiah Auger, it is believed, designed the stone wall with Egyptian battered corners that remains in place. In 1843 the mayor exhibited a revised project by Austin in which the wings were eliminated, and in 1844 the city adopted the design preserved in the collection of Austin's drawings at Yale.[3] Ultimately, however, a final and important change was made: a lintel inserted between the winged orb and the column capitals bears the inscription THE DEAD SHALL BE RAISED. (See Fig. 84.) This quotation from I Corinthians 15:52 was surely intended here as elsewhere where Egyptian forms were used in a Christian context to take the curse off the pagan style.[4] The cornerstone of the gateway was laid with appropriate ceremony in July 1845, and construction began.[5] Thompson & Strong are named as builders, the former being that Isaac Thompson who was building the library at Yale. The whole project was finished in 1848, but the illustration in Louisa Tuthill's *History of Architecture*, published that year, is based on Austin's view of the design as shown in the Yale perspective, that is, as it was before the inscribed lintel was inserted above the columns.[6] As a rule, Tuthill's illustrations of Austin's works were derived from preliminary drawings rather than finished buildings. She knew her way around his office.

The final gateway, the existing monument, is forty-eight feet wide and twenty-

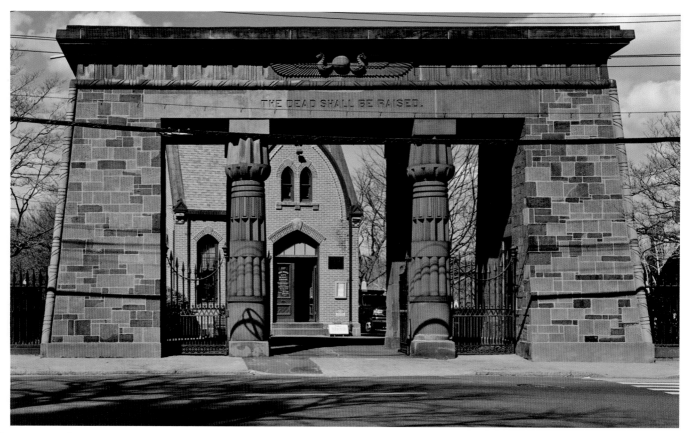

83. Henry Austin, Grove Street Cemetery
Gate, New Haven, Connecticut, 1839–1847.
(© Cervin Robinson, 2007)

five feet high. It is composed of massive battered red sandstone pylons flanking the roadway, with hefty bundled lotus bud columns toward Grove Street and plain piers toward the burial ground that divide the space between pylons into carriageway and pedestrian passages.[7] Small rooms within the pylons are closed by cast-iron doors with recessed panels. The present random ashlar surfaces of the pylons, which are in rough condition, are shown in Austin's perspective as layered ashlar, although perhaps this was intended to be scored stucco. The pylons are edged with a torus molding with incised beading and surmounted by an architrave and cavetto cornice. Above the biblical inscription, the winged orb with flanking asps is carved in relief. The gateway seems to be an anomaly in Austin's work, the one purely Egyptian design that can certainly be ascribed to his office.[8]

The Grove Street gateway is one of the canonical monuments of the Egyptian craze that swept the architecture of the West in the first half of the nineteenth century. Sources of general inspiration and specific forms for Austin's design

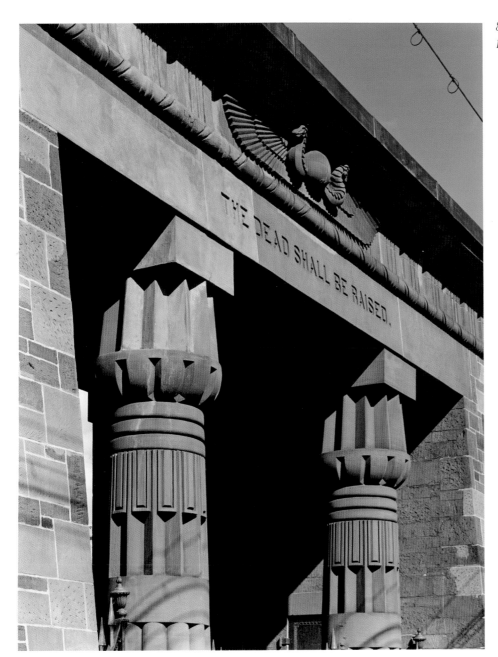

84. *Austin, Grove Street Cemetery Gate.*
Detail. (© Cervin Robinson, 2007)

are legion, although his is an original interpretation of his research. Among previous executed works in the style in this country, the most germane for Austin would seem to have been Jacob Bigelow's gateway for Mount Auburn Cemetery in Cambridge, Massachusetts, originally erected in wood in 1831 but rebuilt in granite in 1842.[9] I have seen no record of a trip to Cambridge by Austin, but he must have known this design as early as 1839, because Bigelow placed wings or lodges flanking his central gate, which is composed of piers surmounted, as at New Haven, by a lintel inscribed with a biblical quotation (there from Ecclesiastes 12:7) beneath a cavetto cornice bearing a winged orb.

Austin, as we see throughout his career, also relied heavily on published sources for inspiration. The massive report of Napoleon's Egyptian campaign of 1798, the profusely illustrated *Description de l'Egypte*, which by the second edition of 1820–1830 had reached twenty-four volumes (fourteen of plates), as well as Baron Dominique Vivant Denon's illustrated *Voyage dans la Basse et la Haute Egypte* of 1802 (immediately issued in English editions) were available in Town's library. According to James Curl, Denon became for the Egyptian Revival what James Stuart and Nicholas Revett's *Antiquities of Athens* was to the Grecian Revival: a basic reference source.[10] Such books provided for contemporary architects a vast array of suggestive visual material based on actual monuments they had not seen, and several of those architects, in turn, published their own designs inspired by the ancient mode. As I have said, Austin's historical sources were often filtered through English reworkings. John Foulston's *Public Buildings Erected in the West of England* of 1838, which I have cited as probably an important source for Austin's candelabra columns and other exotic details of domestic design, may also have provided Austin with the impetus for the final form of the gateway.[11] Battered pylons and columns *in antis* appear in Foulston's plate showing the main elevation of his 1823 Civil and Military Library in Devonport, a work he said he designed "to shew the possibility of adapting this variety of Architecture to modern and domestic purposes."[12] This was a possibility Austin explored at the Burial Ground.

Austin, we remember, was engaged in Hartford as well as New Haven in the early 1840s. On 12 January 1841 the *Hartford Courant* reported that town meeting had approved a "plan drawn by Mr. Henry Austin, Architect," for a new almshouse for the city estimated to cost $15,000. This was Hartford's second such facility, built in 1842 to replace one standing since 1822. In this instance Austin turned not to an exotic style but inexplicably drew a late Federal, pedimented pavilion with a central cupola. There is in the collection of the Connecticut Historical Society Museum a signed ink-and-wash elevation for the almshouse that shows

*85. Henry Austin, almshouse, Hartford,
Connecticut, 1842. Elevation.
(The Connecticut Historical Society,
Hartford, Connecticut)*

an eleven-bay, two-and-a-half-story façade with a three-bay central salient flanked
by doors probably intended one each for men and women. (See Fig. 85.) The axis
of the composition is marked by wider spacing between it and the flanking win-
dows of the salient, the central entrance (into the keeper's residence, presumably)
reached by a short flight of steps and set within its own flat-topped salient, a Palla-
dian window in the pediment, and the cupola topped with a weather vane. In the
context of the architect's contemporary work this is another maverick, the only
such design uncovered in preparation for this study.[13] The building was added to
the next year, and was demolished in 1889 to make way for a replacement.[14]

There is nothing in the design for the Hartford almshouse that reflects any-
thing in the contemporary Grecian work of Alexander Jackson Davis, but the
latter was much in evidence in Austin's life in these years. We also remember
that Ithiel Town wrote a letter to Davis in July 1839 introducing Austin and ask-
ing Davis to show him his drawings. Among Davis's many projects by that date
were several studies in the Egyptian style.[15] Within two months, by 21 September

1839, Austin had proposed his Egyptian Burial Ground gateway. Whether there is any connection is impossible to know, since there is no known confirmation that Davis and Austin met immediately (or ever) as a consequence of the letter or, if they did, that Davis showed Austin any drawings, but a link between these two men was forged at some time during this period, and that link, however poorly we now understand its character, is reflected in the next years in two of the most important buildings of Austin's early career bouncing in the cars between Hartford and New Haven: the Wadsworth Atheneum and the first library building for Yale College.

There has long been a problem of attribution for the designs of these coeval buildings, but it is now generally conceded that Henry Austin and Alexander Jackson Davis (in association with Ithiel Town) were probably responsible for both, and perhaps it can also be said that Austin laid out the planning and Davis drew the elevations.[16] Neither of these buildings can be usefully discussed without the other; they are fraternal twins. Both group four cultural institutions into one composition, both are medieval revival in style, and they were designed simultaneously in 1842. The Atheneum (1842–1844) was a compact multiuse packaging of Daniel Wadsworth's Gallery of Fine Arts flanked by the Young Men's Institute and the Natural History Society beneath the Connecticut Historical Society. The result was a contained block.[17] (See Fig. 86.) The Yale library (1842–1847) was erected to house the school's book collection and those of three undergraduate literary societies (Linonian, Brothers in Unity, and Calliope). The plan is an extended Palladian one composed of a central block with lateral flankers attached by links. (See Fig. 87.) The result is a broad series of semidetached units. The Athenaeum is Tudor Castellated; the Yale building, Tudor Gothic. The names of Austin and Davis are interwoven in the documents and notices relating to the design and execution of both buildings. The effect is bewildering. A definitive answer about the exact contributions of the two men is not possible given the present state of knowledge, but it is useful to review what we do know or can surmise.

Daniel Wadsworth put into motion his idea to establish a Gallery of Fine Arts in Hartford when, in December 1841, he appointed a commission to procure a design for a building. On 11 January 1842 Davis entered in his Day Book a "Design for Ithiel Town. Acad. of Fine Arts, Hartford, Ct. $10.00."[18] The editor of the *New Haven Palladium* wrote a week later, on the 17th, that he had seen in Austin's office a draft of the building, a magnificent Gothic edifice with towers and wings to cost fifteen thousand dollars. The description fits the final organization of the façade. Austin had, of course, recently returned his office to New Haven

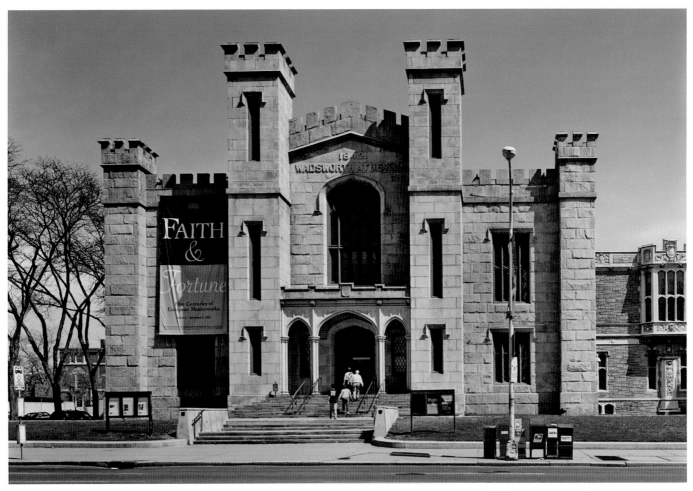

86. Henry Austin and A. J. Davis,
Wadsworth Atheneum, Hartford,
Connecticut, 1842–1844.
(© Cervin Robinson, 2007)

from Hartford, where he may have been contacted by Wadsworth. A design was submitted to Wadsworth's commission and approved on 2 February. On 1 May, Town and Davis briefly resumed their partnership. The client broke ground in April. On 21 September a visitor from Boston went to see the Atheneum, "which is now erecting from a plan of Mr. Austin, in the castellated domestic architecture of the Elizabethan age. It promises to be a splendid structure."[19] In October and November, Davis was drawing plans, elevations, and details for the building. An article in *The New Englander* in July 1843, a quarterly published in the Yale orbit, credited the building to Austin.[20] Construction continued into July 1844, when the commissioners assigned the *elevation* of the building to "Towne [*sic*] & A. J. Davis, New York." The frontispiece to Chester Hills's *The Builder's Guide*, in the revised edition with an 1845 copyright, is a perspective view of the building lithographed by the Kelloggs, for whom Austin had designed a house a few years

87. Henry Austin and A. J. Davis, library building (now Dwight Hall), Yale College, 1842–1847. (Yale Literary Magazine, December 1843)

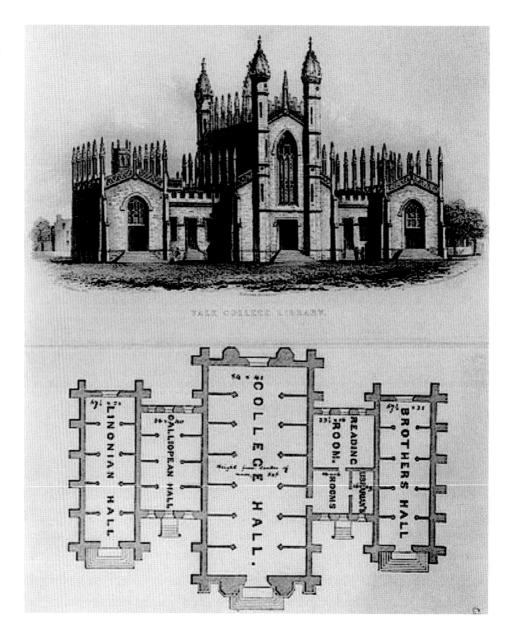

earlier, and credited to "H. Austin Archt." Finally, Tuthill's *History of Architecture* of 1848 illustrates the building and ascribes it to Austin.

If we take the commissioners' own statement of 1844, Davis designed the elevation. That leaves the plan to Austin, although that may be too neat a division. As we have seen, within weeks of the establishment of the commission and one week after Davis first logged in his design, Austin had in his office a drawing or drawings for the building. We hear nothing of a competition, however, and what

the *Palladium* editor saw seems to match the final building. Was this Davis's elevation, given to Austin to match to his plan? Or was it given to him so that he could begin to think about how to construct the building? Older observers have always wanted to divide responsibility for the Atheneum between Davis as designer and Austin as builder because of Davis's superior artistic abilities and Austin's reputed beginnings as a builder, but as we shall see, the story of the Yale library suggests the possibility of a different scenario.

Although we may never have a clear answer to this dilemma, I side with *The Builder's Guide* and Louisa Tuthill in giving Austin at least partial credit for the Atheneum. Unfortunately, the preliminary plan for the building published by Jane Davies in 1959 is missing, but it could have been Austin's based on Davis's elevation.[21] The Boston visitor who saw the building in September specifically assigned the plan to Austin. (Although laymen do use "plan" in a very general sense, this unidentified observer seems knowledgeable.) It was not unheard of in these years for one architect to draw the plan of a building and another its façades. Boston's Hammatt Billings seems to have made something of a career doing just that.[22] There is reason to believe that the same division of responsibility characterized the design of the contemporary Yale library as well. We know Austin planned the library, and like the Atheneum, it had to accommodate different institutions in one building.

The Gallery of Fine Arts occupied the center of the Atheneum, while the Connecticut Historical Society moved into the southern third with the Natural History Society on the second floor, and the Young Men's Institute and its library occupied the northern section. Davis may have chosen the Castellated style because the tripartite Hartford building had to be compact. The Atheneum required a more concentrated building mass than the Yale library because, instead of a roomy campus site, it was to stand on an urban lot hemmed in by streets to the north and west and a building lot to the south. Its three sections were nonetheless clearly marked by the blocky crenelated towers flanking the entrance portico formed of a wide Tudor archway flanked by narrower pointed arches. The rectangular mass of the whole building was framed by lower but equally crenelated towers, one at each corner. Large mullioned windows lit the interiors. The exterior material is gneiss taken from nearby Glastonbury. As a whole, the Atheneum is more severe, more cubical, and denser of surface than the Yale library, as befits an urban monument.

The origin of the library commission is somewhat more obscure than that of the Atheneum, but we know this: an alumnus of the college, Aaron N. Skinner,

who had in 1831–1833 built a villa on Hillhouse Avenue in New Haven designed by Davis, asked Davis in 1835 for a "chaste & classical plan for a College Library." In the collection of Davis material at the Metropolitan Museum of Art in New York City are several sheets of studies for circular library plans connected to this project,[23] and there is in the Beinecke Library at Yale a set of finished drawings for a Grecian Pantheon, obviously inspired in form if not precise classical precedent by Thomas Jefferson's work at the University of Virginia. The caption reads: BIBLIOTECA FOR YALE, DONE IN 1830 BY A. J. D. This date is off by five years. The past tense suggests that Davis later added this title to the drawing (or that this entire drawing dates from a later year), when he spent his disgruntled old age reliving (and revising the chronology of) his glory days. I suggest that the precise date would have dimmed in his memory.

The project developed slowly. Several years had elapsed when, in March 1839, Davis noted in his daybook that he was working on a "Col Lib" for Skinner and a couple more before P. L. Forbes of the New York Library Society, in a letter to the Yale treasurer dated November 1841 obviously reacting to a request to criticize Davis's project, rejected the round plan and recommended a rectangle lined with book alcoves, the standard library arrangement of the day and the design ultimately used. Four months later, Ithiel Town, once Davis's partner and soon to be again,[24] wrote to Yale's treasurer that "The subject of a library-building for Y. College has been on my mind & I have fixed upon a general plan." He then asked for a month's delay, during which time, he strangely—or perhaps confidently— added, the treasurer "will be able to see the best that others can do." One week later, on 24 March 1842, Davis wrote in his journal that he was preparing drawings for a "Library for Yale College, Gothic Style." If Town had set a plan, Davis must have been working on the sections and elevations, but with that entry both Town and Davis vanish from the written documentation regarding the design of the building.[25]

In the collection of the Connecticut Historical Society Museum in Hartford are three sheets of drawings, a front elevation and two cross sections, but no plan, signed by Town and Davis but undated, that were once filed under "Atheneum" but are clearly not for that commission.[26] (See Fig. 88.) This is a project for a library modeled on King's College Chapel in Cambridge that inspired the Town and Davis partnership's 1830s main hall at New York University and its project for the University of Wisconsin (but represents neither), as well as the Yale library building. The set is surely contemporary with these works. Although it shows only the central block without the flankers, and although the proportions

88. Ithiel Town and A. J. Davis, design
for a library, 1842(?). (The Connecticut
Historical Society, Hartford, Connecticut).

and some details of the executed building vary from them, it clearly suggests the library, and since, as far as can be established, it has never been mentioned in print as related to any other project by Town and Davis, it is possible that this set of drawings represents a Tudor Gothic design for the library by Davis and perhaps the one he said he was working on in March 1842. The library set the stage for the Gothic buildings that followed on the Yale campus.

Schooners loaded with freestone for the library began to arrive at the New Haven docks from the quarry up the Connecticut River at Portland in the spring of that year. Henry Austin now enters the picture, out of the blue as it were, although he may have been one of those "others" Town mentioned so vaguely.

There is in the treasurer's records at Yale an undated contract that surely stems from 1842 that says that "Mr. Henry Austin shall receive not less than Two Hundred and Fifty Dollars for plans & specifications furnished by him for a Library Building for Yale College including the necessary drawings for execution and oversight of the work exclusive of ornature [?]."[27] There is also the whiff of a kickback in the records that may account for the change of architects, for also preserved is a promissory note dated 30 May 1842 (just two months after Davis's last known contact with the project) in which Austin agreed to pay one hundred fifty dollars "to aid in erecting a library building for said College, provided the plans which I have furnished . . . shall be adopted."[28] Austin signed a preliminary plan for what was eventually built, and the earliest published views of the building, which must have stemmed from drawings rather than the finished work, credit him with the design.[29]

The exterior of the library is a group of narrow, gabled blocks built of brownstone laid up in a picturesque, rough-face, irregular fashion. Had the building been constructed following what seems to have been the original intention, that visual energy would have been continued into the skyline, where, as shown in early views and described by an early observer, phalanges of tall, slender "bayonet-like" pinnacles topping the walls were to pierce the air. They never materialized in stone, giving the existing silhouette a much calmer appearance. The current building also lacks the thirty-two ornamental wooden heads that clung to the turrets.[30] (See Figs. 87, 89, and 90.)

The plan of the main block of the library is a long, narrow rectangle divided into a central area and narrower flanking spaces. (See Figs. 87 and 91.) That plan rises into a cross section showing a high central room with pointed clerestory windows beneath overhead arched trusses and lower side spaces separated from the center by piers of clustered colonnettes and covered with shed roofs. Windowless book alcoves occupied these side areas. (See Figs. 91 and 92.) The high "nave" and lower side "aisles," of course, form an ecclesiastical cross section (a fact Yale recognized when it hired Charles Z. Klauder to convert the library into Dwight Chapel in 1931), but not one Austin used in his early church designs.[31] The smaller alcove libraries for the student societies flanking the central one had book alcoves set into a hall with overhead arches and a central lantern. And much later, in 1865, when Austin's office turned out Rich Library at Wesleyan, as we shall see, it inserted, almost like furniture, rows of two-story book alcoves into an open hall beneath arched trusses.[32] The cross section of the Yale library in the Town and Davis drawings at the Connecticut Historical Society, however, shows a

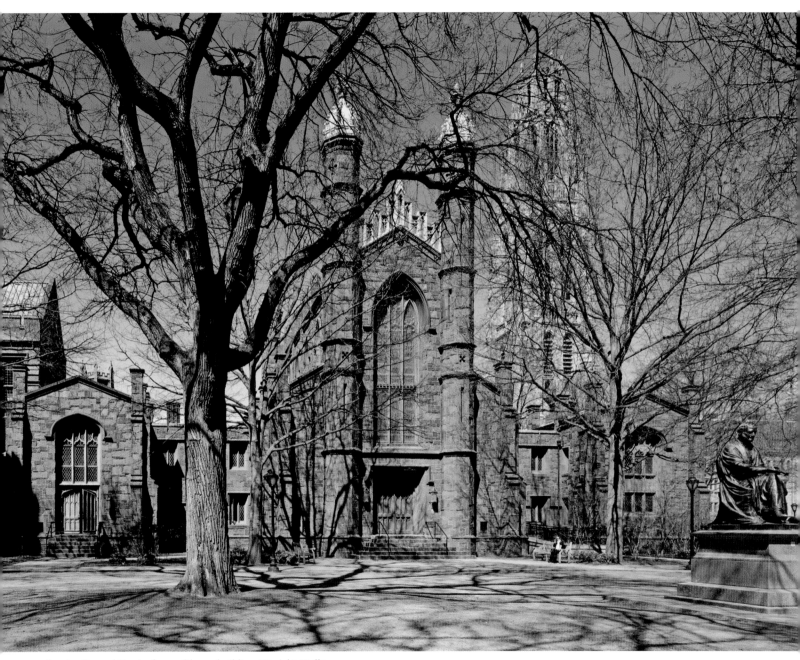

89. *Austin and Davis, former library building (Dwight Hall),*
Yale University. (© Cervin Robinson, 2007)

90. *Austin and Davis, former library building (Dwight Hall), Yale University. Exterior detail. (Ned Goode for the Historic American Buildings Survey)*

three-aisle library room with two tiers of galleries set atop a five-bay ground-floor space with a gallery, a more complex design than that finally achieved at Yale but one that would produce the same silhouette as the one there. There have been attempts to make Austin solely responsible for the library, but even if Austin modified Davis's plan and section, the spirit of Davis seems to hover over the final product.

During his early professional years, as when he designed Park Row in Trenton, seemingly with one eye on Alexander Jackson Davis's Ravenswood project, Henry Austin followed in the footsteps of his contemporary, whose career was well developed long before that of Austin. Somewhere around 1840, then, the two architects were in contact, even perhaps in collaboration. How this played out remains a mystery, but the association appears not to have lasted very long.

Given the suspicion of a kickback on the Yale commission, Austin's receiving sole published credit for the Atheneum in the works of Hills, Tuthill, and elsewhere, and Davis's apparently complete silence about Austin over the years, we might guess that they did not part on the friendliest terms.[33]

By the mid-1840s in New Haven, Austin's designs for the Egyptian Burial Ground gateway and the Gothic Yale library were still under construction. In new commissions he began to incorporate those signature details taken from more exotic sources that have attracted so much attention. These included his candelabra columns in houses like Willis Bristol's on Chapel Street and some of the details on the building that has been singled out as his eclectic if not his functional masterpiece, the New Haven Union Station of 1848–1849.[34] Patrick Conner, for example, thought that Austin had here "sought an unprecedented combination of forms suitable for the new genre of railway architecture."[35] Although it has been gone for more than a century, the station is now remembered with

nostalgia in the city, and it can be fairly well known from the drawings in the larger book at Yale, including plans, elevations, and a perspective[36] (see Figs. 93 and 95); a lengthy description published at the time it opened;[37] views of the building sketched by others;[38] and drawings at the New Haven Museum and Historical Society made in 1874, when the station was converted into a market. These graphic depictions must, however, be checked against the few surviving vintage photographs.

The railroad had arrived in New Haven by 1840.[39] The building type was thus new in the city, as in the United States in general, but was known from English publications such as *The Illustrated London News* available to Austin.[40] Railroad stations quickly became monumental, signature entrances to a city in one direction and to the marvels of industrialized travel in the other. Union Station was erected to accommodate three lines: the New Haven and Northampton, the New Haven, Hartford, and Springfield, and the New York and New Haven Railroad. According to Carroll Meeks, it was the first station in the country to incorporate a tall clock tower and to depress the tracks. The clock tower was a useful feature for those hurrying to catch a train, but one can only imagine the amount of smoke that belched from the lower tracks into the upper platform. We know that the design had to be corrected twice soon after the facility opened, but even that did not help. George Dudley Seymour remembered the area below stairs as a "cavernous place, dark, confused and full of smoke."[41] He was recalling the angst of a frightened child, but adults concurred. According to *Harper's Weekly* in 1860, "The subterranean abyss under the City of Elms into which the trains shriek with despair, as they rush, is perhaps the most wretched of all railroad retreats in the country."[42] The railroad abandoned the building in 1874, and it burned in 1894.

Austin's station was, like many other large buildings of the period—James Renwick's exactly contemporary Smithsonian Building, for example—symmetrical in plan and asymmetrical in elevation and silhouette.[43] (See Figs. 94 and 95.) Like the Italian villas Austin began to design at the same time, it merged classical forms with a picturesque skyline. The central hall, suspended at street level above the tracks, was flanked by parlors for men and women, and gave access left and right via balconies overlooking the tracks to stairways descending sixteen feet to the trains, or to a bridge across the tracks to a stairway leading to trains on the track farthest from the entrance. With Seymour we would like "to know where Austin got the idea of suspending the floor or platform of the structure by iron rods from a trussed roof."[44] Square rooms at the base of flanking towers stood at the ends of the corridors. In the 300-foot-long elevation, the "grand

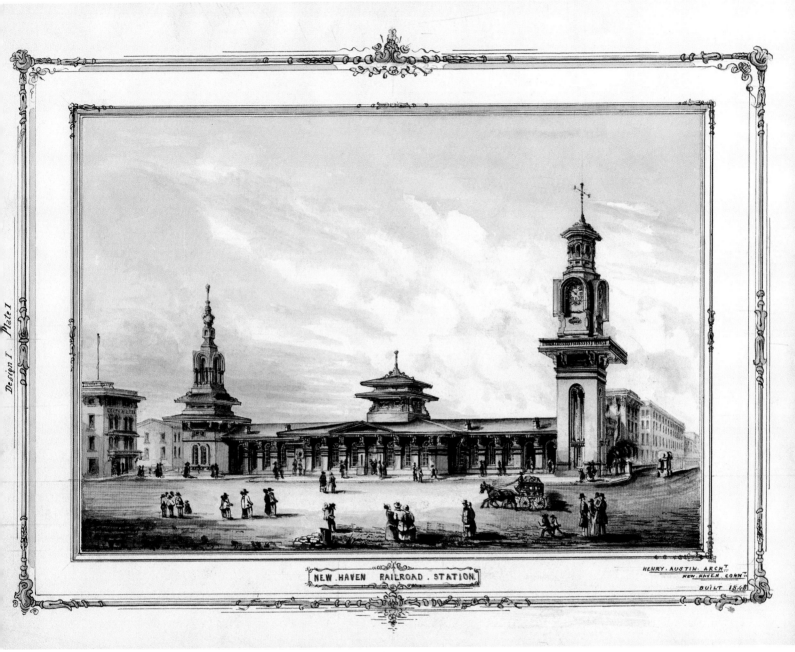

NEW.HAVEN.RAILROAD.STATION.

HENRY.AUSTIN.ARCH.ᵗ
NEW.HAVEN.CONN.ᵗ
BUILT 1848

93. *Henry Austin, New Haven, Connecticut, Railroad Station, 1847–1848.*
(Austin Papers, Manuscripts and Archives, Sterling Library, Yale University)

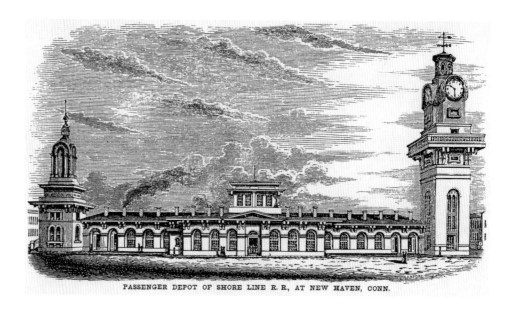

PASSENGER DEPOT OF SHORE LINE R. R., AT NEW HAVEN, CONN.

entrance for passengers" at the center of a seven-bay salient was achieved "by a spacious doorway" marked by a low triangular pediment and a cupola above the parlors. Recessed flanking walls each stretched for six more bays to encounter the bases of the embracing towers. Eighteen[45] semicircular arched windows produced a broad arcade on piers beneath an overhanging eave supported by over-sized brackets.

To this point, the style was Italianate and fell in line with contemporary stations such as Thomas Tefft's Union Depot in Providence, Rhode Island. Austin's New Haven contemporaries saw his building as largely linked to his earlier work, but as Carroll Meeks put it, "Fantasy began above the cornice." A statement by the railroad's board of directors defended its departure from strict economy in the building by saying that the liberal treatment of the line by New Haven and its citizens had led it to the "selection of a popular architect of the city and the erection of a station of more ornament and elegance than would otherwise have been" the case.[46] The elegance extended into the ladies' parlor, which was furnished "with a profusion of rich and costly sofas, divans, chairs, ottomans, mirrors, etc." The skyline was remarkably eye-catching and was often described as more exotic than the Orient-inspired furnishings of the ladies' parlor. Everyone who has commented on Austin's station has emphasized the curious forms of its unequal towers. For Clay Lancaster, for example, the central cupola seemed a "double–pagoda-roof superstructure." The 140-foot northern tower or "minaret" sported clocks "under chaitya-arch hoods," and the stubbier southern tower was "as close to the stupa

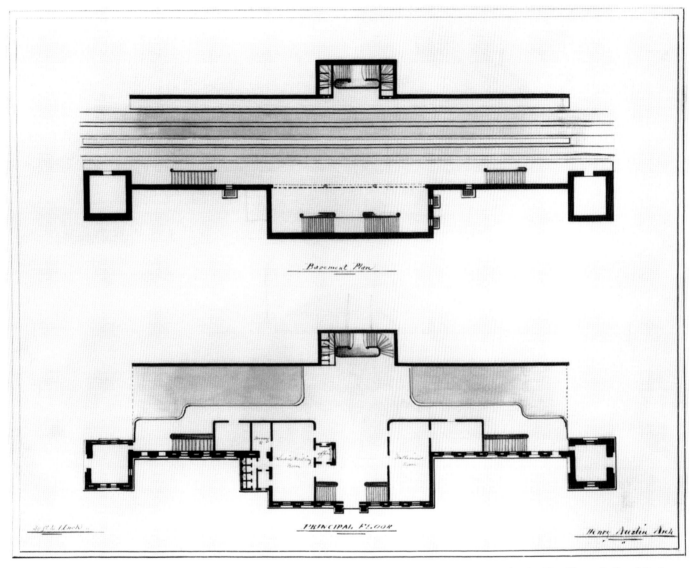

Basement Plan

PRINCIPAL FLOOR

95. Austin, New Haven Railroad Station. Plans. (Austin Papers, Manuscripts and Archives, Sterling Library, Yale University)

form of Greater India as any building in Europe or America." Meeks thought of the taller tower as a campanile and agreed with the Indian origin of the station's details, and he too thought the central cupola Chinese.[47] Raymond Head thought the building made references "to architecture from many sources: China, Tibet and Europe."[48] The terminal of the lower tower might be thought of as vaguely reminiscent of a stupa, something like the silhouette of that at the cave-temple of Karli (Ekvera) as illustrated by the Daniells, for example,[49] and Austin had used Indian motifs on other buildings of this time, but the individual elements of the composition are not unknown in Western design. I fail to see a Chinese

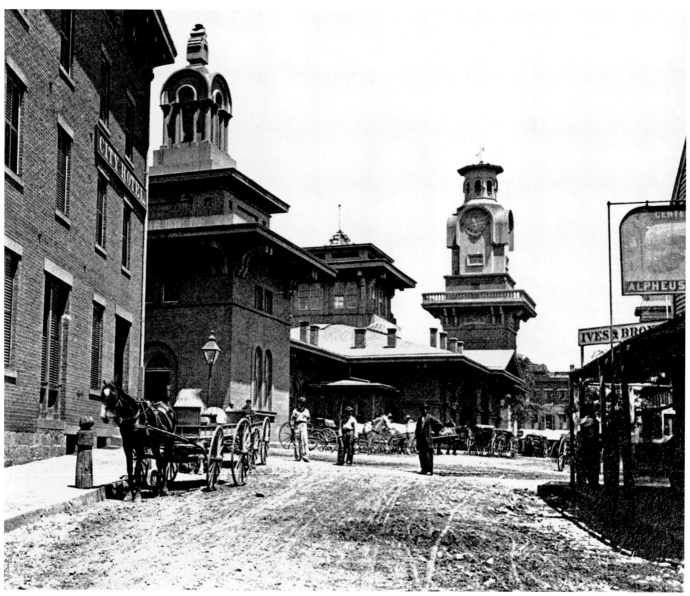

96. Austin, New Haven Railroad Station.
(The New Haven Museum & Historical
Society)

form above the entrance. A pagoda is usually defined as a tower with many con-
cavely curved roofs, and Austin could have seen a woodcut of one in many publi-
cations, including Louisa Tuthill's *History of Architecture* of 1848, where a number
of his own works were illustrated.[50] Patrick Conner thought the "central roofs . . .
ambiguous."[51] Austin's use of two roofs on his cupola is redundant but hardly ori-
ental, a fact that shows up better in vintage photographs than in the drawings and
woodcuts other commentators have studied. (See Fig. 96.) It is cousin to those
with which he was crowning contemporary domestic designs such as the Philo

Brown house. It is not necessary to exaggerate Austin's exotic sources to empha-size the extraordinary character of his work on the New Haven station.

While Austin contemplated the big station in New Haven, he also had on the boards projects for small depots at Plainville and Collinsville, Connecticut. (See Figs. 97 and 98.) Both are known from drawings in the larger book at Yale.[52] Each is in plan a forty- by twenty-foot rectangle subdivided into two parlors separated

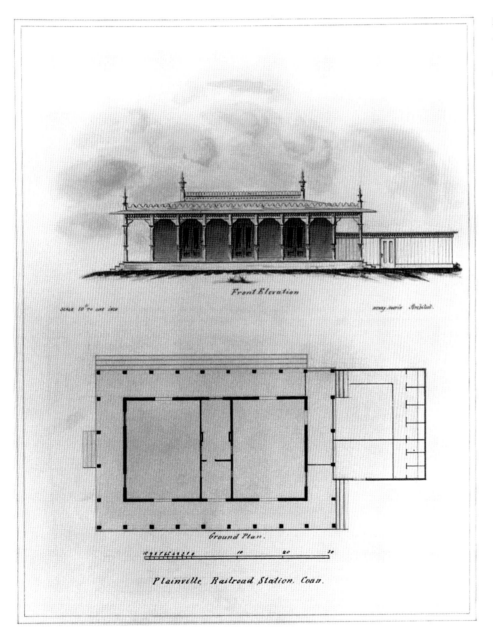

97. Henry Austin, Railroad Depot, Plainville, Connecticut, 1847. (Austin Papers, Manuscripts and Archives, Sterling Library, Yale University)

98. *Railroad Depot, Collinsville,*
Connecticut, 1847. (Austin Papers,
Manuscripts and Archives,
Sterling Library, Yale University)

Design XXXII. Plate I

Front Elevation.

SCALE 10 FT TO ONE INCH

H. AUSTIN Architect.

Side Elevation.

Collinsville Railroad Station. Conn

by an office, with an adjacent fenced-in area for privies and one story in elevation. The depots stand on low platforms. The Plainville depot is surrounded by a covered piazza defined by columns upholding architraves resting on bolsters. The low skyline is punctuated by crestings and spiky corner finials. The depot at Collinsville lacks the piazza but is more elaborately articulated. Corners are marked by inset boltels; openings are framed with the kind of heavy surrounds we find on contemporary houses by Austin such as Philo Brown's in Waterbury; the roof has a broad overhang that rises above the curve of the entrance to form the base of a freestanding cartouche decorated with a railroad wheel; and the whole is crowned with a turret that is a three-dimensional version of Austin's window and door frames. Raymond Head calls the Plainville station "Indian."[53] Meeks calls the details at Collinsville Moorish, and connects these designs to those British stations by Francis Thompson that were illustrated in the 1842 supplement to Loudon's *Encyclopaedia*, which Austin owned. I have looked at these drawings several times and can find nothing particularly oriental about either of these stations.

Austin's preoccupation with such an important commission as the Union Station probably caused him to entrust the design of the New Haven House hotel to Gervase Wheeler. We know from Wheeler's letter of 27 September 1848 to President Leonard Woods of Bowdoin College that he was "getting out" drawings for a hotel for New Haven and that he was looking to Charles Barry's Italianate London club houses for inspiration.[54] The only Austin New Haven hotel I know that fits the bill was the New Haven House, a building that stands out from other office work of the period. (See Fig. 99.) The large, four-square block, which stood on the southwest corner of Chapel and College Streets until the early twentieth century, was designed for Augustus R. Street to accommodate two hundred lodgers. The main façade, which faced the green, was six bays wide and five stories high, plus an attic marked by horizontal oval windows. A cupola rose above the roof, surely lighting an interior stair. Shops occupied the ground floor; tall windows with balconies opened the second. The two central bays were capped by bold segmental pediments on consoles, while those of the third floor were topped by triangular pediments. Such frames reached New Haven from Raphael's Palazzo Pandolfini in Florence via Leeds's well-known work published in London,[55] the usual circuitous route by which knowledge of Italian and other architectures arrived in the nineteenth-century United States. Austin's office apparently modified this design for the contemporary but now lost Wooster House in Danbury, Connecticut, with the addition of a four-story portico.

What the New Haven House might have looked like if Wheeler had not been

in residence we can guess from the elevation of a hotel preserved in the larger drawing book at Yale, and thus more or less contemporary with Wheeler's work.[56] (See Fig. 100.) Nine bays across and five stories high, with shops at ground level and a cupola crowning the profile, it has a slightly larger façade than that of the hotel that was erected. But this design is overloaded with Austinian details, especially the plastic window frames and the profusion of ornamental leafage that clings to them. Such details we also find on contemporary drawings for a shop front and for a small bank building in the smaller drawing book and on the interiors of some contemporary banks and domestic designs.[57]

The bank known from Austin's drawing that is prominently labeled SPRING-FIELD BANK on the façade but otherwise still unidentified is perhaps one of the earliest of a series of such smaller commercial institutions that came from the office in the 1850s. This shows a two-story, three-bay front edged with quoins and capped with a projecting cornice on paired brackets with a high parapet above. Shop fronts occupy the ground floor; the central doorway (surely intended to give access to a second-floor banking room) and the window above are topped by low triangular pediments supported by exaggerated consoles, while the flanking second-floor windows have flat projecting heads carried on the same consoles. All the windows at this level were intended to be encrusted with ornamental carvings or castings. The style is emphatically a personal take on the Italian Renaissance

100. Henry Austin, hotel before 1851.
(Austin Papers, Manuscripts and Archives,
Sterling Library, Yale University)

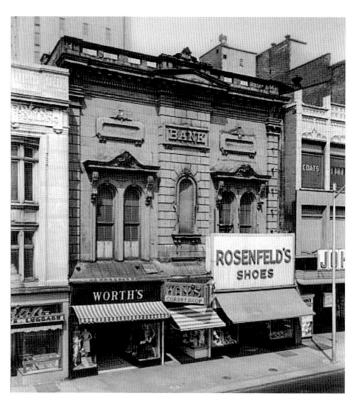

(left)
101. Henry Austin, (Townsend) City
Savings Bank, New Haven, Connecticut,
ca. 1852. (From G. and D. Cook & Co.,
Illustrated Carriages, 1860)

(right)
102. Austin, (Townsend) City Savings
Bank. Exterior. (Ned Goode for the
Historic American Buildings Survey)

Revival, a style Austin and others found compatible with banking and other institutional projects in this decade.

Austin has been named the architect of the building in New Haven erected on Chapel Street in 1852–1853 that was known variously as the Sheffield Bank Building, the Tradesman's Bank, or the City Savings Bank.[58] The City Savings Bank replaced the Tradesman's in 1860, and a few years later moved to a new building designed by Sidney Mason Stone. The impressive front was an elaboration of the design for Springfield, but this was the more sophisticated work. (See Figs. 101 and 102.) The architect adopted the same two-story, three-bay format for this larger façade, with a richly ornamented central doorway between shop fronts on the ground floor. The windows above, separated by a rusticated salient rising from the entrance past a narrow round-headed niche and the word BANK to a triangular pediment at the cornice, were double round-arched openings beneath broken pediments supported on foliate brackets. Ornamental panels floated above them. The words CITY SAVINGS BANK stretched across window heads and salient. Corner rusticated quoins began at the top of the ground story and rose to the cornice topped by a balustrade. The façade consisted of brownstone over brick.

103. Austin, (Townsend) City Saving Bank.
Detail of interior. (Ned Goode for the
Historic American Buildings Survey)

Stepping through the central entrance to this building, a visitor found a grand staircase leading up to a semicircular lobby and then into a monumental banking room. This was barrel vaulted with a central dome. As with most banks of this period, the architectural articulation of the room was large-scale, bold, and impressive. The doorway between lobby and banking room photographed for the Historic American Buildings Survey shows paneled Doric piers upholding a pronounced architrave surmounted by carved classical ornament focused on a central anthemion. (See Fig. 103.) This sort of decorative detail is found in other designs from Austin's office during this period. The classicism of Austin's origins filtered into his work throughout the early decades of his career.

The antiquarian George Dudley Seymour mentioned a "saving bank" by Austin

in Danbury, Connecticut.[59] He may have referred to the Fairfield County and Danbury Bank on Main Street North, a building first occupied in January 1856. A late-nineteenth-century history of the city tells us that a mason and a carpenter contracted to erect the building in June 1855 "after plans made by Henry Austin, of New Haven."[60] What the building looked like has yet to be discovered.

The Merchant's National Bank of 1856 on State Street in New Haven is another Austin attribution, but there seems little reason to doubt it.[61] The president was Nathan Peck, Jr., for whom Austin had designed a house a few years earlier. The main façade, a story and a half capped by a bold pediment, was raised on a high base, the main floor reachable by way of flared stone handrails (akin to those Austin would use again the next year at the Morse-Libby house in Portland, Maine). The main entrance was through an aedicule of Doric pilasters supporting an entablature and a triangular pediment. The doorway and flanking windows were round-arched, the latter surmounted by pronounced semicircular pediments sustained by oversized consoles. Above the entrance a large panel held the name of the bank, and to either side of it was mounted a large carved cartouche. Heavily rusticated quoins locked in the sides.

These years saw a parade of bank designs coming from Austin's office. The larger of the two drawing books at Yale contains a full set of graphics for the Mechanics Bank in New Haven: plan, side elevation, longitudinal and cross sections, and an accomplished perspective view.[62] (See Fig. 104.) This looks very much like a set of presentation graphics intended to sell the design to the client, and the project presents us with a puzzle. The inclusion of the set in the Yale collection strongly suggests a date in or before 1851, while the bank's building on Church Street was erected in 1858. To add to the confusion, it has been asserted that the façade of the bank is a knockoff of Minard Lafever's Brooklyn Savings Bank of 1846–1847, a work Lafever published in his *Architectural Instructor* in 1856.[63] (See Fig. 105.) Since Lafever was on the outskirts of the circle around Ithiel Town, Austin may well have known him, and known of the Brooklyn bank façade long before its publication. There is no document placing Austin in New York at any time, but it would seem ridiculous to assume that he was not there on occasion, especially with the efficient water and rail transport between New Haven and New York. (And he must have been there if he worked for Town before 1835 or if he acted on the letter of introduction from Town to Davis in 1839, for Davis's office was then in the city. Whether he later regularly traveled to New York is another unanswered question.)

The Brooklyn bank sat on a corner site and therefore had an ornamental side

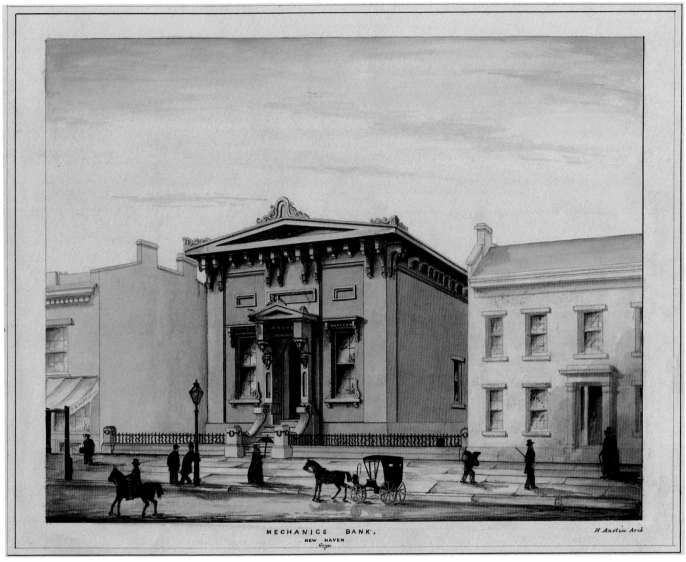

MECHANICS BANK.
NEW HAVEN
Conn.

H Austin Arch

104. Henry Austin, Mechanics' Bank,
New Haven, Connecticut, before 1851.
(Austin Papers, Manuscripts and Archives,
Sterling Library, Yale University)

elevation; the New Haven bank was in midblock, so only the front was developed decoratively. The two fronts are certainly related. Austin had already used the wall capped by a triangular pediment at the Merchants Bank, but the form and articulation of his and Lafever's façades are essentially the same. Austin's decorative detailing is more plastic, however, as one would expect. Compare the entrances, for example. Both are round-arched and framed with an aedicule composed of paneled pilasters topped by projecting pediments upheld by brackets. But Lafever's forms lay against the wall, while Austin's project more boldly and gather more weight as they rise to a pair of heavy uncarved blocks interposed

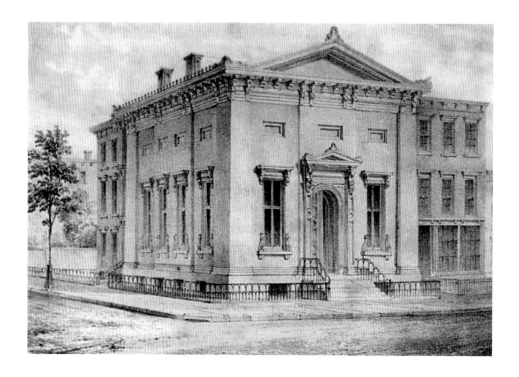

between brackets and pediment. (Here Austin seems almost to anticipate some of the top-heaviness of Frank Furness's post–Civil War detailing on Philadelphia banks.) Compare the delicate, tidy consoles at the cornice of Lafever's façade with the alternation of huge paired brackets with smaller ones under Austin's eaves, or the delicacy of Lafever's stair rails with the massive sides of Austin's entrance steps, or the diminutive size of the acroterion at the point of Lafever's pediment with the massive pile of ornament that crowns Austin's façade. Austin forces the Renaissance Revival to bend to his will here.[64]

The Young Men's Institute on Orange Street of 1855–1856 has been likened to Austin's style.[65] There's no known document assigning the building to him, but the attribution seems sound, especially since one of Austin's later clients, Oliver F. Winchester, was president of the Institute from 1855 to 1859, and another, Joseph Sheffield, made a large donation to the library in 1856. The record of the trustees' meeting at which the design was chosen states merely that "plans for the building have been adopted" without naming the designer.[66] It was somewhat unusual in Austin's work as a straightforward Renaissance Revival façade, but with three stories above a central entrance flanked by shop fronts, edged with lateral quoins and overhead brackets and cornice, with a play of triangular and segmental pediments over the entrance and the windows of the *piano nobile*, the

original five-bay brownstone front could reasonably have come from his office, as from that of any of his peers.[67] (See Fig. 106.)

The Institute itself, founded in 1826, was an educational and cultural center for working men, with a library and reading room that are still in existence.[68] Austin's erstwhile assistant, Robert W. Hill, is said to have learned architectural drawing there, probably in the 1850s.[69] Although formal architectural instruction is usually said to have begun only after the Civil War, and is true in the university setting, in the cities there existed working men's institutions such as this

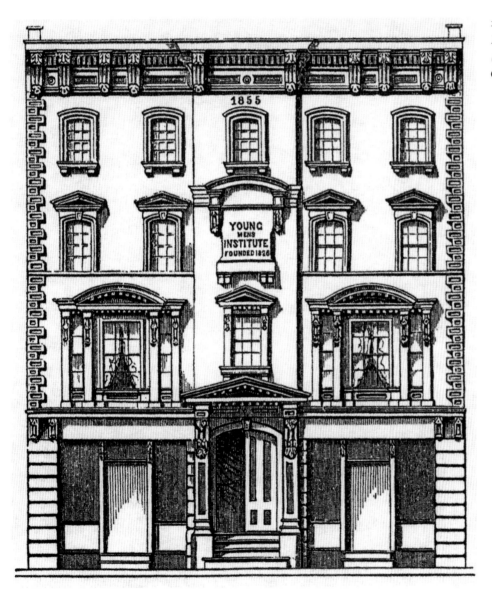

106. Henry Austin, Young Men's Institute, New Haven, Connecticut, 1855–1856. (G. & D. Cook & Co., Illustrated Catalogue, *1860)*

where basic classroom instruction in architecture might have been much earlier available.[70] Although the closest I have come to documenting such instruction at New Haven's Young Men's Institute are mentions of architectural drawing in the list of subjects taught there in 1855 and 1857,[71] there is also circumstantial evidence. In the early 1850s the library, which previously had contained a smattering of books on architecture and allied subjects, began to acquire a relatively large number (for a general library) of works on drawing, geometry, descriptive geometry, engineering and surveying, rudiments of structure and building materials, the use of iron in building, and warming and ventilation. In these years it also added to its shelves William Henry Leeds's *Rudimentary Architecture for Beginners and Students* (1848), C. Bruce Allen's *Cottage Building* (1849–1850), Edward L. Garbett's *Treatise on the Principles of Design in Architecture* (1850), the works of A. J. Downing, and so on. Perhaps Austin's honorific as "Father of Architects"

stemmed in part from an association with this educational program. None of this is conclusive, but it is highly suggestive.

Among other educational commissions of this period attributed to Austin by George Dudley Seymour, the 1854 Eaton School at Jefferson and St. John Streets in New Haven was a three-story Italianate brick box with a high cupola above a symmetrical façade.[72] (See Fig. 107.) It was dedicated on 29 August 1855 to Theophilus Eaton, first governor of the Colony of New Haven.[73] Its mixture of round-headed and trabeated openings perhaps suggests that Austin had one eye on the contemporary school buildings of Thomas Tefft, where one finds a similar mixture; in fact, the building looks like a more elaborate version of Tefft's 1847 design for the school in Warren, Rhode Island,[74] although in its central hall and balanced rooms it was also an institutional version of Austin's urban domestic work of the period. This and the Webster School, the latter dated 1853 and often attributed to Austin, were among the earliest public schools established in New Haven, a result of the educational reform movement led, both organizationally and architecturally, by Henry Barnard, the former commissioner of schools in Rhode Island, who, after service as secretary of the Board of Commissioners of the Common Schools in Connecticut, in 1850 became the state's superintendent of schools. His *School Architecture* appeared in six editions between 1844 and 1855. Of it the *Connecticut Common School Journal* said, "In no spot in all this country is a school edifice of any considerable importance, planned and erected without consulting."[75] (Since Barnard was himself the editor of this periodical, perhaps this was not an unbiased endorsement.) Although he early promoted the work of Thomas Tefft, his fellow Rhode Islander, Barnard did join Austin in the new edition of Chester Hills's revised *Builder's Guide* of 1846 (copyright 1845). There he published a curious design by Austin for a district school in Hartford that he repeated in the 1849 edition of his *School Architecture*, so we know there was some contact between the two men.[76] The *New York Tribune* of 21 April 1856 called the Eaton School "the perfection of school architecture," and Henry Barnard's own *American Journal of Education* said that "in location, spaciousness and furniture, it is not surpassed by any similar structure in the whole country."[77]

In the realm of public and commercial work, Austin's office in its first two and a half decades turned out a series of commissions that would have been the envy of many of his New England contemporaries. The beginning of a new decade also brought onto the boards a major commission, the New Haven City Hall of 1860. Thereafter the office settled into a series of more or less routine works as it drifted toward its ultimate demise in the 1890s.

5

SOME LATER BUILDINGS

By the advent of the Civil War, but certainly unrelated to it, a new stream developed in the already spreading stylistic flow of work that had issued from Austin's office over the previous two decades, a stream that was soon paralleled in the buildings of many American architects of the period. In the history of the New Haven office that direction was marked by an unexpected design, one unpredicted by anything that had come before: the New Haven City Hall of 1860–1862. Austin's reputation in his own day was largely a regional one. We can say with hindsight, for the building does not seem to have been published broadly when it was new, that with this work Austin's practice briefly assumed a national position, for it was one of a small group of early works in this country designed under the influence of the English critic John Ruskin and the High Victorian Gothic style. The precocious English immigrant Jacob Wrey Mould had produced two such works for New York City, All Souls' Unitarian Church of 1853 and the Trinity Church Parish School of 1860.[1] Peter B. Wight's National Academy of Design in New York City, while drawn in 1861, was not erected until 1863–1865. The New Haven City Hall fits neatly into the middle of these developments, although it seems a bit tentative, for it lacks the signature constructive polychrome arches of the established Victorian Gothic. Following Austin's office's foray, the style was to reappear in New Haven in 1864–1866 at Street Hall, Yale's Fine Arts building and Wight's fully fledged local monument to Ruskinian principles.[2] (Since Augustus R. Street, who gave the Fine Arts building to the college, had been an Austin client [at the New Haven House hotel], one wonders at the choice of architect. An Art Council selected by the college made the selection.[3])

"High Victorian Gothic" was not the label used in New Haven at the time, of course. In recommending to its readers in April 1861 that they visit Austin's office to look at the drawings for the building, the *Daily Register* called the style "Continental," a word it probably got from the architect himself. It also said that "everyone must see for himself, the beautiful proportions . . . and the variegated layers of stone with which the front is to be composed."[4] The building was then under construction from "beautiful plans and sightly elevations." (See Fig. 108.) Not everyone who visited the office agreed with the newspaper, however. The novelty of its appearance—unpredicted by anything the region had yet seen—made it

108. David Russell Brown (?) for
Henry Austin, City Hall, New Haven,
Connecticut, 1860–1862.
Presentation drawing.
(The New Haven Museum
& Historical Society)

necessary for the mayor, the Honorable Harmanus M. Welch—for whom Austin was later to design a house in New Haven[5]—to defend it publicly at least twice. "The style of architecture," he told the Common Council in June 1862, "is somewhat new in this part of the country, but it is believed it will stand the ordeal of criticism." And in October, in his brief review of the history of the project, again addressed to the Common Council, he felt it necessary to add, "If the architectural design and proportions are not as some would have them, it may be said the whole is submitted to a fair criticism and a candid people. [Like a] splendid picture [it] may require an artist's eye and a cultivated taste, before a correct judgment is passed upon it."[6] Give it time, he said in his awkward way, and time has vindicated him.

It was not only unfamiliar stylistic detail that caused popular concern about the design. The asymmetrical silhouette of Austin's building must also have aroused consternation. Heretofore city halls had been classical in detail rather than Gothic, to be sure, but they had also, as a rule, presented a symmetrical façade whose formality seemed to connote authority to the citizenry.[7] Bryant and Gilman's contemporary Boston City Hall of 1860–1865, for example, is a stern monochromatic French Second Empire pile centered on a prominent pavilion articulated with classical orders that rise to a mansard roof. (See Fig. 109.) Perhaps in the eyes of some citizens of New Haven, Austin's City Hall was too jaunty. The architect had failed to wrap the building in the balanced decorum proper to earlier seats of government.

New Haven had long felt the need for a governmental center. In January 1849 it voted to erect such a building and requested drawings from two unnamed "experienced" architects. One would immediately jump to the conclusion that these (unpreserved) projects were drawn by Austin and Sidney Mason Stone, the only local architects, but just two years later, the town sought two proposals for an almshouse and received drawings from Stone and Louis Dwight of Boston, so one must not jump to conclusions in such matters.[8] A check in local directories suggests that nothing came of this attempt to house the city government, but the desire lingered on for another decade. Again in 1854, the city and town appointed committees to study the problem.[9] Again there were no immediate results.

Six years later the local authorities revisited the issue. At the end of June 1860 they again voted to pursue designs for a city hall.[10] Mayor Welch's later account of the history of the project says that the next month the committee met to examine "plans" and procure estimates, and "after the most mature deliberation, the plans of Henry Austin, Esq. were agreed upon." This wording suggests that there

109. Gridley J. F. Bryant and Arthur Gilman, City Hall, Boston, 1860–1865. (Courtesy of Roger Reed)

had been something of a competition for the commission, perhaps including a project by Stone. A handsome contemporary tablet at City Hall credits the building to "Architect/Henry Austin," but since George Dudley Seymour's day it has been assumed that David Russell Brown of his office had charge of the design.[11] This is not out of the question. Brown had shared credit with Austin earlier and was to do so again.

A published precedent, as usual, formed the basis for the scheme. Seymour—whom we need always to remember knew or could have known both Brown and Austin—says that "Mr. Brown himself told me not long before his death, that he founded the design for the City Hall on a picture he saw in an English illustrated paper or magazine to which Austin . . . was a subscriber."[12] John B. Kirby, Jr.,

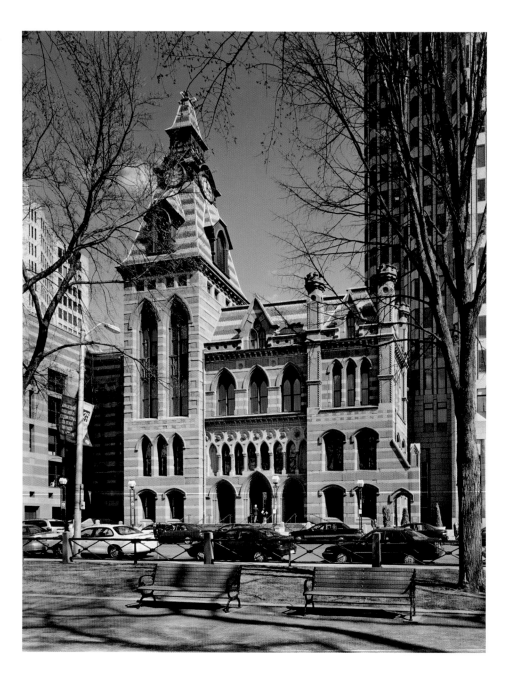

110. Henry Austin, City Hall, New Haven, Connecticut. (© Cervin Robinson, 2007)

identified this source as a Royal Society of Arts Gold Medal–winning project for a metropolitan hotel by the young Ernest Peto that was published in the *Illustrated London News* in early January 1860.[13] This paper had long been for sale on Chapel Street, so it could certainly have reached New Haven within the next six months.[14] (Peto's project may, in turn, have been inspired by some work on the Continent, thus giving the stylistic label used by the newspaper some validity.)

111. Ernest Peto, "Design for a Metropolitan Hotel," 1859. (From The Illustrated London News, *January 1860)*

There is indeed an affinity between the City Hall and the central feature of Peto's project as shown in perspective. (See Figs. 110 and 111.) This is to be found in the asymmetrical juxtaposition of a left-hand tower, opened by tall pointed windows embracing two floors and capped by a high roof with dormers and, to the right, a lower block richly articulated with details recalling Ruskin's favorite building, the Palazzo Ducale in Venice. The exteriors of both the hotel and the City Hall display the "variegated layers of stone" mentioned by the *Daily Register*. In both designs a grand interior staircase, projected by Peto and realized by Austin and Brown, rose from the entrance lobby to the second floor.

Peto's project is a convincing source of inspiration for the New Haven City Hall, but it does not fully account for the frontal massing of the building. There

is another image that may also have come to the office's attention and may have joined Peto's in the designer's mind. A second illustrated English journal, *The Builder*, in its issue of 21 January 1860, published a dramatic perspective of Charles Barry's 1859 Town Hall for Halifax, England.[15] (See Fig. 112.) This was just two weeks after Peto's hotel appeared in the *London News*. Barry's town hall is round-arched and appears monochromatic, but its silhouette is asymmetrical and unbalanced by a tower to the left, like that of City Hall, and the right side of the façade is treated like a pavilion with tall corner turrets, as at City Hall (but not in the Peto project). A commingling of sources of inspiration is characteristic in this emerging period of eclecticism.

For the exterior chromatics at City Hall, however, Austin and Brown were on their own, because both of those precedents were depicted in black-and-white prints. The architects contrasted darker, purplish sandstone with multiple belt courses of a lighter stone to achieve what has been called in other circumstances a "streaky bacon" effect. Jacob Wrey Mould striped his Trinity Church Parish School in somewhat the same way at the same time. Constructional polychrome, such as the alternation of stone and brick voussiors in pointed arches, so characteristic of the style in England, as I have said, is lacking here. The absence of this detail suggests the tentative nature of this early Ruskinian work by Austin's office. David Russell Brown, on his own, adopted the pointed arch of constructive polychrome at the Church of the Redeemer, erected in 1870 just around the corner from City Hall.[16]

There is at the New Haven Museum and Historical Society a large group of drawings for City Hall, many of which were discovered in the structure at the time of its rebuilding in the 1980s (having survived a cry on the part of some citizens that the thing be pulled down entirely).[17] These include an unsigned and undated project that seems to be a preliminary scheme for the building, with a balanced pair of exterior curvilinear entrance stairs leading up to a Corinthian portico fronting the entrance on the second level and, within, twin flights of stairs rising to the third story. It would seem that this stage of the project, which contemplated a more traditional balanced classical façade, predated the arrival of the *London News* and (perhaps) *The Builder* in New Haven. (That this set of drawings might be a competition entry from Stone's or some other office cannot be dismissed out of hand, but the draftsmanship seems identical to that of other sheets representing the finished building.) Whether the decision to choose asymmetrical Gothic over Corinthian balance was made by the Common Council or the architect's office, it was dramatic. The Historical Society collection also holds

112. Sir Charles Barry, Town Hall, Halifax, England, 1859. (From The Builder, *January 1860)*

113. Austin, City Hall, New Haven. Main entrance. (Author, 2006)

the accomplished rendering of the asymmetrical principal façade of City Hall almost exactly as built, presumably from Brown's hand. (See Fig. 108.) It shows the office reaction to the English sources: a cacophonous riot of mismatched blocks and openings, the very model of Victorian picturesque architecture. And cacophony was not confined to the visual either. The 120-foot tower was assigned to the fire lookout, who had a 6,127-pound bell to send "twanging and clanging" across the city.[18] The time capsule placed within the cornerstone included Austin's new card, with its view of his recent remodeling for Joseph E. Sheffield of Ithiel Town's house and library on Hillhouse Avenue.[19] (See Fig. 56.)

As it was at Austin's railroad station, James Renwick's Smithsonian Institution, and many other public buildings, the plan of the front of City Hall is symmetrical; asymmetry occurs in the rising masses of the building.[20] In the edifice as erected the entrance is still on center. (See Fig. 113.) The main stair ascends in two flights from a hall beyond the ground-floor foyer. (See Fig. 114.) Conserved and put back in the rebuilding, it is cast iron with risers pierced in a rinceau pattern, molded cast iron banisters and newels, and wooden hand rails. It ascends in two flights to the second level within a reconstructed hall open, as originally, to the lay light above the third floor,[21] a monumental public space equivalent to the smaller but no less dramatic vertical stair hall at the recently completed Morse-Libby house in Portland, Maine. The door surrounds, also replaced in the rebuilding, are turned wooden colonnettes on plinths supporting a pointed tympanum inset with geometrical tracery. (See Fig. 115.) To the rear of the first floor were twenty-six small jail cells organized into two rows set well back from the exterior walls, as was common in penal confinement at the time.[22] It would have been in one of these tiny cells that the hoodlum being apprehended by the copper in the lower right of the drawing of the front elevation would have been confined.

New Haven City Hall has been remade and added to in recent years, and the emphasis of its spiky silhouette has been diminished against a background of newer high-rise towers. It nonetheless remains an imposing pile. It stands across the Green from the ecclesiastical work of Austin's putative mentor, Ithiel Town, and looks back from midcentury to his professional origins (as did his contemporary reworking of Town's house for Sheffield). City Hall represents an important, perhaps even the culminating, moment in Austin's career, but it also had larger meaning in the urban pattern of New Haven. Its imposing presence on the Green heralded a new era in the city's history as immigrant groups began to assert their presence. (See Fig. 116.) According to Vincent Scully, it was "enough to enable the city to challenge Yale and the churches with some architectural authority."[23]

(left)

114. Austin, City Hall, New Haven. Main stair. (Ned Goode for the Historic American Buildings Survey)

(right)

115. Austin, City Hall, New Haven. Detail of the interior. (Ned Goode for the Historic American Buildings Survey)

In many ways City Hall stands as the high point of Austin's career, after which it began a slow decline.

Austin's office turned out a number of Victorian Gothic buildings during the remainder of the 1860s—for example, Rich Hall, the second library building at what is now Wesleyan University. (See Fig. 117.) It is dated 1866–1868 and credited to Austin and Brown by Montgomery Schuyler.[24] The donor was Isaac Rich of Boston, fish dealer, ship owner, real estate developer, philanthropist, and one of the richest men in New England.[25] In a letter of January 1869 Wesleyan's president, Joseph Cummings, wrote to Professor Willard Fiske of Cornell in answer to a question about the new building, whose erection Cummings had guided. The library, he said, was an eighty- by forty-five-foot rectangle on the interior and built of Portland sandstone. From the entrance one passed between small rooms through inner doors into the main hall with alcoves on either side. (See Figs. 118 and 119.) Galleries (that is, the upper level of the alcoves) extended across the

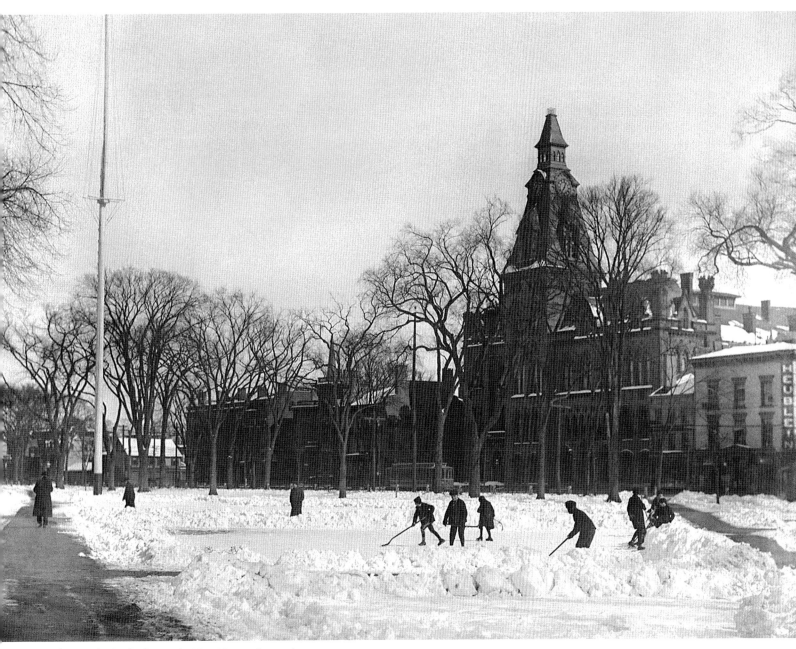

116. *Boys playing hockey on the New Haven, Connecticut, green, ca. 1900.*
(The New Haven Museum & Historical Society)

117. Henry Austin and David Russell Brown, Rich Hall (now the '92 Theater), Wesleyan University, Middletown, Connecticut, 1866–1868.
(Olin Library, Special Collections and Archives, Wesleyan University)

front and down the sides. Although the tone of the letter is one of pride in the building, the writer, rather curiously and without explanation, warned his correspondent against the use of Gothic style. The alcove library at Yale had been one of the precedents studied by Cummings when Wesleyan's new building was under consideration; the Astor Library in New York City and the Public Library in Boston, both round-arched, were the others.[26] But all were faulted for having dark alcoves, and Cummings's letter stresses the need for a window in each of those spaces. These are marked on the exterior flanks by a range of tall, pointed openings separated by unnecessary buttresses. The exterior Gothic details have a dull, frozen effect here, in part because of the monochrome, random ashlar sandstone. The only polychrome is to be found in the roof slates.

Some years ago, the university gutted the building for use as a theater. The alcoves are gone but the overhead wooden Gothic hammer beam trusses remain.

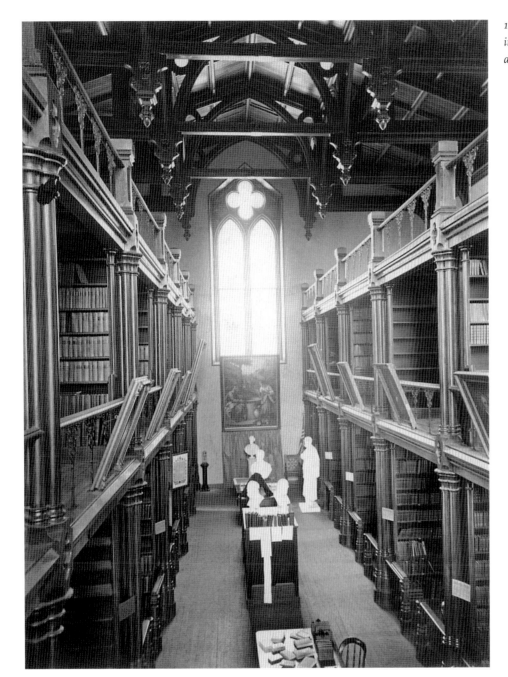

118. *Austin and Brown, Rich Hall. Original interior. (Olin Library, Special Collections and Archives, Wesleyan University)*

They are arched, with wooden cross ties. As it had in its churches of the mid-1840s, the office here used ornamental pendants. Beneath the roof was an open hall into which the wooden book alcoves were inserted, independent of the structural walls, like so much furniture. Within a very few years, such an alcove arrangement would become obsolete, as the self-contained stack system was introduced in 1874 by Ware and Van Brunt in the wing they added to Gore Hall, Harvard's library.

For the narrow façade of the now demolished Daily Register Building in New Haven of 1868, it was Austin's office, according to local tradition, that created three stories of polychromatic segmental arches above a shop front.[27] The wall was layered with contrasting stone and pronounced belt courses and sills, the curves of the intradoes and extradoes of the arches were not concentric and were punctuated with overscaled keystones, and ornamental brooch-like carvings filled the spandrels. Above the deep cornice, a pair of dormers in the plane of the wall echoed the window treatment below. In the Trinity Church Home in New Haven, which opened in 1869, Austin produced a troika of chromatic picturesque buildings.[28] This seems to be an attribution to the architect but a reasonable one. The client was the philanthropist Joseph Earl Sheffield, for whom Austin had remodeled Town's villa in the previous decade. Sheffield made a fortune as a cotton merchant and railroad magnate; at his death his estate was estimated to have been ten million dollars, although it was probated much lower.[29] He commissioned two pairs of town houses for his daughters on George Street with, set back between them to form a court, a complex of three buildings for the benefit of the poor of the parish. Only two of the original seven units survive and they are altered, but comparing an engraved view of the rear buildings (see Fig. 120) to what is left conjures up a fair idea of the original design. From left to right the buildings housed a home for aged women (now minus its high pyramidal roof with dormers and its entrance frame), the church (now minus its spire and entrance porch), and the rector's home and parish school (now entirely lost). The orange-red brickwork striped with many tan stone belt courses recalling the layering at City Hall creates lively exterior walls. Framed rectangular openings light (or lit) the interior of the flanking buildings; the church sports Gothic arches without constructional polychrome.

The architecture of England and France had great impact on the buildings of the United States in the postwar period. Austin's office showed its Anglophile leanings with the previous buildings; by the next decade, it had joined the Francophile mansard craze despite the November 1870 warning published in the *Evening Register* against the erection of such flammable timber roof structures at elevated heights (a warning that became prophetic in the Boston fire of 1872). The H. P. Hoadley Building at Church and Crown Streets may have been the office's first major work of the alternate stylistic breed.[30] (See Fig. 121.) It is dated 1871–1872 in Dana's *New Haven Old and New*; according to an item in the New Haven *Evening Register*, the fronts were fabricated of cast iron.[31] As if to fulfill the *Register*'s warning, it burned in 1904. At four stories plus mansard in height and

120. Henry Austin, Trinity Church home and parish school, New Haven, Connecticut, 1868–1869. (From Trinity Church Home . . . Constitution and By-Laws, *1869)*

eleven bays wide and eight deep, it was surely one of Austin's most imposing commercial buildings. The arrangement of round-arched openings on the front was in the symmetrical grouping 3-2-1-2-3, with emphasis on the center. The two-story entrance archway separated ground-floor shops. The details of the main façade, from the banded pilasters of the central entrance and the implied *pavillons* at the corners to the *lucarnes* that lighted the mansard, all spoke French. It was a canonical, run-of-the-mill example of the prevailing style.[32]

In Austin's work of this period, mansard found employment in domestic as well as commercial architecture. Austin turned out neighboring domestic fraternal twins on New Haven's Prospect Street in the 1860s for a pair of wealthy manufacturers and erstwhile partners. At the John M. Davies house of 1867–1868 and its neighbor, the Oliver F. Winchester house, Austin translated the Italian villa style he had used in the previous decade at the Morse-Libby house in Portland, Maine, into the French mansard mode.[33] The two clients had been partners in a shirt manufacturing business until Winchester founded his repeating firearms company in 1855. At the time of the design of his house, he was lieu-

tenant governor of Connecticut and his company was about to experience explosive development. His house no longer stands. It was similar in plan to Davies's and its massing, like Davies's, echoed that of the earlier Italian villas, but it was given more flamboyant ornament and flaring gables. (See Fig. 122.) After years of neglect the Davies house, often said to be the work of Austin and Brown, was restored for use by Yale.[34] The main block is two-story plus mansard, the tower three-story plus mansard. (See Figs. 123 and 124.) A description of the Davies house at the time of its completion, when it was the largest in New Haven, tells us that it was built of (scored) stucco-covered brick. The segmental or round-arched openings have red sandstone frames much subdued in design compared to those Austin gave to domestic works of the 1840s, such as at the Philo Brown house. The details of the portico are accomplished but lack the boldness and

121. Henry Austin, H. P. Hoadley Building, New Haven, Connecticut, 1871–1872. (Dana Collection, New Haven Museum & Historical Society)

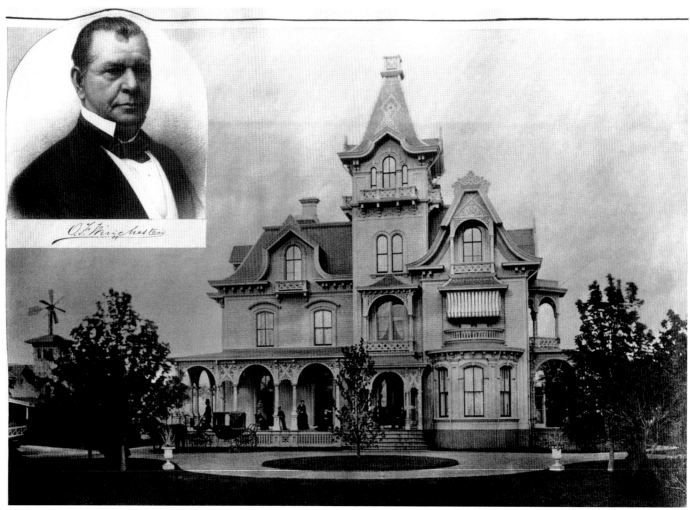

122. *Henry Austin, Oliver F. Winchester house, New Haven, Connecticut, 1867–1868. (The New Haven Museum & Historical Society)*

verve of those of its neighbor or the vigor of his earlier candelabra porticos. (See Fig. 125.) Within the house, to return to the early description, the "ceilings are all elaborately carved plaster. . . . The main staircase [in a lateral space off the entrance hall] runs through to the third story, and is made of black walnut with finely carved banisters and an elaborate newell [*sic*] post," a late version of one of Austin's signature details.[35] (See Fig. 126.) Italian marble set in ornamental black walnut frames encases some fireplaces.

In 1868 the office turned out a more modest cottage for Charles H. Collins at 69 Colony Street in Meriden, Connecticut. Comparing a signed drawing of the front elevation (see Fig. 127) with vintage photos of the demolished cottage shows that it was erected as designed.[36] The main front was symmetrical. It stood on a broad rectangular plan with the second story contained within a gable with long

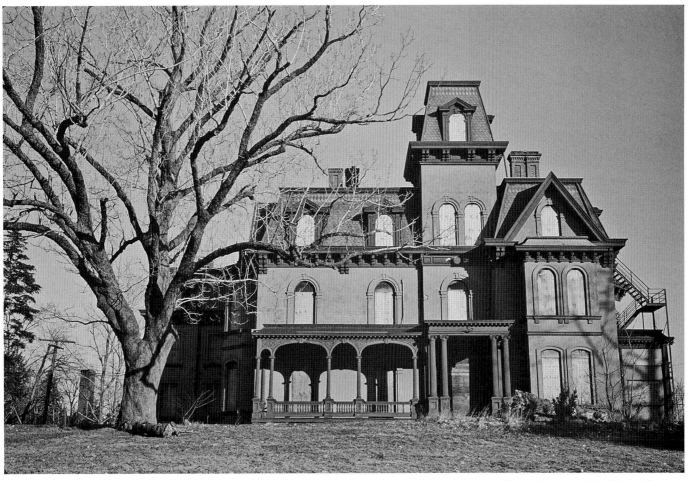

123. Henry Austin and David Russell Brown, John M. Davis house, New Haven, Connecticut, 1867–1868. Before restoration. (The New Haven Museum & Historical Society)

overhangs parallel to the street and a central entrance beneath a portico that jutted out from a narrow gabled salient bay. A tall cupola, simple by Austin's earlier standards, rode the ridge of the main gable above the entry. Semicircular hoods topped by jigsaw acroteria covered the second-floor dormers flanking the salient. King post trusses filled with wooden curvilinear filigree supported the front and side gable ends. The exterior walls were clapboarded to the top of the window heads; beneath the eaves, the siding ran vertical and followed Austin's earlier use of the lambrequin motif. A Tudor arch spanned between the paired chamfered piers of the entrance portico. The woodiness of the design leans toward the chalet style popular at midcentury and seems to anticipate the office's Stick Style work of the next decade.[37] Plans and elevations embossed with Austin's stamp for an unnamed, undated, three-and-a-half-story, clapboarded house on a sloping site are among the architect's drawings in the collection of the Avery Architectural

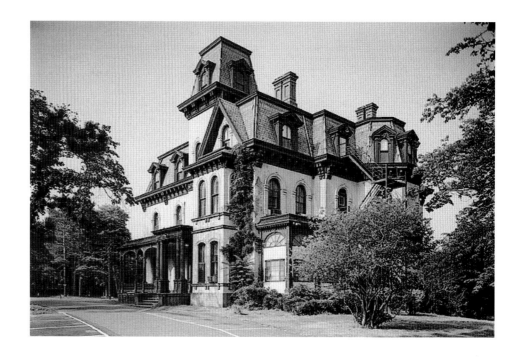

Library at Columbia University. (See Fig. 128.) Woody ornamental details in the gables suggest a date close to that of the Collins house; detailing of the upper level of the two-story porch anticipates that on the porches of the William Clark house at Stony Brook, to be discussed below. The Harmanus M. Welch house of 1870–1871 on West Chapel Street in New Haven, a vertical two-and-a-half-story pile of porches, wings, and chimneys culminating against the sky in open ornamental dormers and gables, all wrapped around a richly finished interior of walnut, echoed in brick the enthusiasm of these later domestic works. Austin's stylistic journey over the previous two decades could be seen—before the demolition of both houses—by contrast to the Italian villa, perhaps also by him, that once stood next to Welch's house.[38]

The Davies house is an impressive pile[39] and the Collins cottage is a charming product, but one begins to miss the special quality of the office's earlier work. This is perhaps best seen in the Elisha Chapman Bishop house on Broad Street in Guilford, a work of 1874. (See Fig. 129.) Several sets of drawings for the house are the property of the First Congregational Church of Guilford, which uses the building as its parish house.[40] Bishop made his money in the oil fields of Titusville, Pennsylvania. A farmer, Republican, Congregationalist, and abolitionist, he fathered twelve children. The large house he commissioned of Austin's office for his home town when he returned from Pennsylvania is a Second Empire wooden

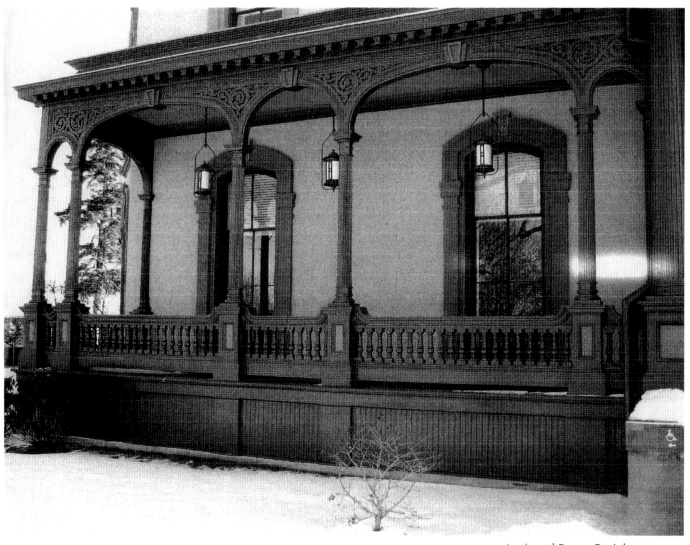

125. Austin and Brown, Davis house. Detail of the exterior. (Author, 2006)

building with clapboards, slate-covered mansard, symmetrical tripartite front, side polygonal bays, round-arched, segmental arched, and trabeated window openings, and other standard details of the style. There is a front block, nearly square in plan, with a wing of nearly equal size offset to the rear. The broad, double-leaf entry doors beyond the porch lead into the central stair hall between the reception room and parlor. The straight flight of stairs rises from Austin's version of a Victorian newel to the second floor divided into seven bedrooms, front and rear, as befitted a man with such prodigious progeny. The third floor, in the mansard, must have accommodated the bevy of servants then thought necessary for such a household. The design is a handsome performance but one that

could have been executed by any number of contemporary architects, and one frequently encountered in the towns of New England and elsewhere.

Austin's office had one more stylistic twist up its sleeve before its principal faded from active participation in a practice that was soon taken over by his son, Fred. In a group of late seaside summer homes, perhaps best represented by the William J. Clark house of 1879–1880 on Prospect Hill in Stony Creek, Branford, Connecticut, the office created some accomplished examples of what Vincent Scully called the Stick Style.[41] (See Fig. 130.) Clark, a state senator and champion of temperance, must have been a killjoy. He was remembered at his death in 1909 as a man who spent his "whole life . . . rooting up the evils that

126. Austin and Brown, Davis house. Stair hall. (Ned Goode for the Historic American Building Survey)

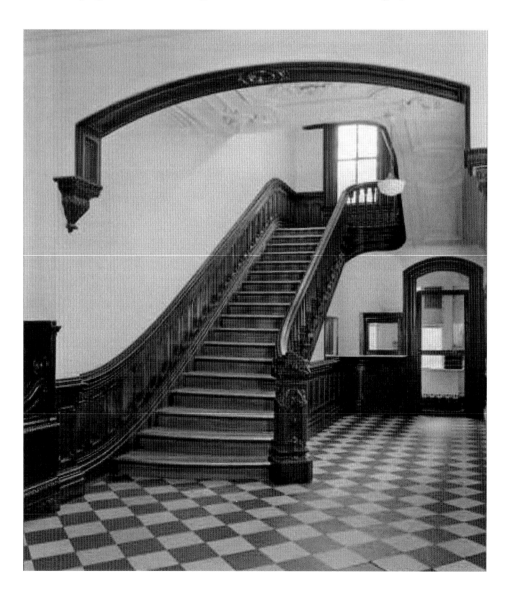

Front Elevation

127. Henry Austin, Charles Collins house, Meriden, Connecticut, 1868. (Photograph © 2008, Museum of Fine Arts, Boston)

he found everywhere."[42] The exuberant house belied the sober man. Like many other coastal houses of the 1870s in Connecticut and Rhode Island, Clark's is a tall wooden gabled dwelling of richly picturesque silhouette and pointed-arched porches created by what Scully said was the constructivist manipulation of the stick. It is clapboarded, with corner boards and a four-story asymmetrical tower with a covered balcony supported on diagonal braces at the third level and topped by a high ornamented gable expanded by tall dormers. Vintage photos show that various gable ridges were edged with cresting and their peaks filled with cutout patterns akin to those at the Collins house in Meridan. As at Dudley Newton's

128. Henry Austin, unnamed house, late 1860s(?). (Avery Architectural Library, Columbia University)

famous 1872 Sturtevant house in Middletown, Rhode Island, the two-story front porch looks out over Long Island Sound. With domestic designs such as this, the Austin office reached a final burst of achievement.

To compare Henry Austin's career to those of his contemporaries such as Ammi B. Young, A. J. Davis, Thomas U. Walter, Isaiah Rogers, Samuel Sloan, or James Renwick is to realize that he was, by contrast, a regional figure. Now described as a "local hero" in southern Connecticut, he indeed had a parochial practice. Yes, there are houses of his design in Maine, and there were commissions in New Jersey and Massachusetts, and perhaps a few other locations, but Austin's career was largely supported by southern Connecticut. It now appears that a numerical majority of his labors were devoted to private houses and small churches, although some of his most memorable works are or were major civic structures in New Haven. Nor did Austin join the profession as a whole. That he never wrote about himself, his work, or the state of architecture of his time, as did contemporaries like T. U. Walter, A. J. Davis, or Thomas Tefft, suggests that he was not a reflective man. One does not find his name in the letters and diaries of a Davis

129. Henry Austin, Elisha Chapman
Bishop house, Guilford, Connecticut, 1874.
(From the Guilford Keeping Society Library
Collection)

or an Isaiah Rogers (who seems to have known and mentioned every peer of con-
sequence). He is not named among the competitors for the design of the Smith-
sonian Institute in 1846 or any other competitions. One does not see him listed
among the conferees, including Ithiel Town, who formed the short-lived Ameri-
can Institution of Architects in 1836 (when, admittedly, he was yet to become a
fully practicing architect) or those who met again in New York to establish the
permanent American Institute of Architects in 1857 (at the height of his career)
and revived it after the Civil War.[43] His Yale Library, Wadsworth Atheneum (both
with A. J. Davis), and New Haven City Hall are important monuments of Ameri-
can architecture, but his reputation does not rest on great works such as Ammi
Young's many government buildings, T. U. Walter's Girard College and exten-
sions to the federal Capitol, James Renwick's Gothic St. Patrick's Cathedral in
New York City, Isaiah Rogers's string of hotels in many cities, or Richard Upjohn's
legion of Protestant churches across the country. The range of his career was

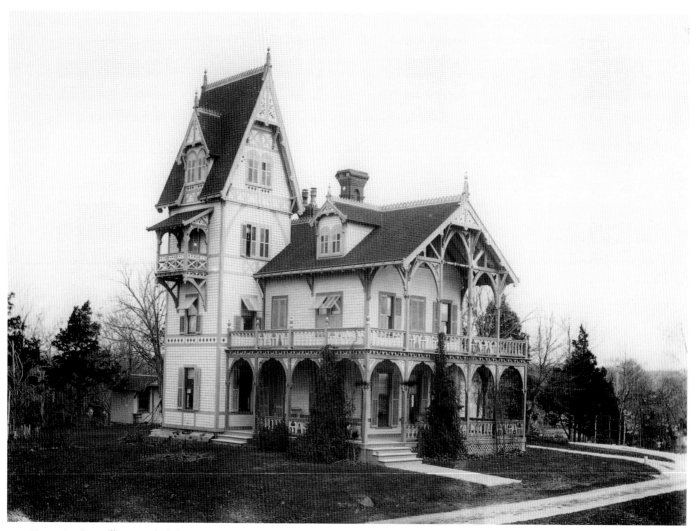

130. Henry Austin, William J. Clark house, Stony Brook (Branford), Connecticut, 1879–1880. (Willoughby Wallace Memorial Library Historical Collection, Stony Brook, Connecticut)

closer to that of his now largely forgotten New Haven rival Sidney Mason Stone or to that of William Fenno Pratt (1814–1900), his near-contemporary in western Massachusetts.

His relative isolation from the mainstream left him free to explore his own tendencies, his own interpretation of useful history, with the aid of available architectural publications. He began to work in a period in which the vast riches of world architecture first became familiar to Western designers. Of the reigning historicism/eclecticism of the era Henry Austin was a master in his own right. He is usually cited for the eccentricity of some exotic forms and details, but that episode was short-lived in comparison to his entire career. In buildings for which he is principally known, from the Egyptian gateway of the New Haven Burial

Ground to the Italianate Morse-Libby house, from the Gothic library at Yale to the creatively eclectic New Haven railway station, Austin produced his own reflection on the culture of his era. And there can be no question that in these and other works he not only shaped the built environment of his native region, he enriched the architectural history of nineteenth-century New England.

There are no hard facts placing Austin in Ithiel Town's office, where he might have had direct contact with the practice and literature of his eventual profession, not as, for example, Thomas Ustick Walter did in Philadelphia under the direct tutelage of William Strickland and John Haviland.[1] But as an architect who developed in Town's shadow, he could have had access to Town's library and must have learned early the necessity of books in the architectural practice of his time. William Dunlap wrote of Town's library that it was "truly magnificent, and unrivalled by anything of the kind in America, perhaps no private library in Europe is its equal. . . . [It] is open to the inspection of the curious, and freely offered for the instruction of the student."[2] Town's origins were in the crafts and he did not draw very well, so he may have accumulated his collection of books to compensate. His erstwhile partner, Alexander Jackson Davis, was a gifted drafter, however, and needed no such compensation, but he too accumulated a large library. Like Town, he offered to share it with anyone interested in improving the public taste.[3] Austin followed suit. What seems to be his earliest advertisement in the local newspaper bears a cut that shows a Corinthian capital resting on drawings, drawing instruments, and books. (See Fig. 2.)

With no collegiate schools of architecture, few institutes that taught drafting, especially outside the large cities, almost no specialized libraries, and few architectural holdings in the public libraries of the time, the emerging professional American architect of the early nineteenth century had typically been forged as an apprentice in a drafting room and was largely dependent upon his own office books, or publications he could borrow from his colleagues, for all he knew about the design, craft, and history of architecture.[4] He aspired to the status of one learned in his métier, like a lawyer or doctor. In a period of historical pluralism in design, as celebrated in Thomas Cole's painting *The Architect's Dream* of 1840, he needed to know the ancient monuments and their modern descendants. There is no record of Austin ever traveling abroad (or anywhere outside of southern Connecticut, for that matter). Few American architects traveled to foreign parts before the Civil War, especially exotic foreign parts, so they had to rely on the latest available publications of their peers. This, of course, largely meant their English and Continental peers, for in the 1830s, when Austin began his career,

there were relatively few publications produced by American architects,[5] and only those abroad had firsthand knowledge of the monuments of the past. Austin's architecture, like that of his colleagues, was *ex libris*.

There is no catalog of Austin's books, as there are of Town's and Davis's.[6] We must rely on scattered bits of evidence and hearsay, as well as surviving books, in order to build a woefully incomplete list of his reference shelf. Where did he find his books? There are sources that say he bought some from auctions of Town's library, whether before or after Town's death in 1844 we do not know. In 1884 Austin apparently told the antiquarian Henry Howe that he had many of Town's books in his possession.[7] George Dudley Seymour also mentions books by Pugin owned by Austin's assistant, Leoni W. Robinson, which Austin had acquired from the sale of Town's library.[8] A surprising number of the latest architectural books were also easily available on the market in New Haven in the 1840s. Between 1842 and 1848, for example, T. H. Pease and S. Babcock, both with bookshops on Chapel Street, offered Joseph Gwilt's *Encyclopaedia of Architecture*, William Ranlett's *The Architect* (in fascicles[9]), Edward Shaw's *Rural Architecture*, George Wightwick's *Hints to Young Architects* (a copy of which we know Austin owned), Asher Benjamin's *The Elements of Architecture*, Chester Hills's *Builder's Guide* (revised, with additions by Austin and Henry Barnard), Louisa Tuthill's *History of Architecture* (featuring five works by Austin), David Henry Arnot's *Gothic Architecture Applied to Modern Residences*, Thomas U. Walter's *Two Hundred Designs for Cottages and Villas* (a title in Austin's library), Walter's *Guide to Workers in Metal and Stone*, William Brown's *The Carpenter's Assistant*, Peter Nicholson's *The Carpenter's New Guide* (13th edition, with additions by William Johnston), John Ritch's *The American Architect* (in fascicles; also in Austin's library), and, to quote Babcock's ad of 10 August 1847, "a great variety of other works on the same subject."[10] Books that Austin might not have owned he could have consulted as well. By the 1850s, there were in New Haven at the Young Men's Institute other reference works on architecture, building, and related subjects.[11]

What is striking about the following list, and suggests its incompleteness, is its overwhelming preponderance of works on domestic architecture. As the foregoing text has demonstrated, Austin was a full-service architect, one who stressed in his early ads his proficiency in domestic design but who, over the decades, turned out buildings to fulfill a broad range of societal needs. Another aspect of this list that argues for its insufficiency is that it largely contains books acquired early in his career. There are just two titles dated after the 1850s. For an architect who relied so heavily on published precedent, he needed to own or have access to

many more books than are catalogued here. And based on what we have here, it can be said that he certainly used his library to suggest visual precedent, for few of these books are largely devoted to the history or theory of architecture.

The following, an annotated list of the books in Austin's possession, is necessarily incomplete, as I have noted, but it does contain some that he referred to for specific projects. In the foregoing text I have mentioned other works—such as John Foulston's *The Public Buildings Erected in the West of England* of 1838—that he must have had access to even if I cannot prove it. There can be little doubt that he owned more than the twenty-four titles listed here. Surely continued search in the vast holdings of the Beinecke, Mudd, and Sterling libraries at Yale University, and perhaps in antiquarian bookstores in southern Connecticut, will uncover more.

In 1948 Carroll Meeks published a list of the books he found at Yale known to have belonged to Austin by the presence of the architect's signature and (often) the date of purchase.[12] They are listed first here. The second group is also at Yale but is not mentioned by Meeks.[13] I have added bibliographical details and notes.

1. John Buonarotti Papworth, *Rural Residences*, 2nd ed., London: R. Ackermann, 1832.

> Purchased for $5 in 1840 ($1 for binding). This volume has no signs of extensive use, no annotations, and nothing that closely resembles Austin's work.

2. Edmund Aiken, *Designs for Villas and Other Rural Buildings*, London: J. Weale, 1835.

> Purchased for $5 in 1836. A well-used book with one domestic design with an overhanging hip roof close to some Austin drawings in the books at Yale. There are also "Mohammedan Style" designs including one with columns vaguely akin to Austin's candelabra supports. The author says that they imitate buildings generally prevalent in Turkish dominions and in "Hindostan." He cites Thomas Daniell's *Oriental Scenery*. The style, he says, has a strong similarity to Gothic and considerable elegance but is inferior to works of the Classic and/or Gothic Revival. Aiken also includes a double bow-front residence akin to Austin's Hotchkiss house of 1850 and other residences.

3. John Claudius Loudon, *An Encyclopaedia of Cottage, Farm and Villa Architecture and Furniture*, new ed., London: Longman, 1835.

> Loudon was a fundamental source of information for American architects. Perhaps this work was acquired from the auction of Town's books in 1847.

Meeks had earlier noted that Austin also possessed the "First additional supplement" to this work dated 1842.[14] He suggested Austin's heavy use of these volumes, as indeed was true of many other American architects and writers of the period, including A. J. Downing.

4. Francis Goodwin, *Rural Architecture . . . Designs for Rustic, Peasants', and Ornamental Cottages, Lodges, and Villas, in Various Styles of Architecture*, 2 vols., 2nd ed., London: J. Weale, 1835.

> Meeks gives no date of acquisition. Goodwin on the Italian villa: "[A] tower or other lofty *belvedere* is a pleasing addition to a country residence, especially if near the sea, or in any situation to command an extensive and varied prospect. . . . [B]esides their other uses, [they] will enable the inmates . . . to espy the approach of unbidden, undesired visitors—any *bores* for instance. . . . [S]uch a place [might be] a delightful *snuggery*— a kind of aerial boudoir, equally fitted either for speculation or for meditation." He shows designs in a complete menu of styles, but seemingly too large for American domestic needs.

5. James Thomson, *Retreats: A Series of Designs, Consisting of Plans and Elevations for Cottages, Villas, and Ornamental Buildings*, 2nd ed., London: M. Taylor, 1835 (1st ed., 1827).

> No date of acquisition given; purchased for $12 ($1 for binding). A series of colored lithographs of elevations set in perspective landscapes. Pl. 38, a bath house, has columns with floral bases: "the ornaments composed of water-leafage or such as have soft and flowing outlines."

6. Peter Fredrick Robinson, *Designs for Ornamental Villas*, 3rd ed., London: Henry G. Bohn, 1836.

> Purchased for $12 on 8 September 1843. Designs for residences in the Swiss, Grecian, Palladian, Old English, Castellated, Ancient Manor House, Modern Italian, Anglo-Norman, Henry VIIth, Elizabethan, Ancient Timber, and Tuscan styles. The author has avoided the "Asiatic mode . . . as incompatible with the arrangements necessary to a residence in the country" and the Egyptian without explanation.

7. Peter Fredrick Robinson, *Domestic Architecture in the Tudor Style*, London: Printed for the author, 1837.

> It is not clear from Meeks's note whether or not this was purchased with the above work.

8. A. J. Davis, *Rural Residences*, New York: for the author, 1838.

> Davis's pioneering house book. Meeks grouped this with the following.

9. [*Plans and Elevations of Buildings Mostly Designed by Ithiel Town and Alexander Jackson Davis*].

> Now in the Beinecke Library. Untitled, undated (although the buildings shown are from the 1830s), bound, engraved sheets. A more descriptive assigned title would be "Engraved Plans and Perspective Views of Buildings Mostly by Town and Davis." Includes T. U. Walter's Girard College and a plan of the U.S. Capitol (measured and drawn by Town and Davis).

10. A. W. N. Pugin, *The True Principles of Pointed or Christian Architecture*, London: Henry G. Bohn, 1841.

> Purchased for $5 on 18 October 1845. According to George Dudley Seymour, Leoni W. Robinson possessed two volumes of Pugin (the other perhaps being *An Apology for the Revival of Christian Architecture*, 1843) that he procured from Austin, who had bought them at one of the auctions of the library of Ithiel Town.[15] A fundamental source for the Gothic Revival.

11. Thomas Ustick Walter and J. Jay Smith, *Two Hundred Designs for Cottages and Villas*, Philadelphia: Carey and Hart, 1846.

> Meeks gives no date of acquisition. A book of largely crude illustrations. Walter here published the plan and elevation of a villa that is strikingly similar to the preliminary design of the Wadsworth Atheneum. Several projects were taken from other publications, such as Papworth's. A copy was available at Babcock's bookstore in New Haven in February 1847, according to an ad in the *Daily Register*.

12. John W. Ritch, *The American Architect, Comprising Original Designs of Cheap Country and Village Residences*, 2 vols., New York: C. M. Saxton, [1847–1850?].

> Meeks gives no date of acquisition. This pattern book was sold in monthly installments, each containing the design for one low-cost house of varying style in the customary set of graphics and specifications intended to make hiring an architect unnecessary. Austin's own design books, had they been published, might have looked something like this. According to the author, "there is no style of Architecture known, which is better adapted for Country Residences, than the Italian." Although intended for a general readership, the complete publication contains many designs related to Austin's earlier domestic work, including a near copy of the George Gabriel house. The first numbers of this publication were advertised by the New Haven booksellers Durrie and Peck in the *Daily Register* for 9 September 1847.

13. George E. Woodward and Edward G. Thompson, *Woodward's National Architect*, New York: George E. Woodward, 1869.

> Purchased for $12 on 8 May 1872. Contains many designs "for the practical construction of dwelling houses for the country, suburb and village." It first appeared in 1868.

14. Ticknor & Company, *Architectural Sketch Book*, Boston, vols. I–IV, 1873–1876.

> With the *New York Sketch Book* of 1874–1876, this series published many examples of what Vincent Scully came to call the Stick Style, a style Austin employed in several late coastal "cottages."

15. *Architektonisches Album*, 3 vols., Potsdam: Ferdinand Riegel, 1840–1859.

> A note in Volume III reads "Henry Austin, 1860, paid $10.00 binding $2.00." Meeks noted that the flyleaves for Volumes I and II were missing. According to the Yale library catalog, the entire title is now missing.[16]

16. Ludwig Hesse, *Sanssouci in seinen Architecturen*, Berlin and Potsdam: Verlag von Fredinand Reigel, 1854–1856.

> According to Meeks, who describes it as containing complete plates for F. L. Persius's Friedenskirche in Potsdam, "this seems also to have been in Austin's hands." The copy I inspected at Yale is not signed.

17. Karl Moellinger, *Elemente des Rundbogenstiles fuer Schulen und zu technischen Zwecken*, Munich: E. Roller, 1845–1847.

> This contains the visual grammar of the Round-arched Style, and Austin certainly found use for it in his ecclesiastical work of the late 1840s.

Other books bearing Austin's signature are in the Beinecke Library at Yale:

18. George Maliphant, *Designs for Sepulchral Monuments, Mural Tablets, &c.*, London: M. Taylor, 1835.

> Signed and dated 1840. There are designs for burial monuments in the larger drawing book at Yale, but they owe nothing to this work, which contains engraved Neo-Classical and a few Gothic designs. Pl. 16, a sepulcher in a niche, bears sketchy graphite changes.

19. Luis de Sousa, *Plans, Elevations, Sections, and Views of the Church of Batalha . . . with the History and Description by Luis de Sousa; with Remarks. To Which Is Prefixed an Introductory Discourse on the Principles of Gothic Architecture by James Murphy*, London: I. & J. Taylor, 1795.

> Signed by Austin and dated 1840. The German scholar Georg Germann characterized this as "the first reproduction of a Gothic building comparable with the . . . reproductions of antique temples" published by

Stuart and Revett "some forty years before."[17] Among the subscribers was Boston's Charles Bulfinch.[18] Town also had a copy. Austin must have salivated over—and was perhaps a bit depressed by—these large, lovely engraved plates depicting a royal monastery in Estramadura as he began his own work designing small, provincial Gothic Revival churches. Murphy's principles may have intrigued him but would seem to have been of little use in southern Connecticut.

20. George Wightwick, *Hints to Young Architects . . . with Additional Notes and Hints to Persons about to Build in the Country by A. J. Downing*, New York & London: Wiley and Putnam, 1847.

> Signed and dated 1849. Austin managed to ignore all of Downing's strictures on the use of the styles of "barbarous or semi-barbarous peoples," although he did follow Downing's preference for cubic or rectangular houses such as those "agreeable" cottages on Hillhouse Avenue in New Haven, and much of his Indian Revival work was behind him by 1850. Downing provides an eighteen-page template for American specification writing to augment Wightwick's eighty-page illustrated template for English specifications. The New Haven bookseller S. Babcock offered this title for sale in the *Daily Register* of 2 February 1847.

21. Robert Meidleham, *A Dictionary of Architecture*, 3 vols., London: Jones, [1825?].

> Volumes 1 and 3 are signed. All three volumes also bear the signature of Fred. D. Austin. The title page gives the author's name as Robert Stuart.
>
> Volume 3 contains plates illustrating articles on architecture and its history.

22. William Pain, *The Practical Builder, or Workman's General Assistant: . . .* [with] *Rules of Carpentry . . . : with Plans and Elevations of Gentlemen's and Farm-houses, Barns, &c.*, 4th ed., London: I. and J. Taylor, 1789.

> A work sold at the Town auction in 1847.

23. John Buonarotti Papworth, *Hints on Ornamental Gardening*, London: R. Ackermann, 1823.

> Signed and dated 1840. Pl. V shows a plantation seat with bronze "pillars" of slender floral candelabra design; Pl. XX is an alcove with iron "pillars" of floral candelabra design.

24. Georg Gottlob Ungewitter, *Vorlegeblaetter fuer Ziegel- und Steinarbaeiten*, 2nd ed., Leipzig: Romberg's Verlag, [1849].

> The flyleaf bears no signature, but it is dated in what looks like Austin's hand: "May 1st 1854 $6." A small folio with details of brick and stone

architecture. One immediately thinks of Austin's brick *Rundbogenstil* church in Waterbury, but it was dedicated in March 1854, so this book could not have been its inspiration.

George Dudley Seymour says that Austin subscribed to English illustrated periodicals. One was certainly the *Illustrated London News*, a cut from which inspired the design for the New Haven City Hall.[19] Another might have been *The Builder*, from which other ideas for City Hall might have come.

At Austin's death, many of his nonprofessional books were bequeathed or sold to the New Haven Public Library. There seems to be no way now to document their titles, although Meeks said they numbered fifty volumes and named some in a talk he gave in the 1940s. He listed the *Autobiography, Reminiscences and Letters of John Trumbull* (1841), *The Private Life of Daniel Webster* (1852), *The Autobiography of J. B. Gough* (1847), *Seymour's Self-Made Man* (1858), and *The History of Napoleon* (1841).[20]

Architects of Austin's generation learned how to draw to set themselves apart as emerging professionals from the mechanics they had been, to assume direction of building operations away from the building site, or to present their services to the public. Because of their skill at the drafting board, they often left an extraordinary record of their careers. Austin's Boston contemporaries, for example, such as Jonathan Preston (1801–1888) and George M. Dexter (1802–1872), left large collections of drawings. The Boston Athenaeum holds eleven volumes containing some 1,200 drawings by Dexter alone, and his successor, Nathaniel J. Bradlee (1829–1888), added another thirty-two volumes and an estimated 5,600 drawings![1] Given such resources, the position of the historian of Boston's nineteenth-century architecture is an enviable one.

Documentation of Henry Austin's life and work is much sparser; the historian's job consequently is more difficult. Austin left nothing like the records of his Boston peers, yet we do know most about his first decade and a half of practice because of the existence of a collection of some one hundred drawings from his office now housed in the Archives and Manuscripts Division of the Sterling Library at Yale University.[2] Little has been written about them, but they deserve special attention because they are so important to our understanding of Austin's early work and because they represent the most concentrated body of information we have about any period in his career. The study of the forty years of his life after these drawings without such a useful guide to his production is a hit-or-miss gathering of scattered information. Drawings exist from this later period, but they are spread throughout other collections and in private hands. The relative density of this early documentation has often made Austin's first years seem to represent his entire career, however, and this has distorted our assessment of his achievement. And the collection of drawings itself raises many unanswered questions. Chief among them might be why Austin never produced more collections of the kind. What we have represents only a fraction of his working life.

The drawings were apparently first mentioned in print by the fundamental—if not entirely reliable—source for the study of Austin, George Dudley Seymour, in his 1910 article on the first library building at Yale.[3] Basing his information

on the memories of architects he interviewed long after the fact, the antiquarian wrote without reservation that an English draftsman named Henry Flockton, who reportedly worked in Austin's office, "was . . . a water-colorist and made the water-color drawings contained in two volumes of Austin's now in the College Library. Some of these water colors by Flockton are dated in the 'forties,' and in this way the fact is established that Flockton as working for Austin at that time."[4] As we shall see, this cannot be verified.

The next apparent mention of the collection is found in Carroll L. V. Meeks's study of Austin and the Italian villa. This I must quote in full:

"The best record of his early work is the one he made himself. Yale University has two volumes of original drawings, neatly bound, and arranged with tables of contents, page numbers, et cetera, which probably indicate that they had been intended for publication, although they may have lain on his waiting-room table like a catalogue of his repertoire. The elevations are exquisitely rendered in watercolor and the pages are framed by tinted washes and colored rulings. They comprise the work executed or designed before 1851, very few of them are dated, but other evidence indicates that they go back to about 1839, two years after he opened his own office."

In a footnote Meeks cited one book as *Churches, Mansions, Villas* and the other as *Dwelling Houses, Stores and Banks*, dated 1851.[5] This description is useful but wants scrutinizing.

The books are now dismantled and the various projects placed in separate folders. The drawings are representative of the draftsmanship of the time. They are all ruled ink or ink and watercolor on woven paper, some with later graphite emendations.[6] There are plans, a few sections, exterior elevations, interior elevations for only one bank project, and an occasional perspective. Repeated examination of the sheets has revealed no signatures or initials (other than Austin's), although we know that there were assistants in the office.[7] At this date draftsmen were not individualized, as some were to be later in the century.

The title page of one collection, the smaller of the two (9⅝" × 12¾"), reads, more correctly, DWELLING HOUSES, / STORES, BANKS, / CHURCHES & MONUMENTS. / designed by / HENRY AUSTIN. / ARCHITECT. / NEW HAVEN. CONN. The date 1851 appears in a cartouche at the bottom of the sheet. A decorative border of flowers, a shell, and female nudes frames the text. (See Fig. 131.) Most of the following plates also have ornate borders. Despite what Meeks wrote, there is no Contents page now present for this gathering, and the numbering of designs ends at sixteen, although there are eight more projects. There is only one bank

DWELLING HOUSES,
STORES, BANKS,
CHURCHES & MONUMENTS.

designed by

HENRY AUSTIN.
ARCHITECT.

NEW HAVEN. CONN.

1851.

in the present collection, but the title is otherwise accurate. All of this makes the compilation (hereafter, and above in the text, called the "smaller book") seem to be tentative, perhaps unfinished.

Meeks oddly says nothing about title pages. I do not know whether he saw one or two, but there is only one now, for none exists for the second group of drawings, on larger sheets (12¾" × 16"), and here too the title he gives is misleading. There are designs for villas, railroad stations, a hotel, a bank, cemetery gates, churches, and a series of door and window frames. There are thirty-eight numbered designs, all labeled (some generically) on the three Index pages of what is hereafter (and in the text above) called the "larger book." The end of the Index is decorated with a tailpiece composed of a cluster including a Corinthian capital, T-square, triangle, calipers, trowel, and a sheet of paper bearing a plan. There is no reason to believe that the drawings are not all contemporary; indeed, the two dates on drawings in the larger book are compatible with the date of the title page of the smaller book. I have combed through both of the gatherings four times, and I have found only two originally dated sheets in the larger book: the Northford church, 1845 (see Fig. 59), and the Moses Beach house, 1850 (see the frontispiece). Although the perspective of the New Haven Railroad Station has the note "Built 1848," it has the look of an inscription added later. (See Fig. 93.) Here too, many of the sheets have ornamental borders. As I have noted, nowhere have I found any initials or any name other than that of Austin. It is sometimes given in script and sometimes in block letters (with variations within those categories). There are no precise duplications between the books, although there are some variant projects. As we shall see, they are not comparable in other ways as well.

The first question to ask of these gatherings is, what do these drawings represent or, better, why were they prepared? They were not intended for the builder, so they must be drawings made for publication and/or to show to prospective clients (the two are not incompatible). There is no sign that they have been scored, pounced, or pricked for copying, as was so often the case with drawings of this kind from this period. The bulk of them are plans and elevations. True perspectives appear for only a small segment of the projects, although many of the elevations are given landscape settings, some unrelated to the actual site on which they were built. Variations in the quality of the renderings of landscape and staffage, as well as in the lettering, seem to suggest the presence of more than one drafter, but the sheets do appear to have been produced over a brief period of time. I assume that all these drawings were begun toward the end of the 1840s. The best

way to think of them is that they were prepared with publication in mind. The ornate title page of the smaller book and the presumed presence at one time of a like page and the surviving Index or Contents page for the larger book suggest this, as does the fact that in some cases the drawings seem after the fact, that is, produced after the buildings were erected. Austin's interest in and use of books for instructing his clients in the various styles is documented.[8]

The drawings were certainly not used to instruct a builder. Few are dimensioned, although a calibrated bar indicating scale is often present. For reasons unknown, they were never published as they appear here (absent financing, lack of interest on the part of a publisher, competition from similar books that appeared at about the same time, the interference of too much other work, the departure of the drafter or drafters?), and they seem to have become just what Meeks suggested: pattern or sales books aimed at a more limited audience, one that came to Austin for a design. This is suggested by the numerous pencil additions, alterations, dimensions, and notes to be found scribbled over many of the finished watercolors. It is also suggested by the fact that the buildings in some unlabeled drawings were later erected or intended to be erected for specific clients, as we learn from their names penciled on the plates. The only other idea consistent with the freehand graphite changes is that the designs were in the process of being revised for publication when the project stopped, but there are changes penciled on designs that were erected without including them. This suggests a conversation between architect and client in which the architect, pencil in hand, says, "We did it this way then, but we can alter it this way for you now."

Who drew these projects? There are five men known or thought to have been in the office during all or part of this period: Austin himself, his brother Merwin, the Englishmen Henry Flockton and Gervase Wheeler, and David Russell Brown.[9] Any or all are therefore candidates for the job. It is always possible, too, that there were others now unknown. The fact that most sheets bear the boss's name says nothing about who drew them. The late drawings prepared at Taliesin are signed or ciphered by Frank Lloyd Wright, but we know he did not execute them. H. H. Richardson ultimately produced nothing but conceptual freehand sketches, but finished drawings bear his name. The same can be said of most offices. There are in collections other than Yale's a few drawings for very early work finished in watercolor washes that might suggest Austin's hand. The elevation of the almshouse for Hartford (see Fig. 85) or the drawing for an unnamed town house suggest that he did not work on the books.[10] The washes of the almshouse drawing especially are below the standard set later, and neither

of these drawings shows the elevation in a landscape setting (or even a ground line). Others in Town's orbit, like Dakin or Davis, proved to be much better drafters.

I detail the presence of Austin's assistants in Appendix C, but must briefly mention here those who were known or thought to have been in the office in the 1840s. Merwin Austin left the office for Rochester in 1844; when he arrived is unknown. It is difficult to date most of the projects, but it is possible to close in on some. The design (if not the precise drawing of it in this collection) for a Gothic cottage in the larger book, for example, must have existed before Merwin decamped, because he drew upon it for Elm-Wood Cottage at Mount Hope, New York, a view of which was published in January 1846.[11] Did he draft the project? As Meeks noted, the designs in the collection may date from anytime between 1839 (the Gabriel house) and 1851 (the date in the cartouche of the title page of the smaller book), but the existing drawings could have been executed at any time after the projects were conceived, and after Merwin departed, so we cannot say for certain that he drafted this or any other sheet.

Henry Flockton, despite Seymour's certainty, may or may not have been the drafter. He was in New Haven between circa 1845 and circa 1851, so he was on the scene, if not certainly in the office. But even if we accept the memories collected by Seymour from old men who had heard stories of his participation, we don't know anything about Flockton's "hand." As an architect trained in England, he should presumably have been skilled at watercolor, as Seymour says. So, indeed, should Gervase Wheeler. We know Wheeler was associated with Austin by 1847 and assume he hung around—or was in and out—for a year or two. (He might have been confused with Flockton in later memories.) That he was a graphic art-ist of some repute is confirmed by his contributing directions for drawing in pen-cil and crayon to C. Kuchel's *Columbian Drawing Book* of 1849.[12] We also have architectural drawings certainly by him. The most pertinent ones are the signed plan and elevations for an unnamed Italian villa dated circa 1850 that entered the collection of Historic New England with some Austin drawings.[13] They look like the drawings in the books, but the problem is that all are standard products of the time and show few personal touches except in setting and staffage. The rudimen-tary landscaping that appears on the Wheeler drawing is found also on some Yale sheets, but this is too indefinite a criterion to establish his hand as a drafter. Some of the landscape settings and the rendering of skies in the collection are quite accomplished, but they are not necessarily the work of a drafter trained in Eng-land. And Wheeler left New Haven well before the 1851 date given as the termi-

nus of these collections. According to Seymour, Brown joined the office at about the same time as Wheeler, at the age of sixteen, with, of course, no prior training that we know of. He stayed into the 1860s. Seymour says that he became a skilled drafter, and the accomplished 1861 watercolor elevation of the New Haven City Hall that is assumed to have been executed by Brown, if it is by Brown, would seem to prove him right.[14] (See Fig. 108.) But did Brown develop so fast that after a year or two he could turn out the drawings in these books?

All of this leaves many questions hanging in the air. When we turn to what the drawings tell us about Austin's work in the first decade of his practice—whatever their reason for existing, whoever drew them—we are on firmer ground. There are designs for executed buildings, unexecuted projects, drawings for structures later altered or demolished, and sheets of standard details. Many are identified, some are not. Some were prepared for named clients, others have later specifics penciled in, some remain generic. Where a design was executed, the existing building usually but not always agrees with the drawings. All are valuable, but not equally.

In the smaller book, the dwellings range from elaborate Italian villas to small or large cubical houses to urban town houses. There are many variations on small, simple Italianate boxes. There are also designs for a church, commercial buildings, the elevation of a bank, and two sheets of cemetery monuments. It would appear that only the bank (labeled SPRINGFIELD BANK) and the church (St. John's Episcopal, Waterbury) were drawn with a specific place or client in mind (several residential designs, including the Carrier house, have penciled client names that must have been added later[15]). Comparison with the larger book suggests that this one, unfinished, largely generic, with projects of a somewhat restricted stylistic range, preceded it.

More than half of the designs in the larger book bear the name of a client, whether a home owner, a railroad depot, a bank, a cemetery, or a congregation, although fifteen of the thirty-eight projects are generic. The designs are more varied than those in the smaller book. Among the houses, for example, are those in the Neo-Classical, Italianate, Gothic Revival, Baroque, octagonal, and Indian Revival styles and some combinations thereof. The bank project adds Renaissance Revival to the menu; the churches tend toward the *Rundbogenstil*. Except for the sheets of window and door designs, which have the appearance of a catalog or kit of design elements available at the architect's office, this has the look of a compilation of specific work projected or accomplished. The book proves that Austin had largely made good on the promise early in his career when he

advertised in the local papers in New Haven and Hartford that he was prepared to design works "in every variety of Architectural style."[16]

Finally, these books tell us something about Austin's approach to architecture. Here we have one sheet after another of manifestations of stylistic variety. There is no text or the traces of an intention to produce one. Austin was a stylist, not a theoretician; a man of forms, not ideas. As we have seen, L. Roy of Hartford thought of him as supplying perfect proportions.[17] This too sets him off from some of his better-known contemporaries. By contrast, for example, during the decade in which Austin's office designed these projects and prepared these drawings, Philadelphia's Thomas Ustick Walter, nearly his exact contemporary, was not only designing buildings but also delivering a series of public lectures on the history and philosophy of architecture, lectures he intended to publish but never did.[18] A. J. Davis also publicly discussed the history and design of buildings. There is no record that Austin did likewise. He used his professional library (see Appendix A) as visual fodder; Walter used his more ample library as intellectual as well as visual stimulus.

There are in scattered collections and individual buildings in New England other drawings known to have originated in Austin's office, some of which have been noted in the forgoing chapters. These are workman-like graphics that add little to our knowledge of Austin's drafting room practice or, indeed, to the history of New England or American architectural graphics. They loom large, however, as added documents of a career that is woefully underrecorded.[19]

When we attribute architectural work to a sole individual, as I did, for example, in *The Architecture of Frank Furness*, we subsume under one name the labors of an office staff that might range from a few drafters to an army of skilled professionals. We know that the person behind the name on the door leads the team, but the team is nonetheless essential. Although ego made it difficult to admit, Louis Sullivan alone could never have turned out the work attributed to him without the engineering of Dankmar Adler or the assistance of Frank Lloyd Wright, George Grant Elmslie, or any number of other office personnel. This is especially true of celebrity architects, like Wright, who often lead glamorous or complicated lives worth the telling in their own right. It does not, however, do full justice to an understanding of the historical process through which the work was accomplished.[1]

It is necessary to think of the architect not as an individual but as the center of a group, as the head of an office, large or small. And it is necessary for historians to learn as much as possible about the makeup of that group, to trace the reciprocal connectors out from the center to those who were on the perimeter but nonetheless in a position to influence the product of that office. As much as possible, we should try to define the character of peripheral members in order better to understand the character of the central figure and the work of the office. Such a task can be relatively easy, as it ought to be in the case of the office of Adler and Sullivan, for example, or it can be more problematic, as in that of Henry Austin, where we lack not only detailed information about the center but about the periphery as well. In any case, we must gather what we can if we are to begin to place Austin's career in context. Although much research still needs to be done in this area, quite a bit is now known about some of his associates.

Austin opened an office first in New Haven in early 1837, moved to Hartford from 1839 to 1841 (or perhaps, better said, also worked out of an office in that city during those years), then resettled in New Haven for the rest of his long career. His first office may have been "over Eli B. Austin's store" in Chapel Street, New Haven.[2] From various other advertisements and directories we learn that in 1840 he drafted "over No. 4 State street" in Hartford and then worked out of the "Kellogg's Building, No. 136 Main Street," in that city. He "re-opened his office at

No. 4 Mitchell's Building" in New Haven in 1841, and by 1860 he was in Street's Building, 746 Chapel Street.[3] At the end of his life, the office had rooms in his Hoadley Building. From various sources, we also know that after the first years he was not alone in any of these places. His position as professional pioneer in Connecticut and teacher of his many assistants led, according to Seymour, to his honorific as the "Father of Architects."[4]

An 1887 article on Austin, written, that is, while he was still alive and presumably available for information, says that by 1840 he needed assistance in the drafting room and had since then continually employed on average three helpers.[5] The first notice I've seen of another person in the office is in an item in the *Palladium* on January 1842 in which the editor describes a visit to the rooms of "Messrs. H. & M. Austin."[6] Although this seems to imply a partnership, that is rather unlikely. Merwin Austin (1814–1890), ten years younger than his brother Henry, would have been twenty-seven at the time.[7] Nothing has yet come to light about his training, but we can imagine that what he knew he learned in that office. He did not stay long. By 1844 he was in Rochester, New York, listing himself in city directories first as an architectural draftsman and then as an architect. A professional pioneer in that area, he practiced until 1868, when he disappeared from local directories, and then returned to New Haven,[8] where he died (although he is buried in Mount Hope Cemetery, Rochester). Did he rejoin his brother's office in the 1870s and 1880s? His first New York buildings show major dependence on the products of the New Haven work of the 1840s: his Gothic Elm-Wood Cottage for Mount Hope, New York, of 1845 is by A. J. Downing out of brother Henry.[9] His 1849 Brewster house in Rochester apes Henry's formula of a box surmounted by a cupola and fronted by a portico, in this case ogival, as was his brother's design for the contemporary Brainerd house in Portland, Connecticut. (See Fig. 27.) Merwin's later work shows more independence. He was soon joined in the area by a teenage A. J. Warner (1833–1910), his (and thus Henry's) nephew, who founded a firm carried on by his son, J. Foster Warner (1859–1937).[10] Through Merwin and the Warners, something of Henry Austin's legacy reached into the mid-twentieth century in Rochester.

A second name that has been associated with Austin's office at this early period is that of Henry Flockton (ca. 1818–after 1872). It should be noted immediately that the name does not appear as Austin's helper in known documents of the period, but at the time there were only two architectural offices in the city, Austin's and that of Sidney Mason Stone, so the chances are fifty-fifty that he did work for

Austin. We first hear of Flockton as Austin's assistant in the articles written much later by the antiquarian George Dudley Seymour (1859–1945) based on his interviews with architects who either worked for or were competitors of Austin. In this source we learn that Leoni W. Robinson (1852–1923), who later worked for Austin, told Seymour of the tradition that "a skilled English draftsman . . . worked on the drawings" for the library at Yale, and that that "helps to account for the merit of the design."[11] That, we are also told, was Henry Flockton, who was also a water-colorist "and made the water-color drawings contained in two volumes" now at Yale, some of which, Seymour says, are dated in the 1840s, proving he was in the office then.[12] From Duncan MacArthur, who worked in the office in the 1870s, Seymour also learned that Austin spoke of Flockton as a genius. And Seymour adds that "Flockton was then a man of middle age and tradition describes him, with reproach, as 'uncommon shiftless.'" This "information" has been carried into later discussions of Austin's work.

Tradition can be a powerful tool for the historian, but in this case it needs adjusting. Flockton may or may not have worked for Austin, but he could not have assisted in the design of the Yale library. The Austin and Davis project was set in 1842.[13] Flockton arrived at New York in 1844, disembarking on 2 April of that year from the clipper ship *Yorkshire* of the Black Ball Line, David Godwin Bailey, master. The list of passengers, who boarded at Liverpool, sworn to by Bailey, includes "#94: Henry Flockton, 26, Architect, England."[14] Unfortunately, we know nothing of his background. He first appeared in the New Haven city directory in 1845 and was continually listed through 1851. According to the directory he did return briefly in the mid-1860s, so MacArthur may have remembered him from a later period, when he would have been middle-aged, but there is no other record of his working for Austin then either. Since his first stay in the city lasted from 1845 to 1851, the latter the date on the title page of one of the drawings books at Yale, he could have been available as draftsman for that collection.[15] There is nothing especially English about most of the watercolor drawings in these books, however, and I can find no signature (other than Austin's) or initials on any sheet. They seem to be the standard drawings that issued from American architectural offices of the period created by draftsmen who emerged from the trades at the beginning of professional practice and lacked the kind of training available to an English architect. As for some projects that came from the office during Flockton's presumed tenure there, his English training might have helped with Gothic ecclesiastical work, but Austin was in the process of shifting to the Round-arched

Style. Sometime in the 1850s Flockton drifted south to Philadelphia, where in the 1860s he shared for a while an address with Samuel Sloan.[16] Nothing more about his New Haven sojourn has come to light.

If it cannot be said with any certainty that Henry Flockton brought an English presence into Austin's office in the 1840s, it can be said without hesitation that Gervase Wheeler did. (Indeed, the latter might have been confused or conflated with Flockton in later memories.) Wheeler's date of birth is given variously as circa 1815, circa 1823, and circa 1825. What is certain is that he disembarked from the *General Victoria* at New York on 10 February 1847,[17] and in March he met William J. Hoppin of that city.[18] In a letter of that month written to Leonard Woods, the president of Bowdoin College, Hoppin reported the encounter and said that Wheeler claimed to have studied with A. W. N. Pugin and R. C. Carpenter, the noted Ecclesiologist. If this was true, he represented the latest phase of the Gothic Revival, a man trained at the cutting edge of the profession in England.[19] Writing himself to Dr. Woods from New Haven five months later, Wheeler said he had "entered into arrangements with a gentleman here (Mr. Austin, an architect of considerable practice & [illegible]) to join in business and our [illegible] commences the 1st September next. . . . My engagement with Mr. Austin will make no difference whatsoever [in regard to you]."[20] The *General Victoria*'s manifest lists Wheeler's age at embarkation as twenty-four. This is either very wrong or, what is more likely, suggests that any contact he had with Pugin and Carpenter was rather brief. And would Austin, then forty-three and an established architect, have taken a raw immigrant into a presumably equal association? Perhaps, if Wheeler had adjusted his age and convinced Austin that he had indeed worked for such distinguished English masters. During Wheeler's American years, his reputation for truth-telling suffered some.

Whatever Wheeler's age or his credentials in ecclesiastical Gothic architecture might have been, what part of that style he might have contributed to Austin's practice in this regard is not easy to determine. From the above, it seems that the "arrangement" was a loose one in which Wheeler was free to take on his own commissions. In any event, by 1847 the library and the Wadsworth Atheneum were history. So was most of Austin's work in the ecclesiastical Gothic, a fact that seems to have pleased Wheeler, who saw little to praise in it. In another letter to Woods written from New Haven in September 1848, he reports oscillating between New Haven and Hartford and goes on to say that "We are very full of business in the office [presumably Austin's] but I am sorry to say have no churches excepting one here nearly finished & of a character that I am glad to

have escaped any connection with. . . . [O]n the whole I am rather glad perhaps that there *are no* churches going on as I know I should be cruelly mortified in having to shape *my* ideas of propriety & beauty and correctness in accordance with those "*critics*" about me."[21]

Despite those caustic remarks, Wheeler also mentions in this letter a joint ecclesiastical venture in Hartford. "They talk of erecting a college chapel there, and Mr. Austin & myself are I suppose certain of doing it," he wrote. Attempts to identify this commission, or to learn whether any drawings were executed, have led nowhere. There is no record of a chapel having been erected at the old campus of Washington, later Trinity, College.[22] And despite his sneering at Austin's Gothic, Wheeler himself turned out a small wooden Gothic church for the Congregationalists of Berlin, Connecticut, in 1849. There is little to choose between it and Austin's work and certainly nothing to suggest that Wheeler had indeed trained with Pugin or Carpenter.[23] Perhaps it was all he could manage in so provincial a situation, but there is a tone of braggadocio in all of his correspondence and a hint of his reputation as a prevaricator in that of others.

Wheeler's carpenter Gothic Boody house in Brunswick, Maine, is dated 1848–1849. At about this time, the office produced a series of designs for Gothic cottages. Wheeler's contribution to these projects is questionable, however. In these works both architects followed the lead of A. J. Downing. The drawings for Austin's Scoville House show his admiration for Downing's s work,[24] while a slightly altered version of the Boody house appears in Downing's *Architecture of Country Houses* of 1850. With Downing's books on his drafting board, as surely he had, although this has not been verified, Austin did not need Wheeler's intervention to produce his Gothic domestic works

The design of one work from Austin's circle can be assigned to Wheeler with some certainty, however, but not a Gothic one. The letter just quoted goes on to say that Wheeler is "getting out" the drawings for a "large hotel about to be built here, which I am endeavoring to make as artistic as I can & it seems to be liked very much. The drawing will be exhibited Friday and I want to hear what the people will say as it is rather an experiment on my part the style being very chaste & purely worked but Italian; one of the fronts being very like Barry's Travelers [*sic*] Club House in London." Wheeler perhaps emphasizes the Italian basis of the "chaste" design as a contrast to the waning Grecian Revival. Such Renaissance Revival buildings inspired by Barry's well-publicized London clubhouses of the 1830s were becoming all the fashion in the cities of the East Coast. To call one an experiment seems a trifle odd, although Wheeler may not have known of other

early examples such as John Notman's Athenaeum of Philadelphia (1845–1847), itself more closely indebted to Barry's works, although it, as well as some of Austin's works, was illustrated in Tuthill's *History of Architecture* of 1848. He presumably refers here to the New Haven House, which opened in 1850 or 1851 at the corner of Chapel and College Streets, opposite Yale.[25] (See Fig. 99.) At five stories plus attic, with shops on the ground floor, its resemblance to the Travellers' is a stretch, but both do sport the pedimented windows of the Florentine cinquecento. One is all the more ready to accept Wheeler's word that he designed it because it stands out among the other products of Austin's office in this period.

Wheeler left Austin's orbit some time in 1849.[26] What else might he have contributed to Austin's practice? He might have introduced to the New Haven office the Round-arch Style that marks Bowdoin's chapel, a work of Richard Upjohn of 1844 well known to Wheeler because he had participated in the decoration of the library, called Bannister Hall, that was part of it.[27] At about the time he arrived in New Haven, Austin began to exchange the pointed arch for the round in Congregational houses.[28] And Wheeler might have directed Austin to the Italian villa style as well, for he was in the area when Austin began the series of Italianate works that were to culminate in the design for the Morse-Libby house in Portland, Maine, in 1857 and the Sheffield remodeling in New Haven of 1859. (See Figs. 50 and 55.) There is a drawing of such a villa by Wheeler at Historic New England in Boston, which came into the collection with other drawings by Austin dated 1850, as well as examples of Wheeler villas erected at this time in Rochester (is there a Merwin Austin connection here?), Norwich, and Long Island. He also included such villas in his books, *Rural Homes* of 1851 (in which there is a plan not unlike that of the Morse-Libby house) and *Homes for the People* of 1855. By 1850, of course, the villa style had been exploited by many, including Upjohn, Davis, Tefft, and Notman, but its previous development in England may have given Wheeler, in Austin's eyes, a particular aura of authority. After a rather spotty career among people who found him less than honorable and whose taste, in his view, apparently did not rise to his own, Wheeler returned to London in 1860.[29]

David Russell Brown (1831–1910) apparently joined the Austin office about the same time as Wheeler, in 1847 that is, although documentation is lacking here, as is so often the case.[30] If this is true, he joined Wheeler and perhaps Flockton on the boards. According to Seymour, upon whose authority so much of our "information" depends, and who certainly knew personally most of the figures he discusses, Brown was sixteen at the time. His rise from office boy to designer did not take long, as the English help departed, for he was just over twenty when

Austin gave him equal credit for the designs the office published in 1853 in *A Book of Plans for Churches and Parsonages*.[31] In 1857 the two briefly formed a partnership.[32] Seymour suggests that Brown quickly became a skilled drafter, and the 1861 watercolor elevation of the New Haven City Hall, whose design, following Seymour, is usually given to him, shows him, if it is his, to have been adept in that craft. (See Fig. 108.) Since he was in the office when the watercolors in the two drawing books now at Yale were created, perhaps we should think of his name when we try to assign some of the drafting of them. The New Haven City Hall is Victorian Gothic; in fact, it is among the earliest buildings in that style to have been erected in the United States.[33] If Brown did design it, or at least suggest the English sources for its design, he dramatically changed the direction of the office, bringing it up to par with postwar developments across the country. Several Victorian Gothic buildings came from the office during his tenure there. He left in the late 1860s,[34] which perhaps makes Rich Hall, the library at Wesleyan University, given to Austin and Brown and dated 1866–1868 by Montgomery Schuyler, among his last contributions.[35] (See Fig. 117.) By 1870, when the *Evening Register* called him "the popular architect," his advertisement in that paper listed among his references James E. English and Joseph E. Sheffield, both former Austin clients.[36] He went on to a distinguished post–Civil War career, alone and in partnership with Clarence H. Stilson and then Ferdinand Von Beren, the first local progeny of Henry Austin's office.[37]

A few more names may be added to this all-too-brief list. Rufus G. Russell (1823–1896) joined Austin and Brown in 1857 after a career as a carpenter. He remained in the office until 1864, and then practiced on his own.[38] From the collection of some one hundred of his drawings now at the New Haven Museum and Historical Society, it is evident that he did not quite rival Brown as a draftsman or as a designer in the Victorian Gothic, Queen Anne, Stick Style, and other late-century modes.[39] We are told that Robert Wakeman Hill (1828–1909) "studied" with Austin after learning architectural drawing at the Young Men's Institute in New Haven.[40] This must have been in the 1850s. He subsequently worked briefly in Milwaukee but set up his practice in Waterbury in 1863. As the state architect, he designed a great many armories and other buildings in a very successful career.[41] Seymour tells us that Leoni W. Robinson worked in the office "during his student-day vacations" in 1866 or 1867.[42] He stayed until 1876. Obituaries cited by the Witheys apparently do not mention this, but do give the date of his opening his own office as 1880.[43] He too went on to a distinguished career, and there is a collection of his drawings at the New Haven Museum and Historical Society.

James W. Moulton drafted in the office from 1867 to 1873; Henry Woodruff was there in 1870 and Charles B. Canada from 1876 to 1879.[44] Duncan MacArthur, who, as we have seen, Seymour also mentions, apprenticed in Austin's office in the 1870s.[45] He seems to have remained a drafter all his life.[46]

In 1881 the name of the firm was changed to Henry Austin & Son when Fredrick D. Austin (1856–1907), who had joined his father as a youngster, perhaps as early as 1873, at least by 1877, was given his name on the door.[47] By 1887 George C. A. Brown was a member of the firm. Fred gradually took over the practice as his father faded. The office is listed in New Haven directories until Henry's death in 1891; then it slowly went under. It was called Henry Austin's Son in 1892, Austin & Brown in 1893–1894, Brown & Austin in 1895, and in 1896–1897 again became Henry Austin's Son (with George C. A. Brown listed separately). Thereafter Fred Austin is named simply as an architect or draftsman, specializing in moderate-cost houses for the expanding New Haven suburbs.[48] He last appears in the city directory of 1907, the year of his death.

If Henry Austin really did have, on average, three draftsmen continually at his side over his long career from the mid-1830s to the late 1880s, he must have employed dozens of men. The above list represents but a fraction of them. If indeed he carried the name of "Father of Architects" later in life, as Seymour asserts, his offspring must have numbered more than this handful.

INTRODUCTION (pp. 1–6)

1. The Austin family monument is in the Grove Street Cemetery. It was most likely designed by the architect. It contains the names of his first wife, Harriet M. Hooker (1808–1835), and three of their children, as well as the names of three other children by his second wife, Jane Hempstead (d. 1895). George Dudley Seymour added Austin's name in the twentieth century. Four children reached adulthood: Willard F. (who moved to New Jersey), Henry F. (d. 1894), David J. (d. 1912), and Fred D. (d. 1907). See Austin's New Haven probate records, 1891–1892. Fred joined his father in practice and carried on the office for a few years after his death. David is listed as a harness maker in the 1890s. He died in an almshouse. Henry appears in directories of the 1890s as a car maker at the New York, New Haven, and Hartford Railroad. He seems to have lived with his mother. (Vital Records, Connecticut State Library.)

2. Hartford *Courant*, 31 July 1841.

3. George Dudley Seymour, *New Haven*, New Haven, CT: privately printed, 1942, 219–230; article in the *Yearbook of the Architectural Club of New Haven*, West Haven, CT: Church Press, 1923, n.p.; and *Researches of an Antiquary*, New Haven: privately printed, 1928.

4. My thanks to James Campbell and Amy Trout of the New Haven Museum and Historical Society for the copy of the photo reproduced here. The original, taken by Hayes of New Haven, is in the possession of the Rev. Kenneth Walsh of Kingston, New York, an Austin descendant.

The wig may or may not reflect vanity. Many architects work into advanced age, and some—especially those with small offices—try to fudge a bit when it comes to counting the years and showing the long passage of time. When he was pushing ninety, Barry Byrne, formerly a protégé of Frank Lloyd Wright in Oak Park, Illinois, lied about his age in reference works because, he told me, he did not want clients to think he might drop dead in the middle of a project. Perhaps Austin had something similar in mind.

5. Obituary in the New Haven *Evening Register*, 17 December 1891. Research at the New Haven Free Public Library and the New Haven Museum and Historical Society produced no information about this post. Austin is not mentioned as an office holder in the city's annual reports, nor is an office of that title named. The notice of his firm in *Leading Business Men of New Haven County* (Boston: Mercantile Publishing Company, 1887, 169) does not mention it.

6. New Haven *Register*, 28 November 1887. See also the *Register* for 8 March 1881 and 16 January 1883.

7. *Leading Business Men*, 169. Austin's death certificate in the Bureau of Vital Statistics, New Haven, gives Hamden, Connecticut, as his place of birth, Daniel Austin and Ada Dorman as his parents, and 17 December 1891 as the date of his death. He was just over eighty-seven years old and died of acute bronchitis.

8. Edward E. Atwater, *History of the City of New Haven to the Present Time*, New York: W. W. Munsell & Co., 1887, 536–537. John B. Kirby, Jr. (*American National Biography*, New

York: Oxford University Press, 1999, 760–761) is more precise, giving 7 January 1837 as the day Austin opened his office in New Haven. That was indeed the date Austin first published an ad in the local newspaper.

9. *New Haven Evening Register*, 17 December 1891, front page. I have garnered a great deal of information about Austin and his work from the New Haven newspapers, but there is much more research to be done in that rich mine of reportage.

10. See Mary N. Woods, *From Craft to Profession*, Berkeley: University of California Press, 1999.

11. See note 3.

12. Roger Hale Newton, *Town & Davis, Architects*, New York: Columbia University Press, 1942, 253.

13. See the *Autobiography of James Gallier Architect*, New York: Da Capo Press, 1973.

14. "Public Libraries," *The New Englander* 1 (July 1843), 311. I owe this reference to Sarah Allaback.

15. "Dear Sir, This will be delivered to you by Mr. Henry Austin an Architect of this city [New Haven]. I have a very high opinion of Mr. Austin's taste and talents in the profession, and you will confer particular favor on me by showing him your drawings—and by any other attention his sojourn may admit of, or make necessary. Very respectfully Sir, Your obt. Sert., Ithiel Town." Town to Davis, 28 July 1839, The Pierpont Morgan Library, Literary and Historical Manuscripts, E3 086 E (In). I owe my knowledge of this key document to Arlene Palmer Schwind, curator of Austin's Morse-Libby house in Portland, Maine, and I must thank Christine Nelson and Anna Lou Ashby of the Morgan Library

for transcribing it for me. They read the date as 28 July rather than 29, as has been broadcast.

16. Henry Howe, "New Haven's Elms and Green," published in thirty chapters in the *New Haven Daily Morning Journal and Courier*, 28 September 1883 to 19 March 1884. Howe quotes Austin in XXVI (6 February 1884). The entire series is available on microfilm at Yale's Sterling Library, Reel B19021 (#13).

17. New Haven *Register*, 28 November and 2 December 1887; 7 February 1888. There was then much discussion about whether to repair or remove the 1827 Greek Revival monument. As a commissioner of public buildings Austin had reported on the condition of the building "several years ago." He had also made a plan for repairing the structure. It was pulled down in 1889.

18. See Chapter 1.

I. A CAREER BEGINS (pp. 7–23)

1. "On Modern Architecture," in Thomas Ustick Walter, *The Lectures on Architecture, 1841–1853*, Jhennifer A. Amundson, ed., Philadelphia: The Athenaeum of Philadelphia, 2006, 175–176. For Walter and his contemporaries, the "modern" era began with the Italian Renaissance.

2. Walter demonstrates this in his lectures, for he discusses, however briefly, not only Egyptian architecture, but Near Eastern, Hindu, Persian, Phoenician, Israelite, Chinese, and ancient American works, as well as the expected parade of Western styles.

3. Augustus Charles and Augustus Welby Northmore Pugin, *Examples of Gothic Architecture*, II, London: Henry G. Bohn, 1836. See Kenneth Hafertepe and James F. O'Gorman, eds., *American Architects and Their Books, 1840–1915*, Amherst: University

of Massachusetts Press, 2007, xviii–xix. The artist was the younger Pugin, who placed his initials in the corner blocks. Cf. the frontispiece to A.W. N. Pugin, *The True Principles of Pointed or Christian Architecture*, London: Henry G. Bohn, 1841, a book Austin owned (see Appendix A).

4. *New Haven Palladium*, 7 January [1839]. Available online at Yale Images.

5. For an accessible discussion of this see James Early, *Romanticism and American Architecture*, New York: A. S. Barnes and Co., Inc., 1965.

6. J. Frederick Kelly, *Early Connecticut Meeting Houses*, New York: Columbia University Press, 1948, I, 217. 30 April 1839: the church committee has proposals for completion of the tower "agreeably to Mr. [Nathaniel] Wheaton's plan, as drawn by Mr. Austen [*sic*]." Wheaton was the rector. For a more recent discussion of Wheaton, and of Town's design, see William Pierson, *American Architects and Their Buildings: Technology and the Picturesque*, Garden City, NY: Doubleday & Company, 1978, 286–288.

7. *New Haven Palladium*, 7 July 1841.

8. For a nearly contemporary ad by an architect more concerned with building technology, see that published in the *Jamestown* [New York] *Journal* by Oliver P. Smith, quoted by Ted Cavanagh in Hafertepe and O'Gorman, eds., *American Architects and Their Books, 1840–1915*, 54–55.

9. *New Haven Palladium*, 7 July 1840.

10. The Hartford and New Haven Railroad requested bids for the erection of its Hartford depot in the *Connecticut Courant* of 25 July 1840. Plans and specifications were to be seen in the office of Sidney Mason Stone.

There is an Austin drawing for a town house signed by New Haven mechanics in 1840 at the New Haven Historical Society. I discuss it in the next chapter.

11. Town to Davis, 28 July 1839. The Mor-

gan Library, Literary and Historical Manuscripts, E3 086 E (In). See note 15 to the Introduction.

12. Sarah Allaback, "Louisa Tuthill, Ithiel Town, and the Beginning of Architectural History Writing in America," in Kenneth Hafertepe and James F. O'Gorman, eds., *American Architects and Their Books to 1848*, Amherst: University of Massachusetts Press, 2001, 199–215.

13. Mary N. Woods, *From Craft to Profession*, Berkeley: University of California Press, 1999, 83–84.

14. I quote from ads clipped from New York newspapers and filed in folders as part of the Davis collection at the Avery Architectural Library, Columbia University.

15. Connecticut Historical Society, Hartford, MS Misc. ltrs "R." Thanks to Barbara Austen for a copy of the letter. That this was general practice at the time is suggested by the following entries in the diary of Isaiah Rogers for 30 August 1844 and 26 March 1855: "A gentleman . . . called on me for a plan of a cottage. . . . Lent him some books and he promised to call again." "Mr. Pratt . . . called on me at [the] office and wished me to make a plan for a cottage. . . . [That evening we] looked over my books on architecture." The diary is in the collection of the Avery Architectural Library, Columbia University.

16. For the Kellogs, see Rhea Mansfield Kittle, "The Kellogs, Hartford Lithographers," *The Magazine Antiques* X (July 1930), and Nancy Finlay, "Founding Brothers: Daniel Wright Kellogg, Elijah Chapman Kellogg, and the Beginnings of Lithography in Hartford," *Imprint* 32 (Autumn 2007), 16–27.

17. *Leading Business Men of New Haven County*, Boston: Mercantile Publishing Company, 1887, 169.

18. The Perkins house, Castine, probably early to mid-1850s, and the Morse-Libby house (Victoria Mansion), Portland, 1857,

in Maine; drawings inscribed for Edward Mays (?) at Washington, Pennsylvania, and Oliver M. Carrier at Olivet, Michigan. Both of the latter can be dated before 1851, but it appears at this writing that neither was built. The Thaddeus Clapp house in Pittsfield, Massachusetts, of 1849, is a variation on his Platt house in Hartford of 1847. The Michael Norton house in Cambridge, Massachusetts, was copied from an Austin design in Chester Hills, *The Builder's Guide. A Practical Treatise on Grecian and Roman Architecture* [etc.], *Revised and Improved, with Additions of Villa and School House Architecture, by H. Austin, Architect, and H. Barnard, Esq.*, Hartford, CT: Case, Tiffany and Burnham, 1846 [c. 1845]. *The Daily Constitution* of Middletown, Connecticut, of 5 September 1872 mentions his plans for the city hospital at Worcester (see Chapter 5, note 32). At Yale there is also a design for a Springfield bank that is usually thought to be for Springfield, Massachusetts, although it is not now identifiable. For a description of the Yale collection, see Appendix B. Austin's other work in Trenton was the Third Presbyterian Church of 1849, discussed in Chapter 3.

19. John O. Raum, *History of the City of Trenton, New Jersey*, Trenton: W. T. Nicholson & Co., 1871, 105. I learned of this commission from the National Register of Historic Places Registration Form for the church, a copy of which was kindly sent to me by Terry Karschner of the New Jersey Historic Preservation Office. Since this is the third building of the First Presbyterian Church, it should not be confused with Austin's later Third Presbyterian Church (see Chapter 3).

20. Elizabeth Mills Brown, *New Haven: A Guide to Architecture and Urban Design*, New Haven, CT, and London: Yale University Press, 1976, 182. Nelson Hotchkiss was later a partner of George B. Rich (1841–1845) and then of William Lewis, Jr. (1846–ca. 1860). For Austin's Hotchkiss house see

the next chapter. "C. Thompson" must have been Charles, the carpenter brother of Isaac, the mason who worked at Austin's cemetery gate and Austin and Davis's Yale library building. A third brother, William, was a plasterer. Roger Hale Newton, *Town & Davis, Architects*, New York: Columbia University Press, 1942, 158.

21. I first learned of Austin's work in Trenton from Constance M. Greiff, *John Notman, Architect*, Philadelphia: the Athenaeum, 1979, 243, where the lithograph is mentioned. The original is scarce. It was the basis for the view published by Barber and Howe in 1844 (see note 40). According to "Trenton in Bygone Days," *Sunday Times Advertiser*, 23 April 1950, citing *The Emporium and True American* for 19 April 1839, the Row was contracted for that day and completed the following year. While this information seems not to appear in the *Emporium* of that day, so the *Advertiser* cited it incorrectly, the validity of the date remains. I am deeply grateful to Lauren Hewes of the American Antiquarian Society for checking the *Emporium* and to Ricki Sablove for her assistance in researching Austin's Trenton projects.

22. See Roger Hale Newton, *Town & Davis, Architects*, New York: Columbia University Press, 1942.

23. See Elizabeth Mills Brown, "Hoadley, David," *Macmillan Encyclopedia of Architects*, Adolf K. Placzek, ed., New York: The Free Press, 1982, 2, 396. Hoadley worked on many buildings designed by Town or Town and Davis.

24. For Stone see George Dudley Seymour, *New Haven*, New Haven, CT: privately printed, 1942, 244–247. It has been said that Austin was the first professional architect in New Haven. Stone actually preceded him. Edward E. Atwater (*History of the City of New Haven*, New York: W. W. Munsell & Co., 1887, 536) dates the beginning of his career

to 1833. He later succeeded to the practice of the architectural partnership of L. B. Platt and Francis Benne. One can watch Stone move into their office and then gobble it up in the ads published in the *New Haven Palladium* of 19 October and 17 December 1836, as well as 19 June and 14 October 1837. Stone had a long, locally distinguished career, especially as an architect of houses, churches, and public buildings. He followed a path similar to Austin's. There were times when he and Austin worked on coeval buildings in the same town and sometimes on the same street. In at least one instance, they were requested to work together to estimate the cost of an addition to the Insane Hospital in Middletown, Connecticut. See the Middletown *Constitution* of 29 June 1870. It would be enlightening to know more about the relationship between them, but documents for Stone seem to be as scarce as those for Austin. His daughter was Harriett Mulford Stone Lothrop ("Margaret Sidney"), popular author of the "Little Peppers" series of children's books. See Chapter 2, note 9.

25. "Trenton in Bygone Days," *Sunday Times Advertiser*, 23 April 1950.

26. For the larger context of English influence on American architecture in the first half of the nineteenth century see W. Barksdale Maynard, *Architecture in the United States, 1800–1850*, New Haven, CT, and London: Yale University Press, 2002.

27. Town to Davis, 28 July 1839. The Morgan Library, Literary and Historical Manuscripts, E3 086 E (In). See note 15 of the Introduction.

28. Maynard, *Architecture in the United States, 1800–1850*, 88; Amelia Peck, ed., *Alexander Jackson Davis, American Architect, 1803–1892*, New York: Rizzoli, 1992, 67.

29. Fredrika Bremer, *The Homes of the New World*, 3 vols., London: Arthur Hall, Virtue, & Co., 1853, 2:93; quoted here from

Maynard, *Architecture in the United States, 1800–1850*, 113.

30. See H. Allen Brooks, "Town's New Haven Villa, 1836–37," *Journal of the Society of Architectural Historians* 13/3 (1954), 27. A related project by Austin is preserved in signed but undated drawings at the New Haven Museum and Historical Society (MSS ADT, folder 6). I discuss it in the next chapter.

31. Andrew Jackson Downing, *A Treatise on the Theory and Practice of Landscape Gardening*, New York: Wiley & Putnam, 1841, 336. Downing meant to have the book ready by 1839. Jane B. Davies wrote that the villa does not represent any house type then existing on Hillhouse Avenue, so perhaps Austin knew it from a drawing: "Davis and Downing: Collaborators in the Picturesque," in George B. Tatum and Elizabeth Blair MacDougall, eds., *Prophet with Honor: The Career of Andrew Jackson Downing, 1815–1852*, Washington, DC, and Philadelphia: The Athenaeum, 1989, 85 note 15.

32. The 1840 date comes from H. Ward Jandl, M.A. thesis on Austin written for Columbia University, ca. 1972. Louisa Tuthill, *History of Architecture from the Earliest Times*, Philadelphia: Lindsay and Blakiston, 1848, 282. For Tuthill's New Haven connections see Sarah Allaback, "Louisa Tuthill, Ithiel Town, and the Beginning of Architectural History Writing in America," in Hafertepe and O'Gorman, eds., *American Architects and Their Books to 1848*, 199–215. None of the period references to the Gabriel house mention Nelson Hotchkiss as collaborator. This suggests that his credit as a designer of the Park Row houses could have been a courtesy.

33. Box 3, folder 49a, Design XXIV: "Residence of Georg [sic] Gabriel Esq. New Haven Conn." On undated JWHATMAN paper, with some graphite changes and various graphite sketches for moldings, an

arcade, and columns on the reverse. Gabriel's name is given as George in the New Haven directories of the day. They make it clear that the house was habitable by 1840.

34. See Appendix B.

35. It should be noted that A. J. Davis had used a perspective view of Charles Roach's own villa at Ravenswood in his ad for his *Rural Residences* of 1836. See Peck, *Davis*, 67.

36. Hills, *The Builder's Guide*, plates III and IV (the date of publication of the revised edition is usually given as 1846 [H.-R. Hitchcock, *American Architectural Books*, New York: Da Capo Press, 1976, 50], but the work was copyrighted in 1845). The plates were lithographed by E. B. and E. C. Kellogg, for whom Austin designed the Gothic villa at Hartford ca. 1841 (*Hartford Daily Courant*, 21 September 1842, 2, a reference I owe to Candice Brashears and Nancy Finlay of the Connecticut Historical Society).

37. Map of the City of Trenton, New Jersey, from actual survey by J. C. Sidney, Philadelphia: M. Dipps, 1849.

38. I have been unable to find the name of the developer/owner of the Row.

39. See Trenton Historical Society, *History of Trenton 1679–1929*, Princeton, NJ: Princeton University Press, 1929.

40. John Warner Barber and Henry Howe, *Historical Collections of the State of New Jersey*, New York: S. Tuttle, 1844.

41. *New Haven Palladium*, 17 January 1842. Henry Howe was a resident of New Haven and presumably knew Austin's office. Merwin, ten years younger than Henry and clearly the subordinate employee, soon left New Haven for Rochester, New York, where his first works aped several of Austin's designed for Connecticut. See Appendix C.

42. *Ballou's Pictorial Drawing-Room Companion* VIII (26 May 1855), 328.

43. Edward Shaw, *Rural Architecture: Consisting of Classical Dwellings, Doric, Ionic, Corinthian and Gothic*, Boston: James B.

Dow, 1843, Pls. 25–26 (for a professional gentleman); John Warren Ritch, *The American Architect: Comprising Original Designs of Cheap Country and Village Residences*, 2 vols. New York: C. M. Saxton, 1847–1849, II (design for a homestead).

44. Carroll L. V. Meeks, "Henry Austin and the Italian Villa," *The Art Bulletin* 30 (June 1848), 145–146. See Appendix A.

2. DOMESTIC ARCHITECTURE OF THE 1840S AND 1850S (pp. 24–76)

1. Banister Fletcher, *A History of Architecture on the Comparative Method*, New York: Charles Scribner's Sons, 1954, 888.

2. See Arabella Berkenbilt, "European Influences on Thomas A. Tefft: Theory and Practice," in *Thomas Alexander Tefft: American Architecture in Transition, 1845–1860*, Providence, RI: Brown University, 1988, 31–32.

3. See Appendix A.

4. A. J. Davis, undated note among his papers at the New-York Historical Society.

5. John Foulston, *The Public Buildings Erected in the West of England*, printed for the author, 1838, Pl. 80.

6. See Appendix A.

7. It is difficult to tell from the drawing if it is true here, but Austin used much later (on the Morse-Libby house in Portland, Maine, designed in 1857) the Ionic order illustrated by Asher Benjamin in *The American Builder's Companion*, 6th ed., Boston: R. P. & Co. Williams, 1827, Design E.

8. Also in the collection of the New Haven Museum is a signed sheet containing a plan and elevations of a boxy, ten- by fifteen-foot Grecian pavilion whose intended use is not readily apparent.

9. The Neo-Classical 1838 Alsop house in Middletown, Connecticut (now the Davidson Art Center at Wesleyan University), a

work sometimes attributed to Austin in the old literature, in fact came from the New Haven office of Platt and Benne and might better be attributed to Sidney Mason Stone, who by then seems to have taken over the practice. See Chapter 1, note 24.

10. *Patten's New Haven Directory*, New Haven, 1840.

11. There are in the smaller drawing book at Yale designs for unlabeled Italianate town houses. See Designs V and VI.

12. The type appears in rudimentary form in A. J. Downing's *A Treatise on the Theory and Practice of Landscape Gardening*, New York, Wiley & Putnam, 1841, 336. It is there called a New Haven Suburban [Italian] Villa. "Moderate in dimension and economical in construction," such edifices "may be considered as models for this kind of dwelling." A. J. Davis collaborated with Downing on this publication. The boxy silhouette surmounted by a low tower ultimately descends, however, like the towered Italian villa, from Tuscan sources. See Claudia Lazzaro, "Rustic House to Refined Farmhouse: The Evolution and Migration of an Architectural Form," *Journal of the Society of Architectural Historians* 44 (December 1985), 346–367.

13. According to architectural dictionaries, a cupola is a small dome crowning a roof or turret. None of Austin's are domical, but "cupola" seems to be what the period called his rectangular lanterns. See, for example, many entries in the diary of his contemporary, Isaiah Rogers (1800–1869), at the Avery Architectural Library, Columbia University.

14. Louisa Tuthill, *History of Architecture from the Earliest Times*, Philadelphia: Lindsay and Blakiston, 1848, 285, for example.

15. *The Connecticut Magazine* 8 (1903–1904), 117–120.

16. Design XXIII.

17. The house has been extensively enlarged for use by the Maresca Funeral Home.

18. These supports have been labeled by other writers to emphasize their vegetable ornament. As we shall see, I adopt a term that emphasizes their shape, a term that springs from the era, as in Foulston, *Public Buildings*, Pl. 66: "candelabra columns" supporting the gallery of his Saint Andrew's Chapel, Plymouth, 1823. See my discussion of the Dana house below.

19. Robert W. Grzywacz, a New Haven architect, has looked at this aspect of Austin's work as closely as anyone. He kindly gave me a copy of his privately printed report, "The Barnes and Smith Houses and Oriental/Vegetal Columns in the Work of Henry Austin."

20. Design IV.

21. *New Haven Architecture* (Selections from the Historic American Buildings Survey, No. 9), Washington, DC: National Park Service, 1970, 111. A reference I owe to Christopher Wigren.

22. Foulston, *The Public Buildings*, Pl. 96.

23. The building is now an apartment house, and the hallway arch has been closed with a wall. I am grateful to Neil Rapuano for giving me a tour of both the English and Bristol houses.

24. Daniel C. Gilman, *The Life of James Dwight Dana*, New York: Harper & Brothers, 1899.

25. Design VII.

26. Brighton could have been available to Austin in Humphrey Repton, *Designs for the Pavilion at Brighton*, London: J. C. Stadler, 1808, or in E. W. Brayley, *Illustrations of Her Majesty's Palace at Brighton*, London: J. B. Nichols and Son, 1838. Austin's limited use of exotic forms in domestic architecture is pointed up by contrasting the houses of the mid-1840s with Leopold Edilitz's contemporary Iranistan for P. T. Barnum at Bridgeport, Connecticut. There bits and pieces of the Brighton Pavilion overwhelm the basic classical parti. See Clay Lancaster, "Oriental Forms in American Architecture, 1800–1870," *The Art Bulletin* 29 (September 1947), 186–187.

27. Chester Hills, *The Builder's Guide. A Practical Treatise and Grecian and Roman Architecture* [etc.], *Revised and Improved, with Additions of Villa and School House Architecture, by H. Austin, Architect, and H. Barnard, Esq.*, Hartford: Case, Tiffany and Burnham, 1846 [c. 1845], 7.

28. Repton, *Designs for the Pavilion at Brighton*, 27–31. A reference I owe to Christopher Wigren.

29. Raymond Head, *The Indian Style*, Chicago: University of Chicago Press, 1986, 21–63. See Mildred Archer, *Early Views of India: The Picturesque Journeys of Thomas and William Daniell, 1786–1794*, London: Thames and Hudson, 1980. James Fergusson's *Illustrations of the Rock-Cut Temples of India* appeared in 1845 (London: J. Weale).

30. Head, *The Indian Style*, 62.

31. Foulston, *The Public Buildings*, Pl. 66.

32. Head, *The Indian Style*, 33–35, notes that Foulston was influenced by Thomas Hope's *Household Furniture and Interior Design* of 1807.

33. I sent a photograph of the Bristol portico to the Swiss architectural historian Jacques Gubler, who had never heard of Austin or known any of his work. In his reply Gubler asked, "Is Austin playing with the orders? Does he emulate profiles used in furniture? . . . Did Austin design furniture?" (I know of no pieces of furniture designed by Austin.)

34. Archer, *Early Views of India*, pl. 153. See also Carmel Berkson, *Ellora: Concept and Style*, New Delhi: Abhinav Publications, 1992, passim.

35. Design XXVI.

36. William Hodges, *Choix de vues de l'Inde / Select Views in India*, London:

Printed for the author, [1786–1788]. Other plates in this collection of aquatints showing picturesque views of exotic architecture engulfed by vegetation suggest the possible origin of Austin's more vegetable columns. See, for example, the view of the mosque at Gazipur. Hodges also makes it clear that the period thought of the origins of Gothic in the East. The mosque at Chunar Gur demonstrated the "perfect similarity" between Indian architecture, brought there from Persia, and that brought to Spain by the Moors, which spread throughout Western Europe as Gothic architecture. See also Edward Daniel Clarke, *Travels in Various Countries of Europe, Asia and Africa*, part 2, 1814, as quoted by Charles Bulfinch in Kenneth Hafertepe and James F. O'Gorman, *American Architects and Their Books*, Amherst: University of Massachusetts Press, 2001, 96. Other, perhaps more cogent sources are the views of Chuner Gur and the Taj Mahal gate in the Daniells' *Oriental Scenery* (Archer, *Early Views*, 69 and 27).

37. The name on the drawing for this house is Nathan Pech, Jr., clearly a drafter's mistake, since Peck was the president of the Merchants National Bank, for which Austin is assumed to have designed a new building two years later. See Chapter 4.

38. Design V.

39. Also called the Brewster-Burke house; now the seat of the Rochester Landmark Society.

40. Alan Gowans, *Styles and Types of North American Architecture*, New York: HarperCollins, 1992, 154. For Gowans, the porch of the Brewster house is Moorish. See note 36.

41. Head, *The Indian Style*, 24.

42. Design VI.

43. Charles S. Northend, *New Britain, Connecticut, Picturesque and Descriptive*, Gardner, MA: Lithotype Publishing Company, 1888. Another boxy Italianate house

with a central one-bay porch and rear ell that has been attributed to Austin is that at 110 Colony Street in Meriden, Connecticut. It is often called the Fenner Bush house after a later occupant. Information from the Meriden Historical Society names Charles P. Colt as the occupant in 1851, when the house was certainly built. (My thanks to Dorothy Daly and Allen Weathers of the Society.) The house exists at this writing but is poorly maintained. The porch is missing. The simple candelabra columns shown on a photograph in *The Golden Jubilee of St. Rose of Lima Church, Meriden, Ct, 1848–1898* are gone, as is the tall cupola. The exterior walls are the original thin horizontal flush boards; the window frames of the second floor of the main block bear carved acroteria motifs; the deep overhang of the roof is supported by paired brackets; and the tripartite window above the entrance has a segmental overhead crown.

44. Box 5, folder 74. This is not part of the originally bound volumes.

45. Elizabeth Mills Brown, "Historic Houses of Wooster Square," New Haven, CT: New Haven Preservation Trust, 1969, 38–39, and Brown, *New Haven, A Guide to Architecture and Urban Design*, New Haven, CT: Yale University Press, 1976, 182.

46. Joseph Anderson, *The Town and City of Waterbury, Conn.*, 2 vols., New Haven, CT: Price & Lee, 1896, 343–344.

47. Design VIII. See also Design IX.

48. Design II. See also Design II in the smaller book.

49. Some of these are preserved in the entrance porch of an otherwise undistinguished commercial building on North Main Street in Wallingford.

50. Cf. James Fergusson, *The Illustrated Handbook of Architecture*, 2nd ed., London: John Murray, 1859, 120, a detail from the eighteenth-century observatory at Benares in India.

51. *New Haven*, New Haven, CT: Yale University Press, 1976, 191.

52. Samuel Sloan includes a design for a "Southern Mansion" in *The Model Architect*, Philadelphia: E. S. Jones & Co., 1852, II, Design 44, that bears similarities to the Beach villa.

53. David F. Ransom, "Biographical Dictionary of Hartford Architects," *The Connecticut Historical Society Bulletin* 54 (Winter–Spring, 1989), 16. Thanks to Nancy Finlay of the Connecticut Historical Society for uncovering a photograph. There are two drawings at Yale related to this porch design, Design VII in the smaller book and Design XXV in the larger. There is also, in the larger drawing book at Yale, a design (XII) for a New Haven house for the Rev. Thomas C. Pitkin. It adds little to the story.

54. My thanks to John B. Kirby, Jr., for this information and to Judy Garrett of the Pittsfield Historical Society for locating a photograph.

55. Brown, *New Haven*, 106 and 161.

56. See folder 22 and cf. Design XIV in the larger book. It was apparently never built. Carrier (1834–1865) graduated from Yale in 1860 and married one of his students at Olivet College in 1862, the year he joined the faculty there, where he taught Latin until his death. Carrier might have asked Austin for a house design at about the time of his marriage, and the architect thought of one of his previous designs for him. My thanks to Mary Jo Blackport, librarian of the college, for her research.

57. Brown, *New Haven*, 182. Measured drawings of the house were prepared for the New Haven Redevelopment Authority in 1969; prints are in the New Haven Museum and Historical Society.

58. New York: Fowler and Wells, 1848; 2nd ed., revised and enlarged, 1854. See Walter Creese, "Fowler and the Domestic

Octagon," *The Art Bulletin* 23 (March 1946), 89–102.

59. Design XI. A pair of neighboring octagons on Marlborough Street in Portland, Connecticut, are often assigned to Austin. They stand across from his Brainerd house but seem to me to be a builder's knockoffs.

60. See Appendix C.

61. See Appendix A.

62. Design XVIII.

63. Design XXI.

64. 283, Fig. 39.

65. Design XX. The Norton house survives. Thanks to Susan Maycock of the Cambridge Historical Commission for this information. See Bainbridge Bunting and Robert H. Nylander, *Survey of Architectural History in Cambridge: Report Four: Old Cambridge*, Cambridge, MA: Cambridge Historical Commission, 1973, 96–97.

66. Anderson, *Waterbury*, 275, 281, 308–311, and William H. Walkins, *Rose Hill*, Waterbury, CT: The Mattatuck Museum, 1973.

67. Anderson, *Waterbury*, 308.

68. David Schuyler, *Apostle of Taste*, Baltimore and London: The Johns Hopkins University Press, 1996, 114.

69. John Claudius Loudon, *An Encyclopaedia of Cottage, Farm, and Villa Architecture*, 2 vols., London: Longman, etc., 1833. Austin had the new edition of 1835 and the supplement of 1842. (See Appendix A.)

Since we know he owned German publications as well as English ones, there may have been a Teutonic connection as well. This is not well understood here, but German architects such as Schinkel, Persius, Ferdiand von Arnim, Johann Strack, and others designed villas inspired by trips to Italy. See Eva Boersch-Supan, *Berliner Baukunst nach Schinkel, 1840–1870*, Munich: Prestel-Verlag, 1977, 108–124 and figs. 251–346, esp. 300. I owe this reference to Michael J. Lewis. (See Appendix A.)

70. I omit mention of A. J. Davis's *Rural Residences* of 1838 because its distribution was certainly more limited than Downing's works.

71. The literature is bulky, but see in particular Carroll L. V. Meeks, "Henry Austin and the Italian Villa," *The Art Bulletin* 30 (June 1948), 145–149; Clay Lancaster, "Italianism in American Architecture before 1860," *American Quarterly* 4 (Summer 1952), 127–148; and Charles E. Brownell, "The Italianate Villa and the Search for an American Style, 1840–1860," in Irma B. Jaffe, ed., *The Italian Presence in American Art*, New York: Fordham University Press, 1989, 208–230.

72. Andrew Jackson Downing, *The Architecture of Country Houses*, New York: D. Appleton & Company, 1850, 285–286.

73. Tuthill, *History*, chap. XXIII.

74. Design XVII. There is another project in the smaller book that should be noted here. Design I is a large house, square in plan with a rear ell. At the center of the main block is a circular space that rises to a light source in the roof. Beyond that is the stair hall that climbs to a stubby tower topped by a belvedere. This is so low that it does not show on the front elevation. This seems an early and tentative approach to the Italian villas to come later.

75. The 1846 Timothy Lester house on Orange Street in New Haven could be the city's first towered villa (its precise building history is a bit sketchy) and has been associated with Austin (Brown, *New Haven*, 157). It is now clapboarded. The Frederick J. Kingsbury house in Waterbury was attributed to Austin by George Dudley Seymour (*Researches of an Antiquary* [New Haven, CT: privately printed, 1928], 16; see H. Ward Jandl, II, 97). It is usually dated ca. 1853. A description by his daughter, Alice E. Kingsbury (*In Old Waterbury*, Waterbury, CT: The Mattatuck Historical Society, 1942), and several photographs at the Mattatuck Historical Society show it as an awkward, blocky, clapboarded structure with a stubby tower, deep overhangs, and an arcaded verandah. Although Ms. Kingsbury described it as "the square solid Italian villa type," there seems to be nothing to compare with it in Austin's known works. A. W. Longfellow later added another tower. It was demolished in 1960.

76. Folder 18.

77. Design X. The villa was recorded by the Historic American Building Survey in 1964.

78. Gervase Wheeler, *Homes for the People for Suburb and Country, the Villa, the Mansion, and the Cottage*, New York: Charles Scribner, 1855, 152.

79. The closest I can come to characterizing the form is to say that it resembles the "shmoo" that appeared in Al Capp's "Li'l Abner" cartoon after 1948.

80. Northrop appears first in ads in the *New Haven Palladium* in October 1837. The men appear, sometimes in adjacent ads, in the *Columbian Register* in August, September, and November 1844, January and February 1846, and so on.

81. This is usually called the Oliver B. North house after a later owner and has been variously dated between 1852 and 1869. The former seems more reasonable in light of Austin's other work. I follow Brown, *New Haven*, 183 (although she retains the North name). The house is attributed to Austin in Edward E. Atwater, *History of the City of New Haven*, New York: W. W. Munsell & Co., 1887, 536. The upper story of the tower, which had been removed, was replaced in 1967 under the direction of the New Haven Preservation Trust and its then president, Christopher Tunnard, the Yale historian. Other alterations, such as the third floor of the west wing, remain.

82. Downing, *Architecture of Country Houses*, Fig. 145; Samuel Sloan, *The Model Architect*, Philadelphia: E. S. Jones, 1852, design VI.

83. Most of what I know about the Morse-Libby house I've learned from Arlene Palmer Schwind, curator, and Robert Wolterstorff, director, of Victoria Mansion, as the house has been called since it has been an historic house museum open to the public. A copy of the specifications, signed by Austin, are in the house. The Libbys were the second inhabitants. See Arlene Palmer, *A Guide to Victoria Mansion*, Portland, ME: The Victoria Mansion, 1997. The house was measured and photographed by the Historic American Buildings Survey.

84. The date is usually given as 1858. Stone for the house shipped from Portland, Connecticut, arrived at the wharf at Portland, Maine, in mid-May 1858, according to a notice in the *Portland Advertiser* on the 24th of that month (saying it had arrived "last week"). Given the time required to discuss the clients' wants, make the drawings (including stonecutters' directions), wait for weather appropriate for extracting the stone from the quarry and ship it around Cape Cod to Casco Bay, it seems logical that the conception for the house is best dated 1857. The building was up by 1860 but the Civil War delayed the Morses inhabiting it until 1866.

85. Wheeler, *Homes for the People*, 70.

86. Arlene Palmer, "Gustave Herter's Interiors and Furniture for the Ruggles S. Morse Mansion," *Nineteenth Century* 16 (1996), and Katherine S. Howe, Alice Cooney Frelinghuysen, and Catherine Hoover Voorsanger, *Herter Brothers: Furniture and Interiors for a Gilded Age*, New York: Harry N. Abrams, 1994, 43, 91, 128–129, 226, 249, and passim.

87. For the location of the Morse-Libby house see Tim Brosnihan, "The Victoria Mansion Property: An Historical and Archaeological Overview, 1783–1858," *Victoria Mansion Newsletter* (Summer 2007), 1–3. It had been the site of the house and shop of famed cabinet and furniture maker John Seymour.

88. Austin may not even have known the site. Where he met Morse is unknown. There is no known record of his having visited Portland. Austin may have merely supplied Morse with drawings based on a house (King's ?) with a very different kind of site.

89. William Willis, *Guide Book for Portland and Vicinity*, Portland, CT: B. Thurston and J. F. Richardson, 1859, 74.

90. The stairs have recently been rebuilt with stone from the original quarry and the rails and baskets have been replaced.

91. Like the stairs, the tower has been recently rebuilt with stone taken from the original quarry at Portland, Connecticut.

92. These columns were originally stone but have been replaced with wooden replicas.

93. Roger Newton Hale, *Town & Davis, Architects*, New York: Columbia University Press, 1942, 128.

94. G. & D. Cook & Co., *Illustrated Catalogue of Carriages*, New York: Baker & Godwin, 1860. At this time, Austin also altered Town's Hillhouse villa for Aaron Skinner, adding second floors to the angle pavilions. He lit them with windows edged with simplified versions of his usual frames. Newton, *Town & Davis*, 125.

95. See James F. O'Gorman, *Accomplished in All Departments of Art: Hammatt Billings in Boston, 1818–1874*, Amherst: University of Massachusetts Press, 1998, 188–189.

3. ECCLESIASTICAL ARCHITECTURE OF THE 1840S AND 1850S
(pp. 77–116)

1. Sydney Ahlstrom, *A Religious History of the American People*, Garden City, NY: Image Books, 1975), I, chaps. 26, 27.

2. This subject has been discussed many times. I have found the following sources most useful: Phoebe B. Stanton, *The Gothic Revival & American Church Architecture*, Baltimore: The Johns Hopkins University Press, 1968; Michael J. Lewis, *The Gothic Revival*, London: Thames & Hudson, 2002, 81–104; Carroll L. V. Meeks, "Romanesque Before Richardson in the United States," *The Art Bulletin* 35 (1953), 17–32; William H. Pierson, Jr., "Richard Upjohn and the American Rundbogenstil," *Winterthur Portfolio* 21 (1986), 223–242; Katherine M. Long, "Style and Choice in Mid-19th-Century Church Architecture," in *Thomas Alexander Tefft: American Architecture in Transition, 1845–1860*, Providence, RI: Brown University, 1988, 79–94; Kathleen Curran, *The Romanesque Revival*, University Park: Pennsylvania State University Press, 2003; and Gwen W. Steege, "The *Book of Plans* and the Early Romanesque Revival in the United States: A Study in Architectural Patronage," *Journal of the Society of Architectural Historians* 46 (September 1987), 215–227.

3. C. L. V. Meeks, "Henry Austin and the Italian Villa," *The Art Bulletin* 30 (June 1948), 145 note 2. See Appendix A.

4. Karl Moellinger, *Elemente des Rundbogenstils*, Munich: E. Roller, 1845–1847. Meeks, "Henry Austin," 21 note 18. See Appendix A.

5. Design XXXVIII in the larger of the two drawing books, for which see Appendix B.

6. Prints rivaled books in Town's library. Stubby towers had existed on the Pantheon since the Middle Ages. Palladio had already used the silhouette at his famous chapel at Maser of the 1560s.

7. C. L. V. Meeks, "Pantheon Paradigm," *Journal of the Society of Architectural Historians* 19 (December 1960), 135–144.

8. Although A. J. Davis used the form in a series of studies for libraries now in the Metropolitan Museum of Art, New York City.

9. "Public Libraries," *The New Englander* 1, July 1843, 311.

10. Church records on microfilm at the Connecticut State Library, Hartford; *A Brief History of St. John's Church, Hartford*, Hartford, 1922; and Nelson R. Burr, *A History of Saint John's Hartford, Connecticut, 1841–1941*, Hartford, 1941, 26–33.

11. In 1844 Austin designed a brick church "in a cheap but neat style" for the black Congregational community in New Haven (*Columbian Register*, 9 April 1844, an item notifying the public that funds were needed for the building). The $2,500 budget equaled that of Austin's Gabriel house designed a few years earlier. There is reason to believe that this project was not built, for the congregation moved in 1847 to an abandoned Methodist church on Temple Street, according to the Dana scrapbooks at the New Haven Museum and Historic Society. In 1864 Austin provided the black community with a building for the Goffe Street School. According to Elizabeth Mills Brown, he must have adapted an earlier church (*New Haven*, New Haven, CT: Yale University Press, 1976, 175). Perhaps that church was the 1844 project for the black Congregationalists.

12. Design XXXVII in the larger drawing book. Sidney Mason Stone designed a Gothic Episcopal church for Northford at the same moment that Austin had the Congregational church on his drafting board. See *Columbian Register*, 26 April 1845. It would be enlightening to know more about the relationship between these contemporary rivals.

13. Church records on microfilm at the Connecticut State Library, Hartford; Charles E. Alling, *History of the Northford Congregational Church, 1750–1986*, 1986, 7–15.

14. Austin frequently used scissors trusses in ecclesiastical work, as, apparently, did his Connecticut predecessor, the builder David Hoadley. See J. Frederick Kelly, *Early Connecticut Meeting Houses*, 2 vols., New York: Columbia University Press, 1948, I, 185.

15. I identified the drawing on a trip to the church in 2005, and it was subsequently sent for treatment to the Northeast Conservation Center in Andover, Massachusetts, funded by grants from the Connecticut Trust for Historical Preservation, my Mellon Fellowship, and the congregation. Aloha Mosier and Jan Finch led the congregation's efforts to conserve the drawing. It is approximately 30 × 36", in manuscript ink on light brown machine-made wove paper embossed "*Universal*" in script. That mark was used by Keuffel and Esser perhaps as early as the 1880s but certainly at the end of the century. (My thanks to Lois Price for this information.) Most of the lines are ruled, but there is some wobbly freehand work as well in minor decorative forms. It is now on deposit at the New Haven Museum and Historical Society.

16. Smith, an extraordinary woman, studied at Mt. Holyoke, received a diploma from the Yale School of Fine Arts in 1889, taught mathematics and art at the Normal School in Bloomsburg, Pennsylvania, in the 1890s, took a Ph.D. in mathematics at Yale in 1904, published a groundbreaking paper on Bessel functions, then joined the faculty and eventually became chair of the Mathematics Department at Wellesley College (1908–1934). Information about Smith is available at the Totoket Historical Society in North Branford, Connecticut, the Archives of Wellesley College, the Archives of Mt. Holyoke College, and at agnesscott.edu/LRIDDLE/WOMEN/smith.htm. My thanks to members of the congregation of the church, the New Haven Museum and Historical Society, and the Archives at Wellesley College.

17. H. Ward Jandl's M.A. thesis on Henry Austin, Columbia University, ca. 1972, II, 152.

18. Arthur Scully, Jr., *James Dakin, Architect*, Baton Rouge: Louisiana State University Press, 1973, 21, and Amelia Peck, ed., *Alexander Jackson Davis, American Architect, 1803–1892*, New York: Rizzoli, 1992, 50.

19. *Godey's Lady's Book*, November 1848, 325.

20. Drawings sent from England by the Ecclesiologists did reach the former colonies (see, for example, Stanton, *Gothic Revival*, 99–100), but this could as well refer to measured drawings of Gothic churches published by the Pugins and others.

21. Design XVI in the smaller drawing book; *Waterbury American*, 15 January 1848. *Godey's Lady's Book*, 1848; Joseph Anderson, ed., *The Town and City of Waterbury, Connecticut*, New Haven, CT: privately published, 1896. A large broadside at the church, produced for the dedication, also contains the perspective and a detailed description of the building from which I quote.

22. The flying buttresses do not appear in the original drawing or the published perspective but do appear in vintage photographs. There are other discrepancies between the views, too, such as the treatment of the upper part of the lesser tower and, more generally, in the more vertical proportions captured in the photographs.

23. See Appendix C.

24. Nothing has come to light to explain how Austin received this New Jersey commission. He had, as we know, already designed Park Row in Trenton some years earlier. Samuel M. Studdiford, *A Discourse Delivered on the Occasion of The Twenty-Fifth Anniversary of the Organization of the Third Presbyterian Church, of Trenton*, Trenton, NJ: Murphy & Bechtel, 1874, 10; *Illustrated Manual of the Third Presbyterian Church of Trenton, N. J.*, Trenton, NJ: Brearley & Stoll, 1879; and Francis Bazley Lee, *History of Trenton, New Jersey*, Trenton, NJ: The State Gazette, 1895, 166.

25. Photos of the exterior of the rebuilt church show that much of Austin's work was retained.

26. Henry-Russell Hitchcock, *Early Victorian Architecture in Britain*, New Haven, CT: Yale University Press, 1954, 109, 115, 129, and 149 for this and following quotes.

27. See Appendix C.

28. Chapel Papers, Bowdoin College Library, Mitchell Department of Special Collections and Archives, Wheeler to Woods, 14 August 1847 and 27 September 1848. Letters with these dates were written from New Haven. Between them Wheeler was in Brunswick, Maine, but the first letter tells us that his arrangement with Austin did not preclude other work.

29. See Appendix C.

30. In 1849 Wheeler designed a Congregational church for Berlin, Connecticut, that is much closer to Austin than to Pugin. See Appendix C.

31. Kathleen Curran, "The Romanesque Revival, Mural Painting, and Protestant Patronage in America," *The Art Bulletin* 81 (December 1999), 699.

32. In the letter just cited, Wheeler also mentions the possibility of working with Austin on the design for a chapel at the college in Hartford (see Appendix C). This remains unidentified or never executed. There are in the smaller drawing book at Yale (folder 24), however, the plan and elevation of a small church or chapel, Gothic in style, that is unidentified but must spring from these years. Since in plan and elevation it is unlike anything else the office produced at that time, it may be attributed to Wheeler.

33. Design XXXIV. See Meeks, "Romanesque," 28–29, and Francis Atwater, *History of Kent, Connecticut*, Meriden, CT: Journal Publishing Company, 1897. My thanks to Melinda Keck, the pastor, for showing me the church.

34. The cross never appears to top the spires in the churches in the Austin drawing books. According to *A Book of Plans* (see note 42), at this period the cross seemed to many Protestants to be an unwanted popish symbol.

35. See Steege, "*Book of Plans*," 224–225.

36. See Meeks's remarks about the decoration of these churches in "Romanesque," 30, and Steege, "*Book of Plans*," 225–226.

37. Kelly, *Meetinghouses*, I, 27. Since Gervase Wheeler joined Austin in that year, after he had worked on decoration at Upjohn's chapel at Bowdoin, he might have consulted about these works. He was described in March 1847 as "quite familiar with the mode of ornamenting in polychromy so much in vogue in Europe." See Curran, *Romanesque Revival*, 271.

38. Designs XXXV and XXXVI.

39. Church records on microfilm at the Connecticut State Library, Hartford; Henry Allen Castle, *The History of Plainville, Connecticut, 1640–1918*, Canaan, NH: The Reporter Press, 1967, 47–49.

40. Church records on microfilm at the Connecticut State Library in Hartford.

41. See Appendix C.

42. Congregational Churches in the United States General Convention, Albany, 1852, *A Book of Plans for Churches and Parsonages. Comprising Designs by Upjohn, Downing, Renwick, Wheeler, Wells, Austin, Stone, Cleaveland, Backus and Reeve*, New York: D. Burgess, 1853. This is a handsome folio with gilt-edged sheets of lithographs in subdued colors. (The reprint available from Books on Demand distributed by Astrologos Books is to be avoided as nearly illegible, and with distorted black-and-white plate images.) See Steege, "*Book of Plans*." Although Brown's name does not appear in the title, he is credited with Austin on the Contents page and on some plates.

There is what appears to be an undated partial reissue of this work with a Chicago imprint in the library formerly owned by the Milwaukee architect Edward Townsend Mix (1831–1890). The book is in the Mix Collection at the Milwaukee Public Library. Mix trained in New Haven in the 1840s with Sidney Mason Stone. See Chris Szczesny-Adams, "Edward Townsend Mix, Books and the Professional Architect in Nineteenth-Century Milwaukee," in *American Architects and Their Books, 1840–1915*, eds. Kenneth Hafertepe and James F. O'Gorman, Amherst: University of Massachusetts Press, 2007, 153, 157, 170. There is another copy at The Loeb Library, Harvard University, issued by the North-western publishing house.

43. William Backus, who spent some time in Upjohn's office, also contributed four designs. He and the others, except Stone and Austin and Brown, came from the New York orbit. It would be of interest to know how these men were selected, and why others were not, but that information is probably not retrievable.

44. Does this imply that Austin and Brown and William Backus were less heavily engaged in the early 1850s, since they contributed the most designs? Or was this just the expected thing to say?

45. See, for example, Lewis, *Gothic Revival*, 97. Lewis writes that this showed a "sublimated Gothic Revival."

46. The only known place Austin used a high-nave, low-side-aisles silhouette occurred in a secular building, Yale's first library, which was later converted into a chapel. See Chapter 4.

47. It has been noted that this odd arrangement appears again in Thomas Tefft's South Baptist Church in Hartford (1852–1854). See Meeks, "Romanesque before Richardson," 28, and *Thomas Alexander Tefft*, 214–215. Meeks thought the Hartford church dated to 1854 and thus was

influenced by Austin's project here, but the Tefft catalog gives the earlier date. Connections between Austin and Tefft have not been established.

48. Anderson, *Waterbury*, III, 707–710; *Waterbury American*, 3 March 1854.

49. See Arabella Berkenbilt, "European Influences on Thomas A. Tefft: Theory and Practice," in *Thomas Alexander Tefft*, 29–45.

50. Cf. Curran, *Romanesque*, Figs. 1 and 55.

51. Austin seems also to have owned G. G. Ungewitter's *Vorlegeblaetter fuer Ziegel- und Steinarbeiten*, [1849], but he acquired it after the dedication of this church. See Appendix A.

52. Photos in *Journal of the Society of Architectural Historians* 38 (December 1979), 343, and Jacob Landy, *The Architecture of Minard Lafever*, New York: Columbia University Press, 1970, 187.

53. Sylvester Smith, *The First Methodist Episcopal Church in New Haven*, New Haven, CT: The Church, [1889?]; Brown, *New Haven*, 104. Austin's work there has been largely erased by subsequent alterations.

54. George L. Wrenn, "'A Return to Solid and Classical Principles,' Arthur D. Gilman, 1859," *Journal of the Society of Architectural Historians* 20 (1961), 191–193.

55. I am indebted to Christopher Wigren of the Connecticut Trust for Historic Preservation for showing me the full extent of this stylistic episode.

56. Kelly, *Meetinghouses*, I, 3–21, 181–182.

57. Kelly, *Meetinghouses*, I, 87–93.

58. Kelly, *Meetinghouses*, I, 242, and Michael C. DeVito, *Historical Sketch of St. John's Episcopal Church, . . . Warehouse Point, Conn., 1802–1979*, Warehouse Point, CT: Wadsworth Press, 1979, 18. There exist two letters with the Austin & Brown letterhead (and signed Austin & Brown) dated 21 March and 21 May, 1856, requesting and acknowledging payment of $35 for drawings for the alterations at the East Windsor Historical Society. Thanks to Michael Salvatore of the society for help.

59. Kelly, *Meetinghouses*, II, 181–185; W. C. Sharpe, *History of Seymour, Connecticut*, Seymour, CT: Record Print, 1879, 28.

60. Church records on microfilm at the Connecticut State Library, Hartford; John Maurice Deyo, *225th Anniversary, First Congregational Church, Danbury, Connecticut*, Danbury: The Church, 1921, 65–67; James Montgomery Bailey, *History of Danbury, Conn., 1684–1896*, New York: Burr Printing House, 1896, 293–294; and George Dudley Seymour, *Researches of an Antiquary*, New Haven, CT: privately printed, 1928, 19–21.

4. public and commercial buildings of the 1840s and 1850s (pp. 117–149)

1. Henry H. Townsend, "The Grove Street Cemetery," a paper read before the New Haven Colony Historical Society in 1947, available at the cemetery's Web site.

2. New Haven *Columbia Register*, 21 September 1839, a reference I owe to John B. Kirby, Jr. There is in the Austin drawing collection at Yale (Design XXX of the larger book) a design for another cemetery entrance, this one in the castellated style with a central Tudor archway flanked by lower pedestrian entries. There is no reason to think that this relates to the Grove Street project, although it does fall stylistically into the category shared by the Wadsworth Atheneum.

3. Design XXIX in the larger book.

4. A. W. Pugin's *Apology for the Revival of Christian Architecture in England*, London: John Weale, 1843, which Austin may have owned but probably not in time to influence his design here, contains a caricature of an Egyptian gate with "words . . . inscribed in Grecian capitals along the frieze" (12). See Appendix A.

5. *Columbia Register*, 17 July 1845. There is an oblique reference to some criticism of the design in the building committee's assertion that it could not have reached this point without deliberation and caution, that "their plans have been subjected to severe scrutiny."

6. Louisa Tuthill, *History of Architecture from the Earliest Times*, Philadelphia: Lindsay and Blakiston, 1848, Pl. XXXIII. That this conforms to Austin's drawing (see note 3) confirms that Tuthill's illustrations must have derived from visits to the office rather than (or in addition to) the buildings.

7. The gateway was recorded in drawings and photographs by the Historic American Buildings Survey in 1964.

8. It has been suggested that the Samuel St. John tomb in the Burial Ground, designed about 1845, was the work of Austin. It does resemble the gateway but all of its details are, like those of the gateway itself, standard elements of the style. Austin's monument to Nathan Hale in the cemetery at Coventry, Connecticut, a work of 1846, is a modified obelisk with the winged orb motif set within a triangular pediment with acroteria, a good example of Austin's eclecticism. See David F. Ransom and Mary M. Donohue, *Coventry's Captain Nathan Hale Monument: History and Design*, Hartford: Connecticut Historical Commission, 1998. Thanks to Laura Katz Smith of the University of Connecticut for supplying me with a copy of this report. It has been said that the rather undernourished wooden gateway to Memento Mori Cemetery in Farmington, Connecticut, was inspired by Austin's in New Haven.

9. James Stevens Curl, *The Egyptian Revival*, London and New York: Routledge, 2005, 299. Other studies of the Egyptian mode include Richard G. Carrott, *The*

Egyptian Revival, Berkeley: University of California Press, 1978, and Frank J. Roos, Jr., "The Egyptian Style," *The Magazine of Art* 33 (April 1940), 218–223.

10. Curl, *The Egyptian Revival*, 204–206.

11. Thanks to John B. Kirby, Jr. for pointing this out.

12. John Foulston, *Public Buildings Erected in West of England*, printed for the author, 1838, 61 and Pls. 92–93. See also Curl, *The Egyptian Revival*, 265.

13. Although, as we have seen in Chapter 3, he was very familiar with Federal ecclesiastical architecture.

14. I am grateful to Margaret Vincent for information about this project and to Nancy Finlay of the museum for showing it to me. The drawing measures 23¾ × 36¼". It was executed in ruled black ink and muddy washes on paper laid on board.

15. Amelia Peck, ed., *Alexander Jackson Davis, American Architect, 1803–1892*, New York: Rizzoli, 1992, Pls. 1, 26, 32, etc. Davis seems not to have been averse to showing his drawings to other professionals. In 1838 he offered "to show . . . any work, views or plans" in his possession to a young A. J. Downing: Jane B. Davies, "Davis and Downing," in George B. Tatum and Elizabeth Blair Macdougall, eds., *Prophet with Honor: The Career of Andrew Jackson Downing, 1815–1852*, Philadelphia: The Athenaeum of Philadelphia, 1989, 81. The friction that one senses between Austin and Davis would not have existed as early as 1839, presumably.

16. I first discussed this subject in my "Who Designed Yale's First Library Building?," *Nineteenth Century* 26 (Fall 2006), 12–17. For the facts cited below see Jane B. Davies, "The Wadsworth Atheneum's Original Building: I. Town & A. J. Davis, Architects," *Wadsworth Atheneum Bulletin* 5th ser., no. 1 (1959), 7–18, and her contributions to Peck, *Davis*, 21, 36, and 110; and Lila Freedman, "Yale's First Library Build-ing, 1842–44–46," *Journal of the New Haven Colony Historical Society* 41 (Fall 1994), 17–36. (There was a library on the upper floor of Yale's first chapel, but this was the first building devoted exclusively to books. See Vincent Scully, Catherine Lynn, Erik Vogt, and Paul Goldberger, *Yale in New Haven: Architecture & Urbanism*, New Haven, CT: Yale University Press, 2004, 56.)

17. The original building has been added to many times.

18. Davies called this entry a puzzler ("Wadsworth," 11). I doubt that Davis's drawing of the Atheneum showing the plan and front elevation now in the collection at the Metropolitan Museum of Art (Peck, *Davis*, 36) is the one referred to here. Davis redrew projects later in life, and the wording N. YORK IN 1842 smacks of a later notation.

19. *Hartford Daily Courant*, 21 September 1842, 2; article signed "Viator."

20. "Public Libraries," *The New Eng-lander* 1, July 1843, 311.

21. Davies said it was in the collection of the Connecticut Historical Society, but it cannot now be located. It showed diagonal buttresses at the corners of the main block that were changed to square towers in the building. Davies in 1959 denied Austin any participation in the design, but later she did give the plan to him and the elevation to Davis. See her remarks in the publication cited in note 15 here and her entry on Davis in the *Macmillan Encyclopedia of Architects*, New York: The Free Press, 1982, I, 505–514.

22. See James F. O'Gorman, *Accomplished in All Departments of Art: Hammatt Billings of Boston, 1818–1874*, Amherst: University of Massachusetts Press, 1998. In February 1851 Isaiah Rogers in Cincinnati agreed to draw the elevations for an asylum from plans prepared in Indianapolis. This is recorded in his diary, now at the Avery Architectural Library, Columbia University.

23. One, labeled STUDY FOR MY LIBRARY OF ARCHITECTURE OR YALE, is signed and dated 1840.

24. The partnership existed from February 1829 to May 1835, and the pair rejoined forces from May 1842 to July 1843. That the Yale documents cited here predate the official rejoining is not a problem since they were often in contact during the break. See Peck, *Davis*, 18–19.

25. In 1850 Davis was called upon by the president of Yale, Edward Elbridge Salisbury, to design commemorative plaques for the main reading room: "Now please exercise your taste, and send me some very chaste designs, *faultless* in point of taste, and sufficiently ornate, but suiting the prevailing subdued style of the architecture of the library." Davis Papers, New York Public Library, Box 1, Folder 4, 4 March 1850. These memorial tablets are no longer in the room. I have been unable to learn whether they have survived somewhere else.

26. I am most grateful to Nancy Finlay of the museum for information about these drawings, whose provenance links them to both the Atheneum and Professor Benjamin Silliman of Yale.

27. Sterling Memorial Library, Manuscripts and Archives, Treasurer's Papers, Old Library, Yale Record Group 5, Record Unit 15, Box 445, folder 13.

28. "Kickback" is Freedman's word (see note 16).

29. See "Public Libraries," 310–311. It was long thought that Henry Flockton, the English draftsman who may have joined Austin's office in the 1840s, was responsible for the library, but it is certain that he did not arrive in this country in time to take part in the design. See Appendix C and O'Gorman, "Who Designed," 15 and 17, fn. 14. Austin's plan is mentioned by Freedman and recorded by the Historic American Buildings Survey, but at the moment it is misplaced in Yale's Sterling Library.

George Dudley Seymour (*New Haven*, New Haven, CT: privately printed, 1942, 223) says that Austin was approached by Yale "on his return for a business trip to Charleston." Robert S. Russell, architectural historian at the College of Charleston, assures me that there is no known record of his having visited there or any Austin buildings in that area.

30. "Public Libraries," 311, and Freedman, "Yale's First Library Building," 28–31. An observer of the 1870s described the library as "truncated" Tudor because of the "omission of stone pinnacles all around the building. But with due regard to the feelings of those who might have occasion to look at the building, models of the larger turret terminations in wood have been set up to show what they might be if made of stone." "New Haven Revisited," *American Architect and Building News* IV (9 November 1878), 155–156.

31. See Chapter 3. The main room in the library "will resemble in form a Gothic chapel, with its nave and aisles," according to "Public Libraries," 311, an article written long before the room was finished. According to this source, a "gallery is to extend on all sides of the room, and is to contain a number of alcoves." Pre-1931 photographs (see Fig. 91) show that the gallery existed to service the upper bookcases of the sides and did not extend across the central space. The article also says that the "ceiling is to be finished with groined arches."

32. The book alcoves were removed when the building became a theater. See Chapter 5.

33. I have looked through much if not all of the Davis papers gathered in the various depositories in New York without finding mention of Austin. Roger Hale Newton states that Austin's name (as well as that of his New Haven contemporary, Sidney Mason Stone) appears nowhere in Davis's literary remains (*Town & Davis, Architects*, New York: Columbia University Press, 1942, 253). In 1855 Davis stayed in Austin's New Haven House hotel without mentioning the designer (Day Book, 1853–1869, Avery Library, 11 August 1855). On other trips to New Haven he lists those he visited without mentioning Austin.

34. All discussions of the station begin with Carroll L. V. Meeks, *The Railroad Station*, New Haven, CT: Yale University Press, 1956, 52–54. See also Clay Lancaster, "Oriental Forms in American Architecture, 1800–1870," *The Art Bulletin* 29 (1947), 183–193.

35. Patrick Conner, *Oriental Architecture in the West*, London: Thames and Hudson, 1979, 176.

36. Design I.

37. *Benham's City Directory*, No. 10, New Haven, 1849, 7–8.

38. A perspective view, "Railroad Station of the New York and New Haven Railroad," *Gleason's Pictorial Drawing Room Companion* I (1851), 509, and an 1869 sketch of the building from the north in the scrapbooks assembled by Arnold G. Dana, "New Haven Old and New," in the New Haven Historical Society, Book 25 (Reel 4).

39. The New Haven *Palladium* of 30 October 1840 carried a request for proposals "for building a Passengers' Depot at New Haven." Plans and specifications could be studied at the offices of the Hartford and New Haven Railroad. No architect is named.

40. See Appendix A.

41. Seymour, *New Haven*, 290.

42. As quoted in the New Haven *Daily Register*, 8 December 1860.

43. The symmetry is not perfect. In order to accommodate "dressing rooms" attached to the ladies' parlor, Austin added a small block to the left side of the central salient. It took the place of one of the arched openings.

44. Seymour, *New Haven*, 288. Meeks surprisingly lets this part of the contemporary description go unremarked. Christopher Wigren notes similar structures upholding the balconies at the University of Virginia and other Neo-Classical buildings, but they represent a very different situation.

45. See note 43.

46. George Dudley Seymour, *New Haven*, 289; Meeks, *Railroad Station*, 53; Lancaster, "Oriental Forms," 187; Edward E. Atwater, *History of the City of New Haven*, New York: W. W. Munsell & Co., 1887, 366.

47. Later writers have followed suit. See, for example, David R. Handlin, *American Architecture*, London: Thames and Hudson, 1985, 77–78.

48. Raymond Head, *The Indian Style*, Chicago: University of Chicago Press, 1986, 62.

49. Mildred Archer, *Early Views of India*, London: Thames and Hudson, 1980, 147.

50. P. 66 and Pl. IV. "There is comparatively little in their [the Chinese] architecture worthy of imitation." Tuthill was well known on the New Haven architectural scene.

51. Conner, *Oriental Architecture*, 176.

52. Designs XXXI and XXXII. See Carroll L. V. Meeks, "Some Early Depot Drawings," *Journal of the Society of Architectural Historians* 8 (1949), 33–42, and Meeks, *Railroad Station*, 52–53.

53. *The Indian Style*, 62.

54. See Appendix C.

55. William Henry Leeds, *The Travellers' Club House*, London: J. Weale, 1839. There is a copy at Yale, but it is not described as having Austin's signature.

56. Design III.

57. Designs XIII and XIV.

58. George Dudley Seymour, *Researches of an Antiquary*, New Haven, CT: privately printed, 1928, 16. The attribution was accepted by the New Haven Preservation Trust according to the Historic American Buildings Survey, which documented the building in 1964. See H. Ward Jandl, M.A.

thesis on Austin, Columbia University, ca. 1972, II, 143.

59. *Researches*, 16–17. He also attributed the New Haven Savings Bank erected on Orange Street in 1847 to Austin. It was a small one-story building capped by a pediment and marked by the words SAVINGS BANK that appeared above the fanlight over the entrance.

60. James Montgomery Bailey, *History of Danbury, Conn.*, New York: Burr Printing House, 1896, 459–460.

61. Jandl, II, 145–146.

62. Design XXVIII.

63. Jandl, II, 148–150. Minard Lafever, *The Architectural Instructor*, New York: George P. Putnam, 1856 (as Henry-Russell Hitchcock noted, the copyright is 1854, suggesting that there may have been an earlier edition, now unknown: *American Architectural Books*, New York: Da Capo Press, 1976, #686). See Jacob Landy, *The Architecture of Minard Lafever*, New York: Columbia University Press, 1970, 160.

64. Seymour (*Researches*, 16) gave the Yale Bank at Chapel and State Streets, New Haven, a post–Civil War work, to Austin. Jandl, II, 151, and *Leading Business Men of New Haven*, Boston: Mercantile Publishing Co., 1887, 169 (Austin ad). It was in the Second Empire style but no longer exists.

65. Elizabeth Mills Brown, *New Haven, A Guide to Architecture and Urban Design*, New Haven, CT: Yale University Press, 1976, 118. The structure was later known as the Palladium Building after the newspaper which occupied it. The façade is shown in an ad for G. A. Shubert, Stone-Cutter, in the 1860 catalogue of carriages published by G. and D. Cook and Company, the caption of which mentions both Austin and Sidney Mason Stone as references.

66. "Minutes 1826–1874," 7 May 1855. Records of the Young Men's Institute, New Haven.

67. Two more bays were added later. See Brown, *New Haven*, 118, and Jandl, II, 138.

68. The library is now located at 847 Chapel Street in an 1877 building designed by Austin's former assistant, Rufus G. Russell. My thanks to the librarian, Rebecca McGaffin, for assistance.

69. Joseph Anderson, ed., *The Town and City of Waterbury, Connecticut*, New Haven, CT: The Price & Lee Company, 1896, III, 1048–1049.

70. See Jeffrey A. Cohen, "Building a Discipline: Early Institutional Settings for Architectural Education in Philadelphia, 1804–1890," *Journal of the Society of Architectural Historians* 53 (June 1994), 139–183.

71. "Minutes," 7 May 1855 and 15 May 1857. The first reference is to classes in geometrical, architectural, and machine drawing; the second, to classes in practical geometry, architecture, machine drawing, carriage drawing (New Haven was a major center of carriage building), etc.

72. *Researches*, 16–17.

73. *The American Journal of Education* I (1856), 647–648.

74. See Leslie De Angela Dees, "The Architectural Expression of School Reform," in *Thomas Alexander Tefft: American Architecture in Transition, 1845–1860*, Providence, RI: Brown University Press, 1988, 47–59, 164–165. Austin could have seen the school illustrated in the 1848 edition of Henry Barnard's *School Architecture*, New York, A. S. Barnes & Co.

75. Vol. X (1954), 405.

76. Chester Hills, *The Builder's Guide. A Practical Treatise on Grecian and Roman Architecture* [etc.], *Revised and Improved, with Additions of Villa and School House Architecture, by H. Austin, Architect, and H. Barnard, Esq.*, Hartford, CT: Case, Tiffany and Burnham, 1846 [c. 1845], 90 fig. 5. The contents page of the 1849 edition of *School Architecture* lists the "Front elevation of a two-story

building, by H. Austin" on page 76, where the same elevation of a temple-form Neo-Classical building appears. It is a puzzle: totally out of place, totally anachronistic in Austin's work of the period, and decidedly unschool-like. The relationship between Austin and Barnard has yet to be studied in detail.

77. I (1856), 647.

5. SOME LATER BUILDINGS
(pp. 150–178)

1. David T. Van Zanten, "Jacob Wrey Mould: Echoes of Owen Jones and the High Victorian Styles in New York, 1853–1865," *Journal of the Society of Architectural Historians* 28 (March 1969), 41–57.

2. Wight saw the Gothic through Ruskin's eyes, and therefore had little use for Austin's and Davis's earlier works at Yale. A good Ruskinian, he especially disliked the use of wood in the upper reaches of the exterior at the library. See Vincent Scully, Catherine Lynn, Erik Vogt, and Paul Goldberger, *Yale in New Haven: Architecture & Urbanism*, New Haven, CT: Yale University Press, 2004, 112.

3. Patrick L. Pinnell, *Yale University*, New York: Princeton Architectural Press, 1999, 31–32.

4. "The New Public Building," *Daily Register*, 27 April 1861.

5. New Haven *Evening News*, 29 July 1870. Elizabeth Mills Brown (*New Haven, A Guide to Architecture and Urban Design*, New Haven, CT: Yale University Press, 1976, 19) cited what she believed to be an earlier Welch house by Austin.

6. New Haven *Daily Register*, 4 June and 7 October 1862. Also available in City of New Haven, *Address of His Honor Mayor Welch . . . on the Opening of the Council Chamber*, New Haven, CT, 1862.

7. Charles E. Brownell, "The Italian Villa and the Search for an American Style, 1840–1860," in Irma B. Jaffe, ed., *The Italian Presence in American Art, 1760–1860*, New York: Fordham University Press, 1989, 222 and passim. I owe this reference to Christopher Wigren.

8. "New City Hall," *New Haven Register*, 12 January 1849. "New Haven Town Records, 1807–1854," II, 26 November 1850 and 27 January 1851 (New Haven Museum and Historical Society). The projects are described in detail by the architects. Dwight (1793–1854), educated at Yale and the Andover Theological Seminary, was a leader in penal reform. At the same time as the New Haven proposal, he teamed with Gridley J. F. Bryant in the design of almshouses in Boston and elsewhere. See Roger G. Reed, *Building Victorian Boston: The Architecture of Gridley J. F. Bryant*, Amherst and Boston: University of Massachusetts Press, 2007, 62–69. Since Dwight was not an architect, the unbuilt New Haven almshouse was probably designed by Bryant and is listed as such in Robert B. McKay, "The Charles Street Jail: Hegemony of a Design," Ph.D. diss., Boston University, 1980, 285 (see Reed, *Building Victorian Boston*, 183).

9. New Haven Town Records, 28 February 1854 (New Haven Museum and Historical Society).

10. In the complex way of New England governments, the building was to house the administrations of both the town and the city, and both appointed building committees: *New Haven Daily Register*, 25 June and 3 July 1860.

11. Brown's name nowhere appears in documents of the time, suggesting a decline in stature since his co-credit in the *Book of Plans* and his brief partnership with Austin. He would soon go off to war. See Appendix C. Brown added the Court House to the left of City Hall in 1871–1872. It was removed

in the recent rebuilding. The tablet naming him as architect has been relocated to the rebuilt City Hall. A later observer had this to say about City Hall and its addition: "with a picturesque outline and a pleasing color effect, [City Hall] was a most extraordinary and incongruous thing in detail. It was the simple but earnest effort of the untutored mind to fathom the mysteries of Gothic architecture. Since then an extension to it by Mr. Brown . . . has been built in much better style." The unnamed author thought more highly of Wight's Street Hall at Yale. "New Haven Revisited," *American Architect and Building News* IV (9 November 1878), 155–156.

12. George Dudley Seymour, *New Haven*, New Haven, CT: privately printed, 1942 (but this section was originally published in 1910), 223; see also 150–151.

13. *Illustrated London News* 36, supplement, January 1860, 17, John B. Kirby, Jr., entry on Austin in the *Macmillan Encyclopedia of Architects*, ed. Adolf K. Placzek, New York: The Free Press, 1982, 1, 117. Downes, the New Haven bookseller, had the *Illustrated London News* for sale on 13 January 1860, according to his ad in the *New Haven Daily Register*.

14. See Appendix A.

15. Henry-Russell Hitchcock, *Early Victorian Architecture in Britain*, New Haven, CT: Yale University Press, 1954, VI, 3.

16. Brown, *New Haven*, 115.

17. Austin, Folder One. I am grateful to librarian James W. Campbell of the society for much guidance in my research. The rebuilding of the hall entailed the destruction of everything behind the façade and the front suite of rooms.

18. *Daily Register*, 22 November 1861.

19. *Daily Register*, 15 July 1861.

20. The building was recorded by the Historic American Buildings Survey in 1964 and 1967.

21. In the year of his death, Austin sanctioned the removal of the colored lay light in order to brighten the stair hall. See the New Haven *Register*, 15 January and 23 February 1891.

22. Norman Johnson, *Forms of Constraint: A History of Prison Architecture*: Urbana and Chicago: University of Illinois Press, 2000, 75–82.

23. Scully et al., *Yale in New Haven*, 17–18.

24. Montgomery Schuyler, "Architecture of American Colleges," *The Architectural Record* 29 (1911), 161–166. I owe this reference to Christopher Wigren, and thanks to Suzy Taraba, the university archivist. It should be said that no known document in the archives names Austin or Brown as the architect. The building has been altered inside and is now called the '92 Theater.

25. James F. O'Gorman, *Accomplished in All Departments of Art: Hammatt Billings of Boston, 1818–1874*, Amherst: University of Massachusetts Press, 1998, 129–130.

26. Cummings Report to the Joint Committee, 1865/66; Wesleyan archives.

27. H. Ward Jandl, M.A. thesis, Columbia University, ca. 1972, II, 132.

28. *Trinity Church Home and Trinity Parish School. Constitution and By-Laws*, New Haven, 1872; Brown, *New Haven*, 110; Jandl, II, 163–164.

29. New Haven *Evening Register*, 30 November 1870. Sheffield also commissioned Austin to transform Ithiel Town's Yale Medical College building into the Scientific School in 1860. The work included the addition of an Italianate tower. Roger Hale Newton, *Town & Davis, Architects*, New York: Columbia University Press, 1942, 42; Jandl, II, 139.

30. The building is assigned to Austin in *Leading Business Men of New Haven*, Boston: Mercantile Publishing Co., 1887, 169. See Jandl, II, 130–131.

31. 9 February 1871.

32. The *Daily Constitution* of Middletown, Connecticut, on 5 September 1872 reported that Austin had prepared plans for a new $300,000 city hospital for Worcester, Massachusetts, "in connection with C. C. Buck." According to Charles Nutt, *History of Worcester*, New York: Lewis Historical Publishing Company, 1919, II, 912–914, which mentions no architects, the hospital buildings were not erected until 1881, so this may have remained a project. For Buck see Appendix C, note 46. Thanks to Susan Ceccacci for the Nutt reference.

33. Brown, *New Haven*, 150. She assigns the Davis house to Austin and Brown. There is at the Connecticut Historical Society Museum a complete set of drawings for another frenchified Italianate villa. This may have been for the Samuel Taylor house in Hartford, for which Austin's specifications are also to be found at the society, but it has not been possible to document firmly the client or the date. My thanks to Nancy Finlay of the museum for trying.

34. The Davis house was recorded by the Historic American Buildings Survey in 1964; I quote from the survey's description below. See Dana, *New Haven Old and New*.

35. At about the same time that Austin worked for Davis and Winchester, he remodeled for Samuel Simpson the old Taber house in Wallingford, Connecticut, giving it a Neo-Classical front and a polygonal wing with midcentury touches. There is a measured drawing of the original house, and a plan and signed elevation with alternate treatment, in the Yale collection (1034, Box 5, folders 73–74, 76). Another drawing of the façade and specifications are in the collection of John B. Kirby, Jr., of Branford, Connecticut.

36. *Selections from the M. & M. Karolik Collection of American Water Colors & Drawings: 1800–1875*, Boston: Museum of Fine Arts, 1962, cat. 64; Fig. 31. I am most grateful to Allen Weathers, curator of the Meriden Historical Society, for identifying the client. Collins moved into the house in 1869; it was demolished in 1955.

37. An earlier related design is the G. N. Graniss house on Church Street in Waterbury, of 1864. It may have been designed by Austin's office.

38. "Mr. Austin, architect, has just completed the plans for a beautiful residence on West Chapel street, for H. M. Welch, Esq. It will be a marked ornament to that section of the city." New Haven *Evening Register*, 29 July 1870. Photos are in the Dana Collection at the New Haven Museum and Historical Society. As noted above, Brown (*New Haven*, 191) cites what she believed to be an earlier Austin house for Welch.

39. There are a number of towered mansard villas in southern Connecticut that have had Austin's name attached to them: those of Thomas R. Trowbridge, Branford, 1870; Edward Malley, West Haven, 1871; Caleb Maltby, West Haven, 1879; Daniel Trowbridge, West Haven, 1880; and others.

40. Some are embossed with Austin's signature shield.

41. See the entry on Austin by John B. Kirby, Jr., in the *Macmillan Encyclopedia of Architects* I, Adolf K. Placzek, ed., New York: The Free Press: 1982, 117–118, and Vincent Scully, "Romantic Rationalism and the Expression of Structure in Wood: Downing, Wheeler, Gardner, and the Stick Style," *The Art Bulletin* 35 (1953), 121–142.

42. Deborah Deford, ed., *Flesh and Stone: Stony Creek and the Age of Granite*, Stony Creek CT: Stony Creek Granite Workers Celebration, in association with Leete's Island Books, 2000, 167–168.

43. Mary N. Woods, *From Craft to Profession*, Berkeley: University of California Press, 1999, 28–29, 33, 198.

APPENDIX A: AUSTIN'S BOOKS
(pp. 179–186)

1. Jhennifer A. Amundson, "'Vast Avenues to Knowledge': Thomas Ustick Walter's Books," in *American Architects and Their Books, 1840–1915*, Kenneth Hafertepe and Jams F. O'Gorman, eds., Amherst: University of Massachusetts Press, 2007, 64–67.

2. William Dunlap, *History of the Rise and Progress of the Arts of Design in the United States*, New York: G. P. Scott and Co., 1834 (I cite the Benjamin Blom edition of 1865), III, 77. See also Roger Hale Newton, *Town & Davis, Architects*, New York: Columbia University Press, 1942, 66–72, and Sarah Allaback, "Louisa Tuthill, Ithiel Town, and the Beginnings of Architectural History Writing in America," Kenneth Hafertepe and James F. O'Gorman, eds., *American Architects and Their Books to 1848*, Amherst: University of Massachusetts Press, 2001, 199–215.

3. There is a manuscript catalog of Davis's library in the collection of the New-York Historical Society. There is an 1840 STUDY FOR MY LIBRARY OF ARCHITECTURE related to his rejected rotunda design for Yale in the Davis collection at the Metropolitan Museum of Art in New York City. For Davis's use of his library for the instruction of potential clients see Mary N. Woods, *From Craft to Profession*, Berkeley: University of California Press, 1999, 83–84. See also Chapter 1.

4. For a broader view of this subject see Hafertepe and O'Gorman, *American Architects and Their Books to 1848*, Amherst: University of Massahusetts Press, 2001, and *American Architects and Their Books, 1840–1915*, Amherst: University of Massachusetts Press, 2007.

5. See Hafertepe and O'Gorman, eds., *American Architects and Their Books to 1848*.

6. Town's books were sold in a number of auctions before and after his death. Catalogs exist from 1842, 1843, 1844, 1847, 1848, and 1850. See Michael C. Quinn, "The Library of Ithiel Town," MA thesis, Yale University, 1976. Some of the important ones are [Ithiel Town], *Important Notice to all Colleges, State, and other Public Libraries . . .* , New York: C. Vinten, 1842; *Catalogue of Scarce, Valuable, and Splendid Books . . .* , New York: Tribune Printing Office, 1844; *Catalogue of an Extensive, Curious and Valuable Collection of Ancient and Modern Books . . .* , New York: Piercy and Houel, 1847.

7. Henry Howe, "New Haven's Elms and Green," *New Haven Daily Morning Journal and Courier*, 6 February 1884. This is one of a series of articles stretching from 28 September 1883 to 19 March 1884. They can be found on microfilm at Yale's Sterling Library (Reel B19021 (#13).

8. George Dudley Seymour, *New Haven*, New Haven, CT: privately printed, 1942 (but originally published 1910).

9. In his *American Architectural Books* (I use the Da Capo Press edition of 1976, 80–81), Henry-Russell Hitchcock wrote that it was unclear whether Volume One first appeared in parts. The ad for T. H. Pease's bookstore that appeared in the *Daily Register* in October 1846 makes it clear that it did.

10. This information comes from advertisements published in the *New Haven Daily Register* during these years.

11. See Chapter 4.

12. Carroll L. V. Meeks, "Henry Austin and the Italian Villa," *The Art Bulletin* 30 (June 1948), 145–146.

13. Thanks to John B. Kirby, Jr., for pointing me toward these.

14. Meeks, "Some Early Depot Drawings," *Journal of the Society of Architectural Historians* 8 (January–June 1949), 36.

15. See note 6.

16. Numbers 15–17 here are cited by Meeks in his "Romanesque before Richardson in the United States," *The Art Bulletin* 35 (1953), 21 note 18 and 23 note 32.

17. Georg Germann, *Gothic Revival in Europe and England*, Cambridge, MA: MIT Press, 1972, 32.

18. James F. O'Gorman, "Bulfinch on Gothic Again," *Journal of the Society of Architectural Historians* 50 (June 1991), 192–194.

19. The New Haven bookseller T. H. Pease offered for sale in *The Daily Register* of 30 January 1847 copies of *The Pictorial Times*, *The Illustrated London News*, and *Punch*.

20. George Dudley Seymour, "Henry Austin," *Year Book of the Architectural Club of New Haven*, West Haven, CT: Church Press, 1923. Carroll L. V. Meeks, "Henry Austin: The Great Eclectic." There is a copy of the text of this talk in my files and another in the files of the Victoria Mansion (the Morse-Libby house) in Portland, Maine. Meeks also mentioned, then crossed out, "several copies of the 'Statesman's Manual.'" Enquiries at the library have produced no results, other than an 1891 list of expenditures for books that contains the following item: "Paid Henry Austin & Son . . . $54.00" (*Fifth Annual Report of the Directors of the Free Public Library of the City of New Haven*, 6).

APPENDIX B: THE AUSTIN DRAWING COLLECTION AT YALE UNIVERSITY (pp. 187–194)

1. James F. O'Gorman, *On the Boards: Drawings by Nineteenth-Century Boston Architects*, Philadelphia: University of Pennsylvania Press, 1989, 39–50.

2. Austin Papers, MS 1034. The col-

lection also contains a few drawings and documents not part of the books discussed here.

3. George Dudley Seymour, *New Haven*, New Haven, CT: privately printed, 1942, 224. This was originally published in 1910.

4. See Appendix C.

5. Carroll L. V. Meeks, "Henry Austin and the Italian Villa," *The Art Bulletin* 30 (June 1948), 145.

6. Advertisements in the *New Haven Daily Register* between 1847 and 1848 show that drawing paper was readily available on Chapel Street. Bassett & Bradley at number 115, for example, had Whatman's in various sizes (there is at least one sheet in the drawing books so watermarked), and London Drawing Paper as well as Faber pencils. Their ad of 29 May 1847 was specifically addressed TO ARCHITECTS, of whom there were exactly two in town: Austin and Sidney Mason Stone. For the fabrication of architectural drawings in this period see Lois Price's forthcoming study, tentatively titled "Line and Wash, Shade and Shadow: The Construction and Preservation of Architectural Drawings."

7. See Appendix C.

8. See his ad in the *Hartford Daily Courant*, 18 March 1841, and Chapter 1 here.

9. See Appendix C for details of the office force.

10. The Almshouse drawing is at the Connecticut Historical Society, Print Drawer 6, #3; the town house elevation is at the New Haven Museum and Historical Society, Folder 4 of the architectural drawing collection.

11. Design XXI. The Merwin Austin design was published in *The Cultivator*, n. s. 3 (January 1846), 24. See David Schuyler, *Apostle of Taste: Andrew Jackson Downing, 1815–1852*, Baltimore and London: The Johns Hopkins University Press, 1996, 114.

12. Hartford: Belknap & Hamerley, 1849, 3–10.

13. See the catalog *Drawn toward Home*, forthcoming from Historic New England.

14. New Haven Museum and Historical Society, Folder 1.

15. Design XIV. Oscar Mortimer Carrier (1834–1865) graduated from Yale in 1860 and some time afterward joined the faculty of Olivet College. He married in 1862. It is highly unlikely that he ordered a house as early as the 1850s. The house seems not to have been built. My thanks to Mary Jo Blackport of Olivet College for her help.

16. *New Haven Palladium*, 20 November 1840, 6 November 1841, etc.

17. See Chapter 1.

18. Jhennifer A. Amundson , ed., *Thomas U. Walter: The Lectures on Architecture, 1841–1853*, Philadelphia: Athenaeum of Philadelphia, 2006.

19. A recently discovered invoice sheds some light on Austin's payment schedule for drawings in the mid-1840s. In the papers of Harpin Lum of New Haven, a builder and dealer in stone, is the following document (New Haven Museum and Historical Society, MSS #32, Box 1/Folder B; courtesy of James Campbell, the Whitney Librarian and Curator of Manuscripts):

Harpin Lum Dr

To Making Specifications drawings and detail drawings for store	$50,00
Making drawings Elliot's store front	10,00
For drawings of No 3 Engine House	10
Drawings Made for Houses to be built by Hervey Sandford	10
June 4, Drawings for garden screen	2
	82,00
one set of plans and specifications for dwelling House	25
	107,00

Jan 3d 1847

Recd paymnt Henry Austin

1. When he won the coveted Pritzker Prize, Richard Rogers, in a statement rarely heard from the "archistars" of today, told the *New York Times* that he had "never really understood how architects can think of themselves as an individual" (29 March 2007).

2. There is no available information about the relationship between these two Austins.

3. Austin advertisements in the *Hartford Courant* from 1839 to 1841 and the *New Haven Palladium* and *New Haven Register* as well as the New Haven city directory. The Mitchell's Building was among Austin's earliest realized buildings (Edward E. Atwater, *History of the City of New Haven*, New York: W. W. Munsell & Co., 536). It was basically a brick box.

4. George Dudley Seymour, *Researches of an Antiquary*, New Haven, CT: privately printed, 1928, 13.

5. *Leading Business Men of New Haven County*, Boston: Mercantile Publishing Company, 1887, 169

6. *Palladium*, 17 January 1842.

7. DOB (1 August 1814) from the "Austins in America" Web site; DOD (April 1890) courtesy of Frank Gillespie of the Friends of Mount Hope Cemetery in Rochester, New York.

8. The 1850 U.S. Census lists him in Rochester; the 1870 Census has him in New Haven.

9. David Schuyler, *Apostle of Taste: Andrew Jackson Downing, 1815–1852*, Baltimore: The Johns Hopkins University Press, 1996, 114. Elm-Wood reflects Henry's Scovill house design (as opposed to its execution). There is reason to believe that the house was never built, since the client (and perhaps codesigner), Thomas Hyatt, does not

show up in Rochester directories until 1851, when he was living at 41 North Street. My thanks to Cynthia Hunt of the Rochester Historical Society.

10. Betsy Brayer, *The Warner Legacy in Western New York*, Rochester: The Landmark Society of Western New York, 1984. My thanks to Roger Reed for a copy of this work. I've seen nothing to suggest that A. J. Warner passed through Henry's New Haven office.

11. George Dudley Seymour, *New Haven*, New Haven, CT: privately printed, 1942, 219–239, based on an article first published in 1910.

12. See Appendix B.

13. For the inclusion of A. J. Davis as codesigner, see my "Who Designed Yale's First Library Building?" *Nineteenth Century* 26 (Fall 2006), 12–17.

14. National Archives and Records Administration, Film M237, Reel 54, List 163 (also available through Ancestry.com). It has been suggested (by Roger Hale Newton, *Town & Davis, Architects*, New York: Columbia University Press, 1942, 241) that Flockton also worked for Town and Davis. If this is true (and I've seen nothing to prove it), it may be that he met Town during Town's trip abroad from July to December 1843. See R. W. Liscombe, "A 'New Era of My Life': Ithiel Town Abroad," *Journal of the Society of Architectural Historians* 50 (March 1991), 17.

15. See Appendix B.

16. Sandra L. Tatman and Roger W. Moss, *Biographical Dictionary of Philadelphia Architects*, Boston: G. K. Hall, 1985. City directories list him there from 1858 to 1872. In 1858 he exhibited a design for a cottage in the recurring fall exhibition at the Franklin Institute. Jeffrey A. Cohen, "Building a Discipline," *Journal of the Society of Architectural Historians* 53 (June 1994), 151 n47. The 1860 U.S. Census tells us that he lived

in Philadelphia's Sixth Ward with his wife, English-born Elizabeth, age given as thirty, and Ada A., age thirteen, born in New York, presumably their daughter (although Elizabeth would seem to have been very young if she gave birth in 1847. By then New York was easily accessible from New Haven by boat or train). Thanks to George E. Thomas for help finding this information. The New Haven city directory lists Flockton in the city in 1864 and 1865.

17. New York Passenger Lists, 1820–1957 (Ancestry.com). The ship left England from London. Wheeler is listed as age twenty-four on the manifest, which would put his birth year nearer to ca. 1823 than the ca. 1815 that is usually given. At such a young age, he must have been a smooth talker to have found employment so quickly. Perhaps he lied about his age.

18. Kathleen Curran, "The Romanesque Revival, Mural Painting, and Protestant Patronage in America," *The Art Bulletin* 81 (December 1999), 699–701, or Curran, *The Romanesque Revival*, University Park: Pennsylvania State University Press, 2003, 271–274. The original letters are in the Chapel Papers at the Bowdoin College Library, Special Collections.

19. See Chapter 3.

20. Wheeler to Woods from New Haven, 14 August 18[47], Chapel Papers, Bowdoin College Library. The arrangement must have been relatively new because Wheeler was still picking up his mail at the post office two weeks later (New Haven *Daily Register*, 1 September 1847).

21. Wheeler to Woods from New Haven, 27 September 1848, Chapel Papers, Bowdoin College Library. The church in question is not identified. Perhaps he referred to Austin's Gothic St. John's Church, Waterbury.

22. My thanks to Kathleen Curran and Peter Knapp of Trinity College, Hartford,

for looking into the problem for me. There is in the smaller book of drawings at Yale, dated 1851 but containing earlier projects, an unidentified and undated plan and elevation of a small Gothic church or chapel (folder 24). It is unlike Austin's other ecclesiastical work and may have been Wheeler's design.

23. Wheeler called for tenders from builders to erect the church in the *New Haven Register* of 1 November 1849. His office was then in Hartford. The building was either badly designed or badly built because it needed alteration immediately and has been worked on many time since, including in 1863 by Austin. See Egbert W. Richards, *Two Centuries Under Covenant: A History of the Berlin Congregational Church, 1775–1915*, Berlin: The Church, 1975, 43–44. My thanks to Meg Coffey, secretary of the church, for her help.

24. See Chapter 2.

25. See Chapter 4.

26. Wheeler was still in New Haven or meant to be there in mid-November 1848 because there was a letter for him at the post office (*Daily Register*, 15 November 1848). Sometime within the next year he left.

27. Wheeler might also have advised Austin on the "fresco" decorations he was adding to existing churches in this period. See Chapter 3.

28. See Chapter 3.

29. Wheeler's American years are only now beginning to come into focus. A rather unsatisfactory account is Jill Allibone's entry in the *Macmillan Encyclopedia of Architects*, ed. Adolf K. Placzek, New York: The Free Press, 1982, 4, 388–389. The brief entry in Tatman and Moss, *Biographical Dictionary*, 849–850, should also be consulted. According to the Web site holmesacourt.com (which lists Wheeler as a descendant of the Holmes a' Court family), Wheeler married Connecticut-born teenage Catherine

Brewer Hyde in New York City on 18 September 1850. The couple had eight children between ca. 1852 and ca. 1868. Wheeler is listed as head of family in the 1860 Census of New York, but sailed on the steamship *Arago* from New York to Southhampton in January 1860 (*New York Times*, 9 January 1860). He is listed as head of household in the 1871 Census of London and the 1881 Census of Hove, Sussex. By the next decennial census Catherine headed the household. For Wheeler's post-Austin career see Michael A. Tomlan's introduction to Henry Hudson Holly's *Country Seats* and *Modern Dwellings*, Watkins Glen, NY: Library of Victorian Culture, 1977 (2nd printing, 1980) and George B. Tatam's introduction to Holly's *Country Seats*, New York: Dover, 1993. Holly apprenticed with Wheeler in New York 1854–1855. The best account of Wheeler's life is the too-little-known M.S. thesis by Renee Elizabeth Tribert, "Gervase Wheeler: Mid-Nineteenth Century British Architect in America," University of Pennsylvania, 1988.

30. Atwater, *History*, 536–537; Seymour, *New Haven*, 250–251.

31. See Chapter 3. Only Austin's name appears on the title page of the book and on some of the plates, but the contents page credits "Austin and Brown" with all the designs from the office.

32. This is referred to, without naming Brown, in the article on Henry Austin & Son in *Leading Business Men of New Haven County*, 169. See also Chapter 3, note 58.

33. See Chapter 5.

34. Seymour gives 1865 as the date of departure, but I have discussed work credited to both Austin and Brown that postdates this. (See Chapter 5.) From 1862 to 1864 Brown served in the 20th Connecticut Volunteers, the first regiment to enter Atlanta after the surrender of the city, but he left the service with a dishonorable discharge, according to *Record of the Service of*

Connecticut Men . . . during the War of the Rebellion (Hartford, CT: Press of the Case, Lockwood & Brainard Co., 1889). Thanks to Nancy Finlay of the Connecticut Historical Society for this information.

35. Montgomery Schuyler, "Architecture of American Colleges," *The Architectural Review* 29 (1911), 161, 163.

36. New Haven *Evening Register*, 7 January and 8 March 1870. In that year alone he had commissions for the Edward Street public school, St. James Episcopal Church in Fair Haven, and a fire house. See also the *Register*, 1 September and 5 October 1870. The partnership of Brown and Van Beren later published *Architecture. A Few Types of Houses and Other Buildings Exemplifying the Tendency of Modern Architecture*, New Haven, CT, ca. 1912. See Vincent Scully, *The Shingle Style*, New Haven, CT: Yale University Press, 1955, 74 note 13 (where it is said that the firm still existed).

37. For works by these architects see Elizabeth Mills Brown, *New Haven: A Guide to Architecture and Urban Design*, New Haven, CT: Yale University Press, 1976.

38. Atwater, *History*, 536–537.

39. Several Russell buildings are illustrated in Brown, *New Haven*.

40. See Chapter 4.

41. Joseph Anderson, ed., *The Town and City of Waterbury, Connecticut*, New Haven, CT: The Price & Lee Company, 1896, III, 1048–1049.

42. Seymour, *New Haven*, 221. Robinson claimed to have designed Austin's Young Men's Institute in his ad in the New Haven city directory for 1880. Since the original building was erected in 1855–1856, that is impossible, but he might have supervised the later addition to the building when it became the home of the *New Haven Morning Palladium*. See H. Ward Jandl, M.A. thesis, Columbia University, ca. 1972, 138.

43. Henry F. Withey and Elsie Rathburn Whitney, *Biographical Dictionary of American Architects*, Los Angeles: New Age Publishing Company, 1956.

44. My thanks to John B. Kirby, Jr., for these last names.

45. Seymour, *New Haven*, 223.

46. Although apparently not a member of the office, Carlos C. Buck (usually given as "C. C."), then of Middletown, Connecticut, collaborated with Austin on planning the Worcester city hospital in 1872, according to the Middletown *Daily Constitution*, 5 September 1872. He was born in Vermont ca. 1843 (age given as seventeen in the 1860 U.S. Census), moved with his family to West Brookfield, Massachusetts, served briefly with Company C of the 21st Massachusetts in 1861, when he called himself a carpenter, and seems to have moved to Worcester and may have been the C. C. Buck listed in the 1870 city directory as a carpenter. Where he received his architectural training is unknown, although it could have been with Elbridge Boyden or Stephen C. Earle in Worcester. After a few years in Middletown (ca. 1872–1875, where he listed himself as architect and building superintendent and designed the Victorian Gothic high school in Putnam, Connecticut, built in 1874), he moved to Hartford and then to New York City, where in the 1880s he published a couple of small books on domestic architecture and interior details (Henry-Russell Hitchcock, *American Architectural Books*, New York: Da Capo Press, 1976, Nos. 230 and 231), and worked for the inspector of buildings. Thanks to Christopher Wigren, Robyn Christensen of the Worcester Historical Society, Donna Baron of the Middlesex County Historical Association, and Susan Ceccacci for help.

47. Henry's 1891 obituary in the *New Haven Register* says that Fred had been with his father for eighteen years, that is, since 1873.

48. *New Haven Register*, 3 and 6 January 1896 and 3 February and 21 July 1900, for example.

Page numbers in *italics* refer to illustrations.

ABOUT THE AUTHOR

James F. O'Gorman is Grace Slack

McNeil Professor Emeritus of the History

of American Art at Wellesley College.

He is chairman of the Maine Historic

Preservation Commission and author

of numerous books, including *ABC of

Architecture* (2000) and *Connecticut Valley

Vernacular* (2002).